ANALOG CULTURE

Analog Culture: Printer's Proofs from the
Schneider/Erdman Photography Lab, 1981–2001

Edited by Jennifer Quick

Harvard Art Museums
Cambridge, Mass.

Distributed by Yale University Press
New Haven and London

IN ALL MY YEARS AS A PRINTER, MY JOB HAS BEEN TO HONOR THE INTENTION OF THE ARTIST. IT IS TO SUSPEND ANY INTERVENTION ON MY PART THAT WOULD INTERRUPT THAT INTENTION, EVEN IF IT MEANS THAT I DO NOT MAKE THE PRINT MORE BEAUTIFUL, OR MORE TECHNICALLY ELEGANT, OR ANY OTHER ATTRIBUTE THAT I MIGHT INSERT AS *MY* VALUE. WITH ALL OF THE ARTISTS I PRINT FOR, IT IS MY JOB TO LOCATE THEIR INTENTION IN ORDER TO REALIZE IT IN THE FINAL PRINT. THIS IS MY TALENT AS A PRINTER.

—GARY SCHNEIDER (2017)

12 Foreword
14 Acknowledgments

I. INTRODUCTION

20 **Schneider/Erdman, Inc., and the Collaborative
 Work of Darkroom Photography**
 Jennifer Quick

30 **Over the Brink: Teaching the History of
 Photography at Harvard in the Early 2000s**
 Robin Kelsey

II. MATERIAL ECONOMIES OF PHOTOGRAPHY

38 **Printing and the Urgency of Translation:
 Peter Hujar, David Wojnarowicz, and the Task of
 Schneider/Erdman, Inc.**
 Jessica Williams

64 **Producing Multiples/Performing Prints:
 Reenacting Czech Modernism in the 1990s**
 Jennifer Quick

III. ORAL HISTORIES

 Reflections

96 **Printing Peter Hujar**
 Gary Schneider and John Erdman
100 **Printing David Wojnarowicz's *Sex Series***
 Gary Schneider and John Erdman

 Interviews

103 **Deborah Bell**
111 **James Casebere**
123 **Gary Schneider**
146 **Lorna Simpson**

 Conversations

150 **Robert Gober,
 with Andrew Rogers and Claudia Carson**
172 **John Schabel**

180 Selected Bibliography

 Glossary (inside back pocket)

FOREWORD

The relationship between photographer and printer, like any collaboration that requires two artists to share time, ideas, and materials, is necessarily built on trust. Over the span of his illustrious career as a photographic printer, Gary Schneider established himself as a master craftsman, earning the trust of such well-known artists as Richard Avedon, James Casebere, Robert Gober, Nan Goldin, Peter Hujar, Gilles Peress, John Schabel, Lorna Simpson, and David Wojnarowicz—artists who handed over their source material to Schneider and divulged their hopes for the print in full confidence that he would enact that vision with sensitivity and technical expertise. Schneider and his partner, John Erdman, have in turn entrusted the Harvard Art Museums with the preservation, exhibition, and study of 445 photographs printed with these and other artists at their Manhattan-based photography lab over the course of its 20-plus years in operation. The printer's proofs, together with Schneider and Erdman's additional gifts of archival and technical material from their lab, have transformed the museums' photography holdings. Already strong in 20th-century American documentary and contemporary photography, the museums' collection now boasts a deep well of study material concerning the darkroom and photographic printmaking, as well as images that speak to the sociopolitical climate of the 1980s and '90s—a period that witnessed the culture wars, the transformation of New York, and the decimation of a generation of artists at the hands of the AIDS epidemic.

In deciding to appoint the Harvard Art Museums as custodian of this unparalleled collection, Schneider and Erdman recognized an institution with the facilities and resources necessary to ensure that the prints, archival documents, and technical tools are cared for appropriately. That infrastructure includes the Center for the Technical Study of Modern Art, a vital resource for conservators and scholars interested in knowing more about the materials and issues associated with the making and conservation of modern works of art. However, they ultimately placed their trust in museum staff—namely, Deborah Martin Kao, former chief curator and Richard L. Menschel Curator of Photography, whose curiosity and insight first brought Schneider's photographic work to the museums, and Jennifer Quick, the John R. and Barbara Robinson Family Associate Research Curator in Photography, who led this multipronged *Analog Culture* project with enthusiasm and thoughtfulness. As editor of this volume, Quick has presented an impressively varied examination of the techniques, materials, and questions of reproduction and intent specific to photographic printmaking; she has sought the perspectives of professors, graduate students, curators, conservators, artists, dealers, studio managers, and Schneider and Erdman themselves, all of whom have lent their voices to this important addition to the history of photography. The broader work of this project now extends to Makeda Best, the museums' new Richard L. Menschel Curator of Photography as of 2017.

Notably, the book is but one point of entry to the printer's proof collection. Through the accompanying online Special Collection, audiences will be able to read case studies of select prints, view recordings of the interviews partially transcribed here, and browse the full scope of archival and technical materials generously gifted by Schneider and Erdman. The accessibility of this online resource is one advantage of the digital era, which has partly eclipsed many of the analog processes studied in this project. Yet as Robin Kelsey, Dean of Arts and Humanities and the Shirley Carter Burden Professor of Photography at Harvard, writes in his contribution to this volume, technological advancement always comes with a trade-off. In recognition of the fact that there is no substitute for examining works of art in person, we encourage all who are able to visit the exhibition, on view in Summer 2018, or to make an appointment to view printer's proofs in our Art Study Center. There, one can pore over the material differences of artists' preferred papers or the effects of gelatin silver versus pigmented ink—nuances that no screen could faithfully convey.

Such unprecedented access to these photographs would of course not be possible without the significant contributions of Schneider and Erdman, whose relationship with the museums runs deep. We extend our gratitude to them and to the Widgeon Point Charitable Foundation, whose generosity helped make the exhibition a reality. Further support for this project was provided by the following endowed funds: the Harvard Art Museums Mellon Publication Funds, including the Carola B. Terwilliger Fund; the John R. and Barbara Robinson Family Fund for Photography; the Agnes Gund Fund for Modern and Contemporary Art; the M. Victor Leventritt Fund; and the Richard L. Menschel Endowment Fund. Modern and contemporary art programs at the Harvard Art Museums are made possible in part by generous support from the Emily Rauh Pulitzer and Joseph Pulitzer, Jr., Fund for Modern and Contemporary Art. Finally, we gratefully acknowledge the Margaret Fisher Fund, which allowed the museums to acquire this truly exciting collection through a two-phase combined purchase and gift in 2011 and 2016.

Born out of a collaborative process between photographer and printer, the printer's proofs now provide inspiration for new collaborations: the combined efforts of practitioners, scholars, and students to preserve and advance our understanding of photographic printmaking. With help from our supporters, Schneider and Erdman's invaluable firsthand knowledge, and the intellectual energy of colleagues and students across campus, we are well positioned to honor Schneider and Erdman's desire that their work serve the museums' teaching and learning mission.

Martha Tedeschi
Elizabeth and John Moors Cabot Director
Harvard Art Museums

ACKNOWLEDGMENTS

The spirit of collaboration that characterizes the partnership between Gary Schneider and John Erdman was channeled fully in the production of *Analog Culture*, a project realized through the hard work and dedication of many. This book and the exhibition are built first and foremost on the efforts of Deborah Martin Kao, former Landon and Lavinia Clay Chief Curator at the Harvard Art Museums, who in her earlier role as photography curator recognized the significance of the printer's proof collection and who worked for years to bring it to the museums. When I first met Debi in 2006, I was a brand new graduate student at Harvard. She immediately took me under her wing, introducing me to incredible opportunities at the museums and to the individuals who would eventually become my colleagues. In 2015, shortly after I completed my Ph.D., Debi hired me to work on an exhibition and catalogue that would showcase the extraordinary collection whose acquisition she had tirelessly pursued. I cannot adequately convey here how much her mentorship and support have meant to me, and how difficult it was to see her step away from the museums where she had spent so much of her career—and which she indelibly shaped—in August 2016. I remain thankful to her for all that she has taught me and for her continued friendship.

It was Debi who invited me into her unique alliance with Gary and John. From the moment I met them, I was struck not only by the rich history they have lived, but by their hospitality and generosity. Acting as both teachers and friends, they lent their support to this project—and to me—in numerous ways, from indulging endless phone calls, emails, and in-person conversations to opening their home to me without a moment's hesitation. The interviews and reflections captured in this book testify to their legacy of artistic and technical excellence and to their wide network of colleagues and friends, so many of whom shared their stories with me because of their appreciation and love for Gary and John. I am honored to have played a part in documenting this legacy and helping make it known to a larger audience.

This project would not have been possible without a group of extraordinary colleagues at the museums and beyond. My warmest thanks to Jessica Ficken, curatorial assistant for the collection in the Division of Modern and Contemporary Art, who calmly and efficiently kept track of all the logistical aspects of the book and exhibition. I am especially grateful to Jessica for her extra support during my leave, as I took time away from work to welcome my first child, trusting fully that the project was in good hands.

Jessica Williams, Ph.D. candidate in the history of art and architecture at Harvard, came on board early in the project's development. Tasked with designing and authoring the bulk of the text for the online resource that is a major component of this undertaking, Jessica also stepped in to write an essay for this volume that adds new and exciting scholarship to the field. In addition to these specific contributions, Jessica's intelligence, sensitivity, and thoughtfulness made her an indispensable and valued colleague in the shaping of this project.

I was lucky to have had two other bright Ph.D. candidates at Harvard assist me with *Analog Culture*. Davida Fernandez-Barkan took up the mantle as curatorial intern for Summer and Fall 2017, contributing important scholarship on works in the printer's proofs collection—including for the online resource—and deftly handling a variety of other tasks, from writing gallery text to faciliating relationships with the many artists involved in this project. Jessica Bardsley formulated an engaging slate of public programming and brought much-needed knowledge of the history of cinema to this project. Their dedication and insights revealed aspects of the collection that would have remained otherwise undiscovered.

Additional contributors to the book include Robin Kelsey, Dean of Arts and Humanities and the Shirley Carter Burden Professor of Photography at Harvard, who shared invaluable reflections on teaching photography, gleaned from his years of instructing Harvard students. Penley Knipe conducted a thorough and insightful interview with Gary Schneider and spearheaded important conservation work on the printer's proofs. Deborah Bell, Claudia Carson, James Casebere, Robert Gober, Andrew Rogers, John Schabel, and Lorna Simpson generously shared with me their experiences in the art world and their memories of collaborating with Schneider/Erdman, Inc. I extend my heartfelt thanks to all who contributed to the manuscript.

Once compiled, this volume benefited immensely from the incisive feedback provided by two anonymous reviewers; their comments came at a pivotal moment, inspiring me to further refine my argument and other aspects of the manuscript. Micah Buis, associate director of publishing and managing editor, and Sarah Kuschner, assistant editor, then stepped in to lend their editorial expertise. With intelligence and sensitivity, they offered feedback that strengthened and sharpened the text. Finally, design manager Zak Jensen and his team, including Adam Sherkanowski and Becky Hunt, conceived a beautiful design that perfectly captured my vision for the book.

Many others at the Harvard Art Museums lent their support along the way. Only a few months into her tenure as the Elizabeth and John Moors Cabot Director, Martha Tedeschi enthusiastically championed the acquisition of the remainder of the printer's proof collection and the production of this book. Lynette Roth, Head of the Division of Modern and Contemporary Art and Daimler Curator of the Busch-Reisinger Museum, acted as an advocate for the project and offered crucial feedback at various stages of development. Special thanks as well to senior archivist and records manager Megan Schwenke, a talented and generous colleague who organized documents and

ephemera from the Schneider/Erdman lab into a coherent archive, accessible to researchers who are sure to find it invaluable now and in the future. In addition to those I have already mentioned within the Division of Modern and Contemporary Art, Makeda Best, Michael Dumas, Mary Schneider Enriquez, and Sarah Kianovksy have provided assistance and counsel to this project. In the Division of Academic and Public Programs, Correna Cohen, Jessica Martinez, Chris Molinski, Erin Northington, David Odo, and Molly Ryan supported pedagogical efforts and exhibition programming. Jennifer Aubin, Daron Manoogian, Lauren Marshall, and Rebecca Torres did an extraordinary job generating and managing promotional material and video content related to the project. Jeff Steward and Stephanie Vecellio were immensely helpful in designing the collection's digital components. I constantly marvel at the professionalism and efficiency of our Collections Management team, who made possible the cataloguing, organization, and installation of the printer's proofs, especially Jennifer Allen, Karen Gausch, Karoline Mansur, and Kathryn Press. Jane Braun and Dana Greenidge ensured that the project moved along in a timely manner. I am grateful, too, to Mary Lister, who facilitated easy access to the collection in the museums' Art Study Center, and to Justin Lee for his stellar exhibition design.

Finally, my deepest thanks to my family, which grew by one during the course of this project. To my husband Walt and to our daughter, Rian, born shortly before this book went to press—all my love and gratitude.

Jennifer Quick
John R. and Barbara Robinson Family Associate Research Curator in Photography
Harvard Art Museums

I

INTRODUCTION

JENNIFER QUICK

SCHNEIDER/ ERDMAN, INC., AND THE COLLABORATIVE WORK OF DARKROOM PHOTOGRAPHY

I HAVE OFTEN SAID THAT THE
NEGATIVE IS SIMILAR TO A
COMPOSER'S SCORE, AND THE PRINT
TO THE PERFORMANCE OF THAT
SCORE. THE NEGATIVE COMES
TO LIFE ONLY WHEN "PERFORMED"
AS A PRINT.

—ANSEL ADAMS, *THE PRINT* (1983)[1]

The history of darkroom photography is a history of negative and print. The darkroom as we know it today made its debut with the invention of dry-plate negatives in the late 19th century: instead of relying on complicated chemistry to create cumbersome wet-plate negatives for their cameras, photographers now had readymade negatives, coated with gelatin, to use on the go.[2] When exposed, these negatives—like their forerunners—became an analog of the light that passed before the camera, preserving a latent image on the surface. But with negatives now pre-prepared, the chemistry once performed on site shifted to the darkroom, the light-sealed space necessary for exposing and developing the negatives as prints. The darkroom truly came into its own as gelatin developing-out papers became increasingly available in the 1900s, and the gelatin silver process, as the technique that employs such papers is called, would dominate art photography throughout that century. Even in our current era of digital photography, gelatin silver remains one of the most widely used types of analog methods. Its rise in popularity prompted specific ways of working with photographs, characterized by an interpretive space and temporal gap between negative and print and defined by a new kind of creative latitude in printing. In developing an image, a photographer translates the grays in the negative—what practitioner and historian Richard Benson called "informational voids"—into the blacks and whites of a print. Thus the negative does not dictate the look of a print, but rather provides what Ansel Adams has called "raw material," open to interpretation in the darkroom. In this sense, as Adams puts it, the negative functions similarly to a composer's score, actualized in the "performance" of printing.[3]

Darkroom photography opened up new opportunities for collaboration. While a maker can and often does both create the negative and derive prints from it, in many cases photographers work with printers, a common yet understudied practice throughout the medium's history. This book, the related exhibition, and the digital resource available on the Harvard Art Museums website all take the photographer/printer relationship as their starting point, arguing that the productive nature of this partnership reveals as much about the practice of making photographs as it does about the aesthetic, historical, technological, and cultural significance of darkroom photography in the 20th century.

The Harvard Art Museums' Schneider/Erdman Printer's Proof Collection, the focus of this project, richly represents the collaborative work of photography. Among the museums' most significant holdings in photography, the collection comprises nearly 450 photographs printed over the course of three decades by Gary Schneider, under the aegis of Schneider/Erdman, Inc. Born and raised in South Africa, Schneider came to New York in 1976 while on break from the Michaelis School of Fine Art. During that time, he worked for Richard Foreman's Ontological-Hysteric Theater, where he met his partner, John Erdman, a New York–born artist involved in performance art, film, and theater; and through John, also met photographer Peter Hujar in 1977. After returning to Michaelis to complete his B.F.A., Schneider came back to New York later in 1977, resuming his work with Foreman's theater company. In 1978, he began graduate school at the Pratt Institute and—finding himself in need of income—started working in a photography lab, a job he found with Hujar's assistance. Eventually, with Hujar's encouragement, Schneider decided to open his own photo lab. He asked Erdman to join him, despite the fact that Erdman had no prior experience with black and white photography. The pair opened their lab in 1981, officially incorporating it as Schneider/Erdman, Inc., two years later. By 1984, they had moved from an apartment on St. Mark's Place in the East Village to their longtime location in a Cooper Square loft. While Schneider continued to cultivate his printing skills, Erdman, who oversaw business operations, became proficient in photographic retouching and finishing. Schneider also trained him to be a second pair of eyes, to study and evaluate prints. Always working collaboratively in their ventures, Schneider and Erdman were—and remain—true partners in every sense of the word (Fig. 1).

Though they did not advertise their services, clients came to Schneider/Erdman through word of mouth, as news of their business circulated within the networks of artists, performers, dealers, and curators who make up the New York art world—a community to which Schneider and Erdman already belonged in their respective artistic capacities.[4] During the pair's most prolific years, from the mid-1980s to the mid-1990s, they worked with many well-known artists, fashion photographers, and photojournalists, including Richard Avedon (Figs. 2–5), Matthew Barney, James Casebere, Louise Dahl-Wolfe, Eric Fischl, Robert Gober, Nan Goldin (Fig. 6), Peter Hujar, Gilles Peress (Fig. 7), John Schabel, Laurie Simmons (Fig. 8), Lorna Simpson, and David Wojnarowicz. Schneider also became known for his prints for reproduction in publications ranging from *The New York Times Magazine* (Fig. 9) to the book *Sex* (1991) by pop singer Madonna.

As a printer, Schneider established his reputation on the basis of his technical skills, knowledge of the materials of silver photography, and capacity for

Fig. 1
Peter Hujar, *John and Gary at Mohonk Mountain House*, 1984. Pigmented ink print, 40.6 × 50.8 cm (16 × 20 in.). Harvard Art Museums/Fogg Museum, Schneider/Erdman Printer's Proof Collection, partial gift, and partial purchase through the Margaret Fisher Fund, 2016.172.

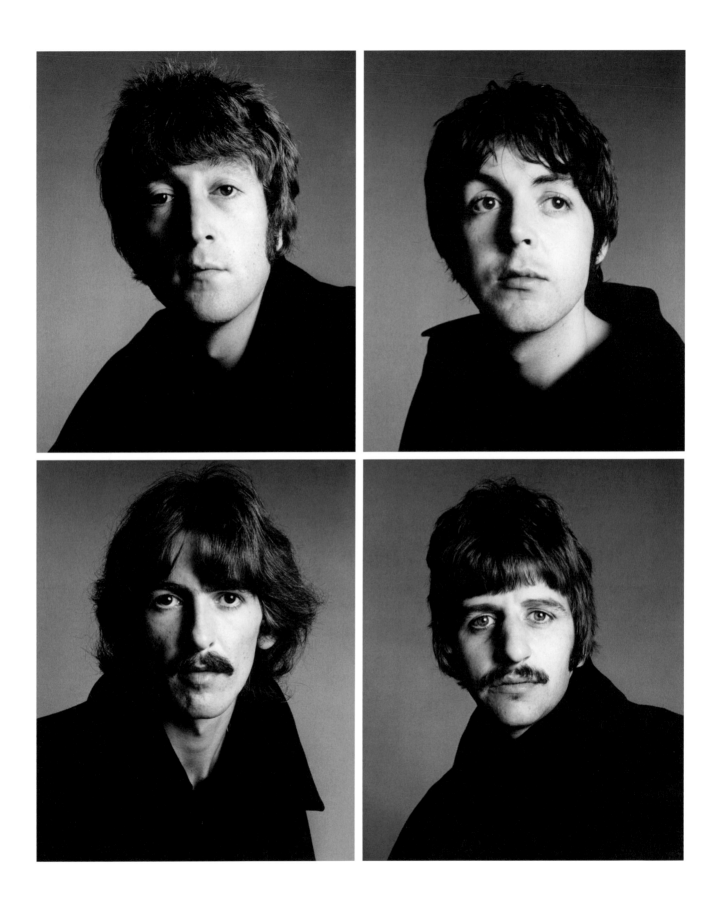

experimentation. Beyond that, however, he cultivated a philosophy of printing that appealed widely to the artists, journalists, and magazine editors who commissioned Schneider/Erdman. In each unique collaboration, Schneider sought, as he has described it, to "catalyze the vision" of his client.[5] Rather than printing in a specific style or with a standard set of methods, he considered each project on a case-by-case basis, meticulously seeking the precise combination of papers, toners, and stabilizers that would produce just the right print. To facilitate their working process, and in partial exchange for their services, Schneider and Erdman established early on the practice of retaining a printer's proof from each edition they made. The term derives from the historical practices of non-photographic printmaking, such as etching and lithography. In that context, a number of proofs are made in the process of printing an edition, including the *bon à tirer* (the "okay to print" proof, or BAT), a print for the artist to retain (the artist's proof, or AP), and a print for the publisher or printer (printer's proof, or PP).[6] Schneider's proofs served the same purpose as the non-photographic PP, but also functioned similarly to the BAT: the proof that results from the collaboration between artist and printer and that is used as a template to create further images. Charly Ritt, a printer from the Gemini graphic arts studio, has said of making the BAT, "[P]roofing has to be real thought out and clear, as precise as possible, and as informative as possible . . . and well documented so that whoever comes along [to print the edition] will know what I did to get the results I got and will have a little more ease in printing."[7] Like Gemini printers, Schneider often went through many proofs in the course of working with his clients, each step carefully considered and executed. Once satisfied with the prints, he would usually invite clients into the lab to review the proofs, and they would decide together how to proceed. Sometimes this resulted in moving forward with one of the existing proofs; in other cases, it meant going back to the drawing board to make others.

While his terminology and process bear resemblance to the PP and BAT as conceived in other workshops, Schneider developed a specific conception of the printer's proof that represented his printing philosophy, especially important in his work with artists. In some instances, such as his prints for Avedon, he hewed closely to the idea of the BAT by making a proof that the artist approved and that he aimed to match as completely as possible

in printing the edition (Fig. 10).[8] In many cases, however, Schneider neither promised nor attempted seamless replication across an edition, or when working with artists on multiple editions. Because an edition is conventionally understood to contain identical multiples, Schneider's stance was unusual in the printing world. As he explains later in this book, darkroom photography by its very nature is a dynamic process, affected by subtle shifts in chemicals, lighting, and temperature.[9] The availability of materials also determines the look and feel of a print. For example, certain photographic papers, such as Agfa's Portriga Rapid, ceased to be produced during Schneider's years as a printer, limiting his ability to match the qualities of that stock.[10] But beyond these material reasons, there is a conceptual impetus behind Schneider's philosophy: namely, the idea that an artist's work, tastes, and goals can change over time. Accordingly, he conceived of his printing practice as an embodied and interpretive activity, akin to Adams's idea that executing a print is like a performance. Rather than trying to match a proof as he printed each edition, Schneider strove to activate the artist's ideas in each iteration of the image, as a means of translating his or her thinking and vision into the materials of photography. Less a template and more so an expression of collaborative decision-making, the printer's proofs also have a different temporality than the BAT, as Schneider often chose his proof after the edition was completed.

Given this approach, each printer's proof in the Schneider/Erdman collection represents a specific collaboration and a distinctive performance. As Schneider discusses elsewhere in this volume, his printing for Hujar (a working relationship that continues to this day with Hujar's estate) represents the clearest example of his performative, malleable approach to printing. The essays presented here explore the way in which his other projects, from printing for Wojnarowicz to the reproduction of 1920s and '30s Czech photography, necessitated their own specific conditions and methods of printing. While this definition of the printer's proof most clearly applies to Schneider's work with artists, he took a similar approach to his prints for reproduction as well as other ventures, such as Madonna's *Sex*.

Over the years, as they accumulated more proofs, Schneider and Erdman began to conceive of the prints as a study collection documenting their collaborations with a range of artists as well as the array of technical processes that Schneider employed in his work. In addition to the photographs, they accrued numerous materials and tools to support Schneider's printing practice and records of their business, all of which they have generously given to the Harvard Art Museums. Complementary to the actual printer's proofs, these other collections are housed in the museums' Center for the Technical Study of Modern Art and archives. Together these holdings record a history of the lab and the New York world that it was part of during

Figs. 2–5
Richard Avedon, *The Beatles, London, August 11, 1967*, 1967. Gelatin silver prints, each: 61 × 50.8 cm (24 × 20 in.). Harvard Art Museums/Fogg Museum, Schneider/Erdman Printer's Proof Collection, partial gift, and partial purchase through the Margaret Fisher Fund, 2016.140.1–4.

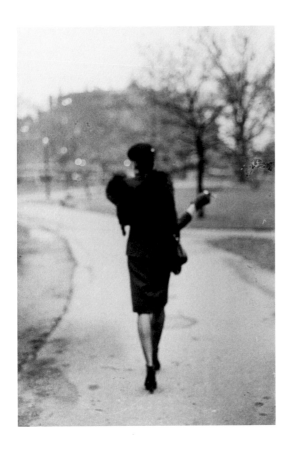

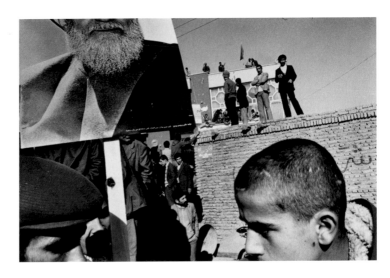

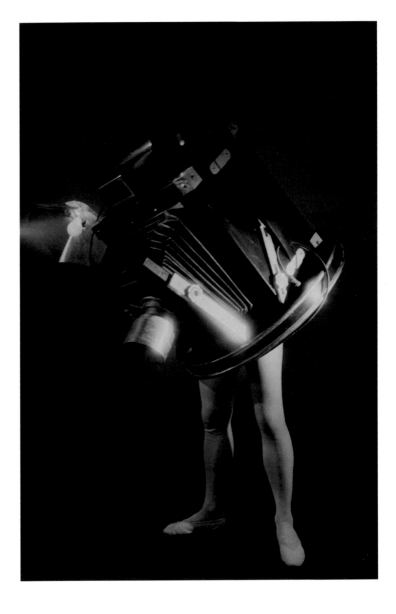

Fig. 6
Nan Goldin, *Ivy in the Boston Garden: back, Boston*, 1973. Gelatin silver print, 50.8 × 40.6 cm (20 × 16 in.). Harvard Art Museums/Fogg Museum, Schneider/ Erdman Printer's Proof Collection, partial gift, and partial purchase through the Margaret Fisher Fund, 2011.209.

Fig. 7
Gilles Peress, *Pro-Shariatmadari Demonstration, Tabriz*, 1979. Gelatin silver print, 40.6 × 50.8 cm (16 × 20 in.). Harvard Art Museums/Fogg Museum, Schneider/Erdman Printer's Proof Collection, partial gift, and partial purchase through the Margaret Fisher Fund, 2011.404.

Fig. 8
Laurie Simmons, *Walking Camera I (Jimmy the Camera)*, 1987. Gelatin silver print, 100.5 × 70.8 cm (39⁹/₁₆ × 27⅞ in.). Harvard Art Museums/Fogg Museum, Schneider/Erdman Printer's Proof Collection, partial gift, and partial purchase through the Margaret Fisher Fund, 2011.437.

the 1980s and '90s, culminating in the effective end of the business around September 11, 2001, shortly after which Schneider and Erdman were forced to leave their space on Cooper Square. These collections document a social as much as a material history of photography. They intertwine with and represent key happenings that coincided with the years of the lab's existence, such as the AIDS crisis, its devastating impact on the art world, and the politics of resistance that emerged in response; the culture wars of the 1980s and '90s; and the transformation of New York between 1980 and 2001, including the effect of September 11 on the economy and urban landscape. The lab and its work illuminate a broader artistic and cultural milieu, which this project aims to represent in part by compiling oral histories from Schneider, Erdman, and collaborators. In light of contemporary politics in the United States, many of these histories have taken on greater significance. Issues of identity, difference, and funding for the arts have again become especially urgent, reminding us that this work of history is also relevant to understanding the present.

In each of its three components (the book, exhibition, and extensive digital resource), this project weaves these stories throughout, framing the printer's proof collection as a window into photography's technological and cultural histories. This volume, a research companion for the collection, compiles the scholarship and firsthand accounts that the project has generated, including essays, excerpts from interviews, and written reflections by Schneider and others. The exhibition showcases key works from the printer's proof collection as well as related materials, as a means of documenting Schneider/Erdman's history and printing practice while educating viewers about the technical processes and historical significance of darkroom photography. The glossary included in this volume, specifically tailored to Schneider's printing, assists readers in navigating the technical nuances of gelatin silver processes. Finally, the online resource, which contains some of the material in this volume but also features new case studies and technical information on select printer's proofs, serves as a comprehensive digital repository for the collections, including the archival and research materials. As the project progresses, the digital component will capture new and ongoing research that is beyond the scope of this publication, much of it undertaken by

Harvard graduate students. For instance, firmer dates for the printing of the individual photos will be added as that information is determined. (In this volume, only dates for the original photos have been included in image captions.)

With its attention to material histories, *Analog Culture* aims to address certain gaps in the art historical literature on photography. While recent scholarship on non-photographic printmaking has delved into technique, materials, and the makeup of the printing studio, as well as collaboration in printing, histories of photography are often not as attentive to analogous printing circumstances.[11] This lack of focus on printing derives in part from the traditional hierarchy of artist and artisan, which, though outdated, still colors contemporary scholarship insofar as the skills of technicians are frequently overlooked, under-theorized, and regarded as secondary to those of the artist. This is especially true of collaborative projects, in which technicians are seen as—and often perceive themselves to be—vessels for realizing the artist's vision rather than active participants in the creative process. Another reason stems from the postmodern and critical theory that flourished in the late 1970s and into the '80s and '90s, in which emphasis was placed on photography as an object of theory rather than on the medium's material forms and economies. (One example, as discussed in my essay in this volume, is Douglas Crimp's argument concerning the "photographic activity" of postmodern art.) Moreover, when printing is mentioned in the context of photographs, it is often done in the interest of establishing an authorial link between artist and printer, thus solidifying the authenticity of posthumous

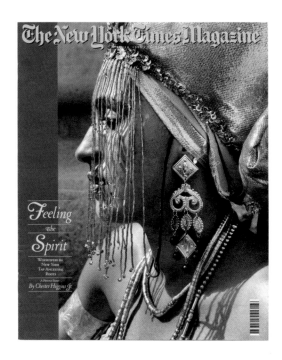

Fig. 9
Cover of *The New York Times Magazine*, April 19, 1992, featuring "Feeling the Spirit: Worshipers in New York Tap Ancestral Roots," a photo essay by Chester Higgins, Jr. Harvard Art Museums Archives, Gift of John Erdman and Gary Schneider, ARCH.2017.4.7.

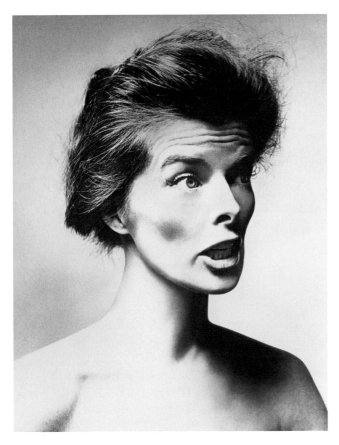

Fig. 10
Richard Avedon, *Katharine Hepburn, actress, New York, March 2, 1955*, 1955. Gelatin silver print, 35.6 × 27.9 cm (14 × 11 in.). Harvard Art Museums/Fogg Museum, Schneider/Erdman Printer's Proof Collection, partial gift, and partial purchase through the Margaret Fisher Fund, 2011.112.

multiple copies," shapes its meaning.[15] In his encyclopedic survey of photographic printing techniques, Benson looks closely at many processes, from stenciling to inkjet. Like Benson, my colleagues and I argue that studying the making of photographs, and looking closely at them, yields significant insight into how and why photographs attain meaning, how they communicate, and how we perceive them. If the print is, as William Ivins has said, "an exactly repeatable pictorial statement," studying how these repeatable statements come into being helps us grasp what is involved, and what is at stake, in the production of images.[16] Benson's work remains a touchstone for any scholar seeking to learn more about print processes, as well as for practitioners such as Schneider, who has acknowledged Benson's impact on his own work.[17] Another important precedent for the research presented here is the Museum of Modern Art's *Object:Photo. Modern Photographs: The Thomas Walther Collection 1909–1949*, published as a book and an extensive and detailed website. A joint effort between curators and conservators, *Object:Photo* is "based on the premise that photographs were not born as disembodied images; they are physical things. . . . [T]he photographic print harbors clues to maker and making, to the causes it may have served and to the treatment it has received."[18] Using the printer's proof collection as a case study, *Analog Culture* seeks to identify and historicize these "clues" regarding both the making and printing of photographs.

This project is the fruit of Schneider and Erdman's long relationship with the Harvard Art Museums, which began with Deborah Martin Kao, the former Landon and Lavinia Clay Chief Curator. Schneider and Kao first met in 1995, when Kao was serving as the Richard L. Menschel Curator of Photography. In 2004, she organized *Gary Schneider: Portraits*, a mid-career retrospective of his work. Examining Schneider's long-standing interest in portraiture and the representation of identity, the show included his *Genetic Self-Portrait* (1999), a large-scale work of 55 photographs based on the research and imaging methods of the Human Genome Project. (This work is now in the museums' collections, object number 2017.183.) As Kao was organizing the *Portraits* exhibition, she learned of Schneider's career as a printer and about the extraordinary collection he and Erdman had built. In 2012, Kao spearheaded the acquisition of over 300 photographs that became the basis of the Schneider/Erdman Printer's Proof Collection. This transformative acquisition came about through a combination of Kao's vision together with Schneider and Erdman's generosity and dedication to the teaching mission of our institution. In 2016, with support from Martha Tedeschi, the newly appointed Elizabeth and John Moors Cabot Director, and under Kao's continued leadership, the museums acquired the remaining 66 printer's proofs. Throughout the period leading up to the 2018 exhibition, Schneider and Erdman have gifted

prints, as in the case of Diane Arbus and Neil Selkirk.[12] In other notable cases, such as Berenice Abbott's printing of Eugène Atget's photographs, discussion tends toward the theoretical and historical implications of the differences between prints by each artist.[13] This project goes beyond the documentation of processes or questions of attribution and authorship; instead it looks at the ways in which printing opens up important and unexplored avenues in the meaning, function, and histories of photographs.

While the role of the printer has traditionally been overlooked, recent scholarship originating from the museum context has paid greater attention to the materiality of photographs. Preeminent among these works, Richard Benson's *The Printed Picture* has been a key point of reference for this project.[14] Presented as both an exhibition and a book, Benson's thesis follows from the deceptively simple notion that the making of a print, or what he describes as "creating fixed visual forms in

works of fine art and research and archival materials. This project, therefore, is just the beginning of the research that will emerge from studying these extraordinary collections in the years ahead. I hope these resources will serve as a useful tool for the range of audiences we welcome to the museums and the many more who visit us digitally. In working with the printer's proof collection, however, I have thought especially of our student audiences, who in general have little, if any, knowledge of darkroom photography and its histories. The importance of this research, then, goes beyond understanding how pictures are made to ask how knowledge of photographic processes helps us better understand the medium's historical and social significance. Even with the rise of digital photography, the darkroom lingers in our collective consciousness. Giving rise to key iconography and metaphors of modernity, it is a place, and a way of thinking, whose imagery continues to imprint how we see and describe the world.

Jennifer Quick is the John R. and Barbara Robinson Family Associate Research Curator in Photography at the Harvard Art Museums.

1
Ansel Adams, *The Print* (New York: Little, Brown and Company, 1983), 2.
2
Richard Benson, *The Printed Picture* (New York: Museum of Modern Art, 2008), 160.
3
Adams, *The Print*, 1.
4
John Erdman, in conversation with the author, April 27, 2017. Erdman's own background is important to the lab's history given his connections with artists. Specifically, he was involved with performance art beginning in the 1970s, working with Joan Jonas, Yvonne Rainer, Robert Wilson, and Karole Armitage, among others.
5
Schneider used this phrase in multiple conversations with the author, including in October 2016 and January 2017.
6
For explanations of these terms in the context of non-photographic printmaking, see the glossary in the Gemini G.E.L. Online Catalogue Raisonné, compiled by the National Gallery of Art, Washington, D.C., available at http://www.nga.gov/gemini/glossary.htm. See also the interview with Deborah Bell and the glossary in this book for more on the printer's proof.
7
Quoted in Ruth Fine, *Gemini G.E.L.: Art and Collaboration* (Washington, D.C.: National Gallery of Art; New York: Abbeville Press, 1984), 29.
8
Avedon requested that his proofs be called "artist's proofs" rather than "printer's proofs." They are marked as such on the versos.
9
See Schneider's statement on printing for Peter Hujar in this volume.
10
For more on Portriga Rapid, see Jessica Williams's essay and the glossary in this volume.
11
In reference to 20th-century printmaking, see, for example, Fine, *Gemini G.E.L.*; Trudy V. Hansen, *Printmaking in America: Collaborative Prints and Presses, 1960–1990* (New York: Harry N. Abrams, 1995); Karin Breuer, *Thirty-Five Years at Crown Point Press: Making Prints, Doing Art* (Berkeley: University of California Press, 1997); Marjorie Devon, *Tamarind Touchstones: Fabulous at Fifty: Celebrating Excellence in Fine Art Lithography* (Albuquerque: University of New Mexico Press, 2010); and Judith Brodie, *Yes, No, Maybe: Artists Working at Crown Point Press* (Washington, D.C.: National Gallery of Art, 2013). There is also an important body of literature on printmaking and the workshop in the 16th century; see David Landau and Peter Parshall, *The Renaissance Print* (New Haven, Conn.: Yale University Press, 2004).
12
See Neil Selkirk, "In the Darkroom," in *Diane Arbus, Revelations* (New York: Random House, 2003).
13
See Clark Worswick, *Berenice Abbott, Eugène Atget* (Santa Fe: Arena Editions, 2002).
14
Sadly, Benson passed away while this book was in production and before the exhibition opened. See Richard Sandomir, "Richard Benson, Photographer and Printer, Dies at 73," *The New York Times*, June 27, 2017.
15
Benson, *The Printed Picture*, 3.
16
William Ivins, *Prints and Visual Communication* (Cambridge, Mass.: Harvard University Press, 1953), 2.
17
Gary Schneider, in conversation with the author, January 2017. Benson was one of the many collaborators on *Sex*, one of Schneider's most technically advanced projects.
18
Maris Morris Hambourg, Lee Ann Daffner, and Mitra Abbaspour, "Introduction," *Object:Photo. Modern Photographs: The Thomas Walther Collection 1909–1949*, available at https://www.moma.org/interactives/objectphoto/the_project.html#intro (accessed May 1, 2017). For the print version, see Mitra Abbaspour, ed., *Object:Photo. Modern Photographs: The Thomas Walther Collection 1909–1949* (New York: Museum of Modern Art, 2014).

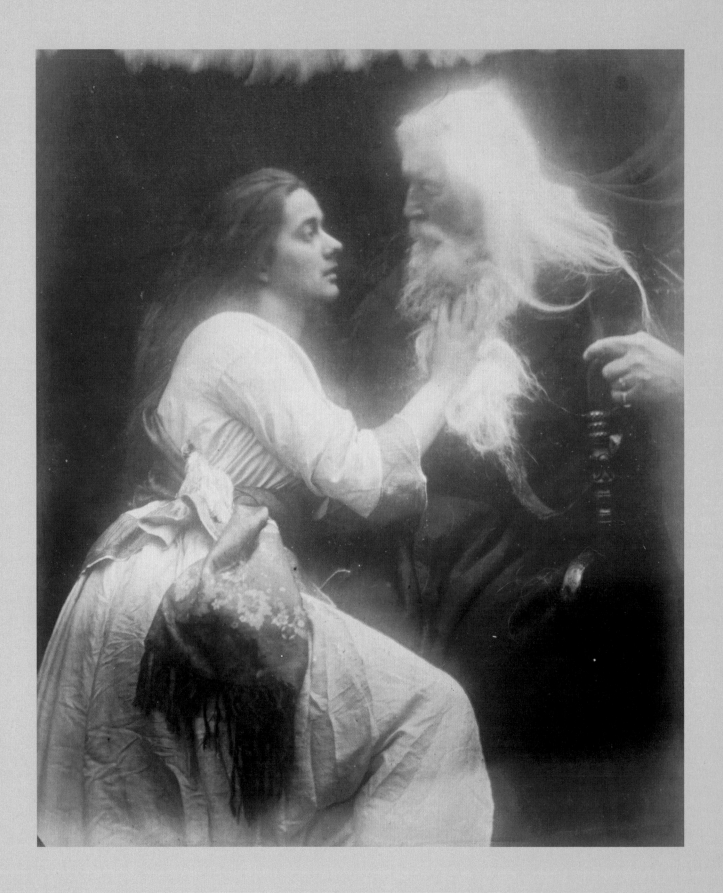

ROBIN KELSEY

OVER THE BRINK:

TEACHING THE HISTORY OF PHOTOGRAPHY AT HARVARD IN THE EARLY 2000s

I began teaching the history of photography at Harvard on September 13, 2001, two days after al Qaeda agents rammed hijacked planes into the twin towers of the World Trade Center in New York. Although the politics of that horror had much to do with photographs and other images, everyone attending the opening lecture of my survey course, including me, struggled to focus on my remarks about the syllabus and course requirements.

I used two carousels of film slides to project images that day, a practice I would continue until 2007. In those early years, preparing for a class meant going down to the slide collection of the Fine Arts Library in the Fogg Museum and working alongside faculty colleagues and teaching fellows. From rows of gray cabinets we would pull slides, substituting for each a personalized slip to record our borrowing. If the collection lacked an image we needed, a staff photographer working in a small room off the stairwell would make a new slide from any book or catalogue illustration we might provide.[1] Slides in hand, we would sit down at one of the internally illuminated slide tables and begin to arrange them into a series, consisting mostly of image pairs. This process provided a material sense of constructing the flow of argument for a lecture or of discussion for a seminar. The primacy of slides distinguished the pedagogy of art history. They were not merely illustrations of arguments already formed, they were the building blocks of our lesson plans.

The slide collection was a place of solitary tasks but also of social activity. Instructors would look over one another's shoulders to see a lesson plan in progress. One might ask another to recommend a work of art that would help raise a particular issue in class. The friendly library staff was always ready to track down anything difficult to find. The material scarcity of our images gave us a focal point for congregation and exchange.

A rosy picture of old times, that. But of course the slide room could also be a site of consternation. When time was tight, a missing slide could send an instructor into a panic, and an interruption by a less harried colleague might test one's temper. Moreover, even under the best of circumstances, the slide room could never match computer storage for efficiency. I would wager that most every art historian of a certain age remembers teaching a course for the second time using presentation software. The first time was really no more efficient than using slides—actually less so, because digital images were scarce, and therefore many slides had to be pulled anyway for scanning. The second time, however, was

magical: we marveled at the instantaneous replenishment of every slide used previously, arranged by lecture and in the proper order, without a drawer opened or a speck of new dust deposited.

My students in 2001 were well acquainted with slides and other artifacts of analog photography. Smartphones did not yet exist, and even if a student owned a digital camera, the odds were good that at least one of her parents or grandparents still used film. Almost every student had encountered analog cameras lying around the house. As a result of this familiarity, my class readily understood that an analog camera was a box with an aperture and a sheet of film, and that if the aperture was opened for a certain length of time, the film would react chemically to the entering light to form the matrix of a picture.

Students grasped the mechanics of the older technology, but they also understood that radical change was under way. The digital was surging; the analog was on the run. Prophecy about where this would lead, however, remained a tricky business. In 2001, the emphasis of most forecasting was on new possibilities for image manipulation and the effects that this would have on the social function of photographs as evidence. The possibility that translating light into bits of data might ultimately accelerate the dissemination and consumption of photography to the point that photographs would become the stuff of moment-to-moment communication received scant attention. Photoshop, in other words, was on people's minds, but Snapchat and Instagram belonged to a hazy future.

As the years progressed, student familiarity with film cameras and processes dwindled. For a teacher of the history of photography, keeping track of this growing estrangement was a challenge. With the arrival of the iPhone in 2007, the very notion of the camera as a box began to fade. Although I would start each semester with a discussion of the basic elements of analog photography as a technology, increasingly students struggled to comprehend its historical arc. One day, a student came up to me after a lecture on the photography of Julia Margaret Cameron (Fig. 1) and asked, "These pictures weren't made with a camera, were they?" I realized then that the effort required to ensure that my students would understand the basic technological history of photography was greater than I had imagined.

My teaching has sensitized me to the ways in which the analog era, as a matter of history, is a product of the digital one. The elements of analog photography that we emphasize today—its messy chemical origins, its dependence on duration, its darkroom alchemy, its object-like product—were all more or less evident 40 years ago. But so were many other aspects of photography. The designation of certain elements of analog photography as definitive of "the analog," and the very constitution of the analog era *as* an era, came about through the onset of the

Fig. 1
Julia Margaret Cameron, *Vivien and Merlin*, 1874. Albumen silver print, 32 × 27 cm (12⁵⁄₈ × 10⁵⁄₈ in.). Harvard Art Museums/Fogg Museum, Purchase through the generosity of Melvin R. Seiden, P1982.323.

digital and its distinctive properties. As a French literature scholar remarked to me soon after I joined the Harvard faculty, "Now you historians of photography have a corpse to study."

The corpse of analog photography has a coherence that the living practice lacked. With the emergence of the digital, the various technological episodes of the first 150 years of the medium, including the early forays on metal, paper, and glass, the advent of Kodak and industrial processing, and the rise of Polaroid, suddenly became bound together. The digital gave them a new commonality. As the pre-digital era of photography came to an end, historians pounced on the chance to describe it afresh.[2] Publication of books on the history of analog photography burgeoned.

The various analog technologies were marked by their liquid ways of development.[3] The analog image emerged from wetness. Even the squishy packets of chemicals at the base of Polaroid's SX-70 film attested to that. Prior to the digital era, this liquidity seemed no more remarkable than many other aspects of photography. But once the latter era commenced, the liquid ways of analog photography seemed contingent and peculiar. Although our current technology is awash with wet metaphors of freedom and evanescence—we surf the Internet, we store our data in the Cloud—the material experience of the digital is dry.

Digital processes pushed certain qualities of photography to an extreme, casting analog photography in a new light. For example, while artists from Marcel Duchamp to John Baldessari associated analog photography with automatism and de-skilling, the digital age has made photography so easy and idiot-proof that many analog processes seem artisanal by comparison. Time travelers from as recently as the mid-20th century would be flabbergasted to see how routinely we classify analog photographs as fine art. When I teach from salt paper or albumen prints in the Harvard Art Museums, students treat them with all the attention to technique and material specificity once reserved for older media, such as painting and drawing.

One of the virtues of teaching the history of analog photography is that it enables students to appreciate the non-linearity of technological change. Digital technologies are understood digitally. Do you still have the iPhone 5? I had the 6 but recently upgraded to the 7. Are you still using version 5.2 of that app? I just downloaded version 5.4. The numbers attached to our devices and software ascend over time, signifying a progressive ratcheting up of computing power, speed, and number of features. Although the commercial interests that marketed analog processes and equipment in the 20th century also heralded each new version as an advance, progress was unquestionably muddled. In terms of image resolution, the passage from daguerreotype to wet-plate collodion

negative and albumen print was a decline, as was the passage from the latter to the Kodak snapshot. Every new technology suppresses certain powers even as it amplifies others, and the history of analog photography offers many case studies of that oft-forgotten principle.

Most important, the study of analog photography gives students a chance to reflect critically on their own digital moment. While my lectures are not designed to inspire nostalgia for the days of darkrooms, I do encourage students to question the frequently unthoughtful assent to technological change that capitalist modernity fosters. Are life and world better with digital photography than they were with analog? What are the advantages and disadvantages of each? When might one choose to make analog pictures even in a digital era? Such questions open the minds of students to broad issues concerning the structure of society and the shaping of history.

When I was a first-year law student at Yale, my torts professor, Guido Calabresi, asked my class to imagine an evil deity who offered America a magical convenience in exchange for authority to consign thousands of people each year to violent death. Should the country accept the offer? Put this way, the deal seems patently horrible, but as Professor Calabresi pointed out, these terms are essentially those of the automobile. For me, the greatest takeaway of this exercise was the recognition that society does no such contractual bargaining before it embraces a new technology. Before the newest smartphone is sold, no authorities sit down to weigh the prospective costs of distraction, shortened attention span, cyberstalking and -bullying, and other attendant problems against the added convenience the device will supply. Legislatures can make adjustments after the fact to mitigate social ills, but the mechanism is weak. New technologies are judged haphazardly in the market by the individual decisions of consumers who are subject to the relentless pressure of profit and the pleas of advertising. When the number of consumers opting into a new technology grows large or fast enough, society begins to structure itself around the technology, making opting out exceedingly difficult.

Giving students a chance to understand how their society organizes itself around mass commerce puts their lives into a broader perspective. This is a good thing. They have already experienced in their lifetimes the swift brutality of the "out with the old, in with the new" ways of capitalism. Like their parents before them, they are likely to witness the evisceration of entire skill sets, occupations, and industries in a matter of years. Some call this process "creative destruction," but it can be ruthless and euphoric as well as generative. We are promised that we are being spared labor, but labor is a way to make a living—and a way to make a life.

Today, the analog is settling into a market niche. I learned of this niche several years ago, when I visited a typewriter shop that had relocated to Arlington,

Massachusetts, after many years in Harvard Square. Surprised that the shop was still in existence, I asked the proprietor about his customer base. He told me that he was selling many of his typewriters to twentysomethings in Brooklyn. Since then, the appetite among hipsters for typewriters, turntables, and certain film cameras has grown. On the one hand, this refusal to hew exclusively to digital technologies seems a tame or even quaint form of rebellion, a tiny release valve on a system addicted to augmenting control, ease, and stimulation. On the other hand, a willingness to question the necessity of the ratcheting up of these forms opens the possibility of more complex modes of cultural temporality and more radical forms of dissent.

In the meantime, teaching the history of photography has become more important than ever. By many orders of magnitude, more communication takes the form of a photographic image than it did a generation ago. The impulse to live for the image of living has never had such an engine behind it. To understand the liquid ways of analog photography is to understand a key element in the emergence of our troubled image society. It is also a way to begin fathoming some of the greatest art of the past 180 years.

Robin Kelsey is Dean of Arts and Humanities and the Shirley Carter Burden Professor of Photography in the Department of History of Art and Architecture at Harvard University.

1

Until she died in 2003, that photographer was the crusty and bighearted Bonnie Solomon, who spent decades rescuing department faculty and graduate students unable to find what they sought in the slide collection.

2

By "pre-digital era," I mean the period before digital cameras were widely available to consumers. The historical emergence of the digital is a complex matter that spanned several decades.

3

See Jeff Wall, "Photographie et intelligence liquid/Photography and Liquid Intelligence," in Jean-François Chevrier and James Lingwood, *Une autre objectivité/Another Objectivity* (Prato, Italy: Centro per l'Arte Contemporanea Luigi Pecci, 1989).

II

MATERIAL ECONOMIES OF PHOTOGRAPHY

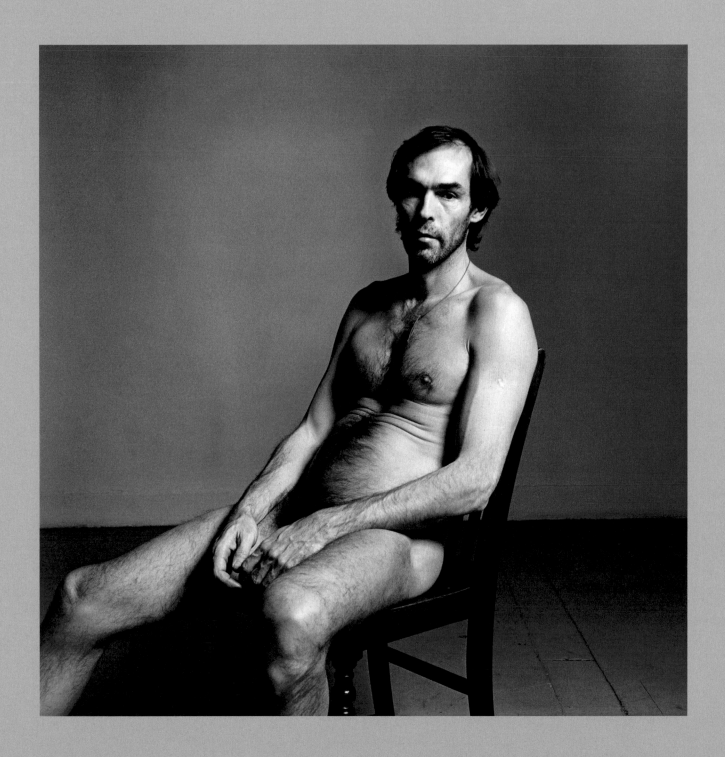

JESSICA WILLIAMS

PRINTING AND THE URGENCY OF TRANSLATION:

PETER HUJAR, DAVID WOJNAROWICZ, AND THE TASK OF SCHNEIDER/ERDMAN, INC.

For almost as long as photography has existed, critics and scholars have sought to locate its meaning in and around the medium's two poles of indexicality: the subjective inner world of the photographer who releases her camera's shutter and the objective outer world that lies before her lens.[1] Unfortunately, our infatuation with these two indices and the supposed ease of photographs' reproducibility has obscured our understanding of the labor that goes into making prints.[2] When Weimar cultural critic Walter Benjamin wrote that "for the first time, photography freed the hand from the most important artistic tasks in the process of pictorial reproduction—tasks that now devolved upon the eye alone," he was not thinking about the tacit knowledge required to physically develop and construct an image in the darkroom.[3] Like the generations of cultural theorists and photo historians who followed, Benjamin was interested in the politics of the reproducibility of images, not in the intricate processes of their physical reproduction.[4]

In a period of renewed Benjaminian anxiety over the loss of an object's "aura," the work of Schneider/Erdman, Inc., recalls a discussion by the same cultural theorist that is less-cited in the history of photography: namely, his consideration of the task of the translator.[5] Published in 1923 as a foreword to his own translation of Baudelaire's *Tableaux parisiens*, Benjamin's essay on the translator's task addresses numerous issues fundamental to printing and provides an inroad into considering the role of the printer with more nuance than has historically been the case. When we acknowledge the difficulty of printing and look at how meaning is built in the darkroom—through subtle changes in tone, the intensification of contrasts, or the delicate introduction and control of highlights, among other effects—our notions about the mechanical ease of making a photograph fall away to reveal the complexities of its language. In an age of technological reproduction, the images discussed here may be infinitely reproducible, but are they translatable?

Through two case studies—an animal portrait that Schneider printed at Peter Hujar's behest in the last months of his life and a politically astute series of photographs David Wojnarowicz montaged in Hujar's darkroom following his death—this essay explores the labor of printing as an enigmatic form of translation.[6] The first case study focuses on two printer's proofs of Hujar's *Will*: one in gelatin silver editioned during the artist's lifetime, the other posthumously made in pigmented ink. In addition to

providing an opportunity to consider the shift from analog to digital printing more broadly, these two prints (both in the Harvard Art Museums collections) afford a compelling discussion of how an artist's visual syntax and aesthetic intent can be partially recuperated and translated across media. Highlighting the radicality of Benjamin's claim that a translation can never be totally faithful to its original, these two prints make manifest the enormity of Schneider's task in the face of both material and personal loss.

Exemplifying a different mode of translation, this essay's second case study delves even further into the consideration of intent—something which, after Hujar's death and his own AIDS diagnosis, Wojnarowicz fervently directed into everything he made. In my consideration of a single print from Wojnarowicz's *Sex Series*, Benjamin's writing on the translator's precarious balance between freedom and fidelity to the text is paired with the artist's own resolve to reveal political truths and his adamant defense of, and control over, his works' meanings. By placing the lab and Schneider's relationship with these two artists at the center of my discussion, I aim to show how our understanding of a print can be enriched through close consideration of a photograph's materiality and the intricate processes of its printing. Ultimately at stake, I argue, is our understanding of translation as both a multifaceted task that encompasses a range of modes and an endeavor that can be instrumentalized toward affective and political ends.

From the Schneider/Erdman Printer's Proof Collection in general and the following two case studies in particular emerge questions regarding not only the histories and processes of making—of "dragging prints through chemistry," as Schneider would say—but of photography's material and cultural histories in a vibrant New York scene that was slowly, though not quietly, being decimated. Made during the height of America's AIDS epidemic, Hujar's *Will* and Wojnarowicz's *Sex Series* chronicle the parallel losses of photographic media and two of the era's most influential artists.[7] As black and white photographic papers went out of production, as singular works were sold, and as these artists slipped into the depths of their illnesses, the task of printing their work became laden with aesthetic and political significance. Propelling these prints' affective histories is their sharp sense of urgency in a period harrowed by catastrophe, an urgency that was echoed by Schneider and Erdman's ardent processes of remembering, repeating, and working through in their lab.[8]

Fig. 1
Peter Hujar, *Seated Self-Portrait Depressed*, 1980. Pigmented ink print, 50.8 × 40.6 cm (20 × 16 in.). Harvard Art Museums/Fogg Museum, Schneider/Erdman Printer's Proof Collection, partial gift, and partial purchase through the Margaret Fisher Fund, 2016.156.

PETER HUJAR, *WILL*

Schneider was first introduced to Hujar by Erdman in 1977, while working for Richard Foreman's Ontological-Hysteric Theater. After completing his B.F.A. at the Michaelis School of Fine Art in Cape Town that same year, Schneider returned to New York and began his graduate studies at the Pratt Institute in 1978. It was during this later period that he and Hujar became close friends, bonding, in part, over the medium of photography. Hujar's influence on Schneider and his work as a printer cannot be overstated. The older photographer not only got Schneider his first job in a commercial photo lab but adamantly encouraged him and Erdman to open their own printing business, which they eventually did in a loft on Cooper Square. Along with Lisette Model, Schneider credits Hujar with teaching him how to interpret prints.[9] Though the two men never printed alongside one another in the darkroom, their visits to photography exhibitions and conversations about how prints functioned helped shape both Schneider's eye and his practice as a printer. As a testament to Hujar's capacity as a mentor, both Schneider and Wojnarowicz have written that it was he who taught them how to see.[10] Although Schneider processed all of Hujar's film early on in their friendship, he began printing for him only in 1987, after the artist had been diagnosed with HIV.

The Harvard Art Museums' Schneider/Erdman Printer's Proof Collection includes 54 photographs by Hujar, all of which were printed in the lab between 1987 and 2014. Offering a survey of Hujar's photographic practice as seen through a diverse range of landscapes and portraiture, the collection encapsulates the photographer's aesthetic, emblematized in his recurring center-framed, square-formatted images of isolated and meticulously lit subjects. Formal similarities across Hujar's portraiture gesture toward his discerning consideration of the beauty and frailty of life—seen, for example, in the compositional and tonal affinity shared between his raking depiction of himself seated nude in his sparse loft (Fig. 1) and his similarly concentrated, beautifully tragic portrait of a cow intended for slaughter (Fig. 2).[11] From his intimate portrait of Candy Darling on her deathbed surrounded by blooming chrysanthemums and wilting roses (Fig. 3) to his photograph of a goat balancing on the edge of the discarded tractor tire to which she is chained (Fig. 4), Hujar was able to draw attention to his sitters' idiosyncrasies while imaging their broader conditions as beings. Referring to a portrait of a goose coyly turning to address Hujar's lens (Fig. 5), Hripsimé Visser has noted the photographer's ability to capture his subjects' distinct sensibilities, suggesting that even this domesticated fowl "seems to be conscious of [her] pose in the same way as a mannered transvestite."[12] "Just like people," Visser continues, Hujar's "animals are *alone* in an existential

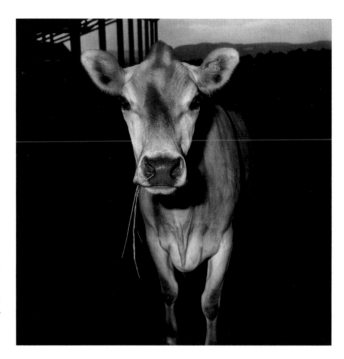

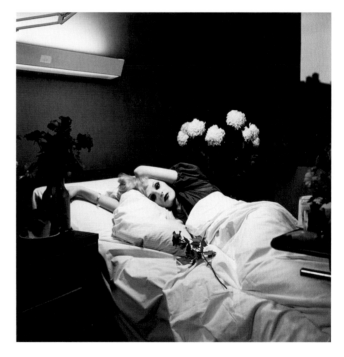

Fig. 2
Peter Hujar, *Cow with Straw in Its Mouth*, 1978. Pigmented ink print, 50.8 × 40.6 cm (20 × 16 in.). Harvard Art Museums/Fogg Museum, Schneider/Erdman Printer's Proof Collection, partial gift, and partial purchase through the Margaret Fisher Fund, 2011.276.

Fig. 3
Peter Hujar, *Candy Darling on Her Deathbed*, 1973. Pigmented ink print, 40.6 × 50.8 cm (16 × 20 in.). Harvard Art Museums/Fogg Museum, Schneider/Erdman Printer's Proof Collection, partial gift, and partial purchase through the Margaret Fisher Fund, 2016.173.

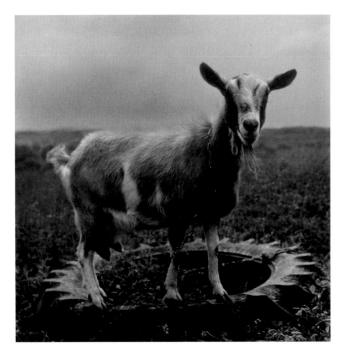

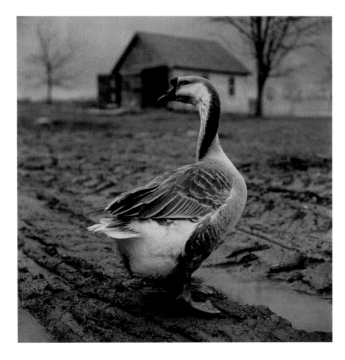

sense," each bearing "the weight of the same tragic and irrevocable mortality as [his] human sitters."[13]

Harvard's gelatin silver printer's proof of *Will* is among the last prints that Schneider made for Hujar before his death from AIDS-related pneumonia in November 1987 (Fig. 6).[14] For his portrait, Will poses regally on a cushion whose fabric echoes his own rolling flesh. Locking his two front legs straight, he turns his head slightly to the right, sweetly bearing his soft chest to Hujar and, by proxy, to us. The photograph is a poignant one, printed specifically by Schneider at Hujar's request for an edition intended as gifts for those who had taken care of him during his illness. Considered alongside a pigmented ink printer's proof of this same portrait made more than 20 years later, the collection's two prints of this image embody histories of material and personal loss that emerge when we consider their making as distinct modes of translation.

In his essay "The Task of the Translator," Benjamin writes that translation is a procedure that can best be understood by returning to the original.[15] However, in a medium for which "to ask for the 'authentic' print makes no sense," the task of returning to an "original" is both materially and theoretically complex.[16] Because the notion of a single, original version of an image neither concerned nor existed for Hujar, printing for him was not about getting back to or reconstructing an earlier and therefore somehow more "authentic" print.[17] In the artist's own practice, creating a print was about communicating an idea, about producing a work that *meant* in a particular way and that would contribute to a yet-to-be-discerned collective aesthetic spanning several generations or versions of an image. Hujar's concern when printing his own work was not that each of his prints perfectly match one another (an impossibility given the contingencies of the darkroom), but rather that each be capable of functioning on the wall.[18] For Hujar, each interpretation or variation of a print got nearer to or supplemented his intention for his image (an issue we will return to in greater detail later). In a medium in which "to ask for the 'authentic' print makes no sense," the artist's own conception of his prints' relationship both to the shared negative from which they were made and to each other collectively is exceptionally fitting.[19] Rather than viewing the negative as holding the original image or pointing to the first edition of prints made from it as being the most "authentic" of its versions, it is more generative (and more accurate) to consider Hujar's "original" in a broader way and to see Schneider's return to it as a dual operation of sorts—one that, in this instance, necessarily pairs a tangible film negative with the photographer's more intangible intent.

Just as a translator of poetry seeks to mobilize a poem's imaginative sense through a play with syntax, a printer works to mobilize a photographer's aesthetic intent in the darkroom through a play with tonality. The negative

Fig. 4
Peter Hujar, *Goat, Hyrkin Farm, Westown, NY*, 1978. Pigmented ink print, 50.8 × 40.6 cm (20 × 16 in.). Harvard Art Museums/Fogg Museum, Schneider/Erdman Printer's Proof Collection, partial gift, and partial purchase through the Margaret Fisher Fund, 2011.275.

Fig. 5
Peter Hujar, *Goose with Bent Neck*, 1981. Pigmented ink print, 50.8 × 40.6 cm (20 × 16 in.). Harvard Art Museums/Fogg Museum, Schneider/Erdman Printer's Proof Collection, partial gift, and partial purchase through the Margaret Fisher Fund, 2011.278.

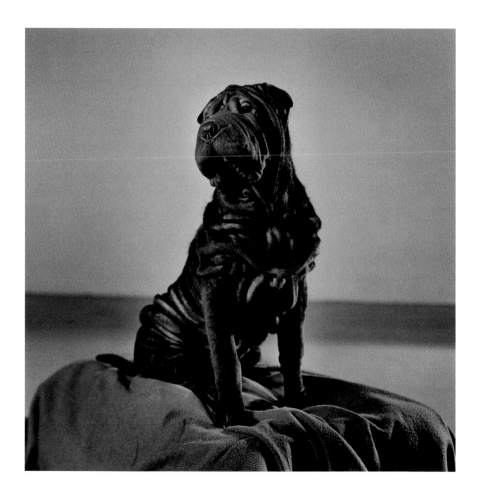

Fig. 6
Peter Hujar, *Will*, 1985. Gelatin silver print, 50.8 × 40.6 cm (20 × 16 in.). Harvard Art Museums/Fogg Museum, Schneider/Erdman Printer's Proof Collection, partial gift, and partial purchase through the Margaret Fisher Fund, 2016.176.

may provide the image's content, but it is the complex labor in the lab that largely shapes and contributes to its meaning.[20] Although Hujar carefully constructed his photographs through his lens, conscientiously lighting his subjects and shifting his focus to coerce subtle details to emerge, he also heavily manipulated his prints in the darkroom. In the process of printing his own work, the artist deliberately selected photographic papers and toners, working in his darkroom to craft his images with light. Rarely, if ever, did Hujar make a straight print from a negative. Even in a seemingly more straightforward image, such as his portrait of his dog, Will, the slight glow around the animal's body needed to be built through a delicate combination of dodging the figure (selectively holding back light to make the print lighter) and burning-in the background (selectively making areas darker by adding more light to the print).[21] When Schneider began printing for Hujar following the artist's diagnosis, he was tasked not with producing a strict, literal translation of the image Hujar had captured in his film's light-sensitive emulsion, but with creating a print that marshaled his mentor's intention for the work. Editioning *Will* in collaboration with Hujar, Schneider has said, forced him to reinterpret how the photographer would have printed

this image himself—in other words, to reverse engineer Hujar's particular process of making and to reconstruct his performance in the darkroom.

To arrive at the gelatin silver printer's proof of *Will*, Schneider began by making a number of variations of the image from Hujar's negative. Through toning, masking, burning, and dodging, he worked in the darkroom to carefully build a print that echoed the artist's vision for the portrait. After discussing different versions of the image together, Hujar would make recommendations for adjustments, which Schneider implemented upon returning to the darkroom. This physical and conceptual back and forth between Hujar's loft on 189 Second Avenue and the Schneider/Erdman lab on Cooper Square was integral to the collaborative process and emblematic of Schneider's procedure as a printer. His task, he has often stated, was not to mechanically reproduce a photograph, but to distill its maker's conception of it. While one print may have had the delicate highlights Hujar wanted, another version may have more effectively encapsulated the range of tones or particular details he felt were necessary for the work to produce meaning. Schneider's role was to merge these desired attributes, which appeared across a number of prints, into a work that Hujar felt aligned

with or complemented his interpretation of the image. Through this collaborative practice, Schneider was able to materially manifest Hujar's intention—his sense of how the image should function on the wall—for this last (and only) silver lifetime edition of *Will*.

Printed on Agfa Portriga Rapid, a now discontinued, fiber-based black and white paper known for its warm tones, this gelatin silver portrait of Will is important within the printer's proof collection not only because of its affective history, but because of its materiality. The year Hujar passed away, Agfa-Gevaert was in the midst of reformulating the artist's beloved chlorobromide paper, removing from its emulsion (at the behest of the EPA) the environmentally destructive amounts of cadmium that had given the paper what Schneider has referred to as its "exceptionally eccentric" qualities.[22] Because Portriga was Hujar's printing paper of choice, Schneider pulled from his own cache of the pre-cadmium-leached material for this sole silver edition of Hujar's animal portrait, creating prints that embodied the parallel loss of both a medium and a mentor.

Though Schneider had started printing for Hujar immediately after the artist was diagnosed with HIV, he did not begin working on this edition of *Will* until Hujar was far along in his illness. In recalling how they made this gelatin silver printer's proof, Schneider and Erdman described bringing the print to the artist in his loft after he had become bedridden. It is here, at Hujar's own figurative deathbed, where Benjamin's ideas about the life of the original and Hujar's conception of the shifting life of an image become imperative to our consideration of these two printer's proofs.

In his essay, Benjamin writes that a successful translation issues not so much from the original's life, but from its afterlife.[23] While successful translations mobilize their original in part by de-canonizing it and showing its instability, they also give their original a new life by allowing it to attain, through them, an "ever-renewed latest and most abundant flowering."[24] When considering the printer's proof collection's two versions of this portrait— the gelatin silver print Hujar approved to be editioned in the last weeks of his life and the pigmented ink print Schneider made for Hujar's estate two decades later—the notion of the translator's task as being intimately tied to the establishment of an afterlife for a work (and its creator) becomes ever-more poignant. Creating the gelatin silver printer's proof of *Will* was marked by an urgency to catalyze Hujar's intent before his death and the discontinuation of his preferred medium; posthumously printing his work in pigmented ink was marked by the desire to galvanize the photographer's legacy.

Relying on extant works printed by Hujar and other interpretations of his images, Schneider has spent over two decades working to translate the vision of his deceased friend and teacher.[25] Initially hoping to posthumously print Hujar's work in gelatin silver, Schneider struggled for a year to find alternatives to Portriga Rapid. Like many photographers, Hujar's aesthetic, and his choice in papers, developers, and toners, changed over the course of his career. After printing on Ilford Galerie for years, Hujar abandoned it for Portriga, preferring the chlorobromide paper for both the wide range of warm tonalities it could produce and the peculiar details it could bring out in his images' shadows.[26] While Hujar's move from Ilford Galerie to Agfa Portriga Rapid resulted from a shift in the artist's own aesthetic disposition, Schneider's task of rethinking the possibilities of commercially available materials in the wake of Portriga's reformulation followed from necessity.[27]

Throughout the 1980s and '90s, photo companies continually altered their black and white photographic papers, decreasing the silver content in their emulsions and changing their papers' weights, textures, and surface sheens. In the face of this material instability, Schneider became tasked with rethinking Hujar's images based on the availability of silver papers and the particular aesthetics they were capable of rendering. Though often overshadowed in scholarship by the primacy of the subject matter depicted, a photograph's material support is equally important to the image and can drastically change the look and feel of a print.[28] Paired with the paper's early high-silver and cadmium-loaded emulsion, Agfa Portriga Rapid's creamy, double-weight fiber base worked—especially with selenium toner—to create images markedly different from other photographic papers on the market at this time. The Harvard collection's printer's proofs of Model's *Fashion Show, Hotel Pierre* (Fig. 7) and Richard Avedon's *Suzy Parker and Mike Nichols, coat by Saint Laurent, The American Hospital, Paris, August 1962* (Fig. 8), for example, epitomize the particularly cool tones and graphic qualities that their (and Hujar's earlier) paper, Ilford Galerie, could manifest.[29] Though favored by many photographers who vied for stark graphic contrasts in their work, the majority of black and white printing papers manufactured during this period afforded an aesthetic almost antithetical to the one needed to translate Hujar's works following Portriga's demise.

Creating proofs using a variety of papers, including Ilford Multigrade FB Warmtone Paper, Schneider slowly discovered that none of the commercially available substrates were capable of reproducing Portriga's signature warm tonalities.[30] Having lost the physical ability to translate Hujar's particular syntax—his muddy warm tones shot-through with graphic blacks and brittle highlights— into silver, Schneider was forced to, as Benjamin puts it, "[come] to terms with the foreignness of languages [to each other]."[31] In other words, Schneider had to concede the impossibility of using commercially available black and white photographic papers to replicate Portriga's

Fig. 7
Lisette Model, *Fashion Show, Hotel Pierre*, 1940–46. Gelatin silver print, 39 × 49 cm (15³⁄₈ × 19⁵⁄₁₆ in.). Harvard Art Museums/Fogg Museum, Schneider/Erdman Printer's Proof Collection, partial gift, and partial purchase through the Margaret Fisher Fund, 2011.381.

aesthetic and instead acknowledge the newfound range of tonalities afforded by pigmented ink and inkjet paper (specifically, Harman by Hahnemühle Gloss Baryta).[32] In 2009, after countless attempts to find a substitute paper or other means through which he could encapsulate Hujar's vision, Schneider reached the conclusion that printing in pigmented ink was the only way he could emulate Hujar's particular tonal range. And here the difference between *emulation* and *simulation* is key, as the task of the translator is not to replicate a work in a target language but to craft its echo.

In his essay, Benjamin writes that the task of translation is complex, not least because it calls into question the relationship between freedom and fidelity—a successful translation, we are told, rests in the tension between these two seemingly competing ends. According to Benjamin, "[T]he task of the translator consists in finding that intended effect [*Intention*] upon the language into which he is translating that produces in it the echo of the original."[33] Benjamin offers a helpful example to illustrate: he likens the relationship between a translation and its original to pottery sherds, which, though they "must match one another in the smallest details" when being glued together, need not be alike.[34] Comprised of numerous unalike but interrelated sherds, the completed vessel represents the "utopian model of the poem which exists silently beyond all translated versions," or what Benjamin refers to somewhat philosophically as "pure language."[35] For our purposes, Benjamin's vessel is symbolic of Hujar's

Fig. 8
Richard Avedon, *Suzy Parker and Mike Nichols, coat by Saint Laurent, The American Hospital, Paris, August 1962*, 1962. Gelatin silver print, 40.6 × 50.8 cm (16 × 20 in.). Harvard Art Museums/Fogg Museum, Schneider/Erdman Printer's Proof Collection, partial gift, and partial purchase through the Margaret Fisher Fund, 2011.113.

ultimate interpretation of his image, the "utopian model of the [print]" that both Hujar and Schneider aimed to get nearer to actualizing in their practice. In translating Hujar's *Will* into pigmented ink, Schneider's task was not simply to simulate an earlier version of this portrait in a new medium and language, but to distill and disarticulate Hujar's aesthetic, moving his interpretation of the image nearer to its ideal form.[36]

Faced with an inability to rehabilitate the aesthetic through which Hujar had created meaning following the reformulation of his cherished chlorobromide paper, Schneider moved past the hand-wringing common on the gallery circuit to pursue Hujar's aesthetic sense at the cost, some might argue, of his work's indexicality.[37] Drum-scanning Hujar's negative (with its language of light) allowed Schneider to translate the image into a digital file (with its binary language of ones and zeros) that could then be manipulated and printed. In refusing "to confuse the root cause of a thing with its essence," Schneider took up what Benjamin refers to as "one of the most powerful and fruitful historical processes" (in this instance, the maturation of photography's language) and embraced the possibilities afforded by the medium's new technologies.[38] Schneider's ambition to get at the poetics—rather than simply the hermeneutics—of Hujar's prints led him away from analog to digital printing, for it was not merely *what* Hujar's prints meant (their content) but *how* they meant (their syntax) that Schneider was after in his lab.

While Benjamin's "The Task of the Translator" offers a compelling theoretical model for considering the larger history of photography, the radical essence of his essay is here felt in its potential to inflect our understanding of the relationship between analog and digital printing. What Benjamin's essay offers, in other words, is the opportunity to move away from a banal comparison between gelatin silver and pigmented ink and toward a more nuanced engagement with photography's burgeoning language in a digital age. As Benjamin argues, "[T]ranslation is so far removed from being the sterile equation of two dead languages that of all literary forms it is the one charged with the special mission of watching over the maturing process of the original language and the birth pangs of its own."[39] The rapid development of digital technologies afforded Schneider the possibility of posthumously translating Hujar's works in a way that not only honored his intention for the image, but probed and expanded the potentials of pigmented ink, his new photographic language in the digital darkroom.

Though the material substrates of these two prints are different, their operations are very much the same. While the gelatin silver printer's proof of *Will* was toned with selenium to stabilize and enrich the silver, the pigmented ink printer's proof, made from scanning Hujar's negative two decades later, was made slightly denser in tone through manipulating the digital file. Both prints call attention to the soft highlights in the folds of Will's fleshy body and the crisp focus of his face, which he turns slightly away from Hujar's lens. Unlike some of Hujar's other portraits, there are no harsh tones in his photograph of Will, only the revelation of a gentle and dignified

disposition meant to reassure and comfort those closest to him in the wake of loss.

After he was diagnosed with HIV, Hujar closed the door to his studio's darkroom, leaving behind a store of unused printing paper and allowing his chemicals to evaporate in their processing trays. Following Hujar's death, Wojnarowicz, the artist's close friend, mentee, and, for a brief period, lover, moved into Hujar's sparse loft, where he lived until his own death from AIDS-related complications in 1992.[40] It was in Hujar's darkroom that Wojnarowicz printed his first 20 × 24 inch unique set of the *Sex Series*, a work that explores sexuality and the politics of silence at the height of America's AIDS crisis.

The processes Schneider undertook to edition Wojnarowicz's *Sex Series* differed conceptually and physically from those needed to edition Hujar's portrait of Will. While Hujar had taught both Schneider and Wojnarowicz a language of photography that was rooted in the ability to construct and read a print's narrative through its tonalities, Wojnarowicz would take the notion of a photographic language one step further in his artistic practice. Writing that he felt himself to be "a prisoner of language that doesn't have a letter or a sign or gesture that approximates what I'm sensing," Wojnarowicz crafted a complex visual syntax that built upon ideas he had tried to express in his literary work.[41] In addition to constructing a photographic language that can be read iconographically, Wojnarowicz also included texts in his photographs and worked in series, aspects that will enter into and inflect our consideration of Schneider's translation of this artist's work.[42]

DAVID WOJNAROWICZ, *SEX SERIES*

Wojnarowicz is perhaps best known for the works he produced throughout the 1980s and early '90s that address, either directly or obliquely, America's AIDS epidemic. A prolific writer and artist, his essays, films, paintings, and prints speak to the urgency of art-making and political action during a period in which America's gay community was under siege. "I feel that I'm caught in the invisible arms of a government in a country slowly dying beyond our grasp," the artist wrote at the height of the epidemic.[43] Though Wojnarowicz had been using photographs in his paintings for years, creatively collaging both found and original photos as well as images from contact sheets into his works, it was not until 1988, after he had moved into Hujar's apartment and inherited his intact darkroom, that he became serious about printing his own work.[44] "When Peter died in 1987," Schneider recalled in a brief piece written for *Aperture*, "David immediately began using his darkroom. . . . It was only after Peter's death that David made photographs as objects for the wall, as works of art in and of themselves."[45]

Among the first of these images is Wojnarowicz's now-iconic *Untitled (Buffalo)* (Fig. 9), a work that in its quiet imaging of free-falling symbols of Americana, speaks to both the plight of a community being driven to destruction and, implicitly, the policies that were driving them there. The image demonstrates Wojnarowicz's ability to create complex meaning from seemingly banal subject matter—in this instance, a diorama at the Smithsonian's Museum of Natural History in Washington, D.C., meant to teach children a sanitized history of a culture's lost way of life. Initially intended to be included among other images in a work he was creating in memory of Paul Thek, Wojnarowicz instead decided to allow this photograph to stand on its own, printing a small edition of five 16 × 20 inch prints in Hujar's darkroom.[46] Despite their similar tonal range, Wojnarowicz's photograph of buffalo throwing themselves off a cliff is vastly different from Hujar's delicately sweet portrait of Will.[47] While Hujar's animal portraits were meant to serve as a reminder of himself for his friends, loved ones, and caregivers, Wojnarowicz's buffalo were intended as a pointed commentary on the violence of Hujar's death and the AIDS crisis more broadly. "Even a tiny charcoal scratching done as a gesture to mark a person's response to this epidemic means whole worlds to me if it is hung in public," the artist wrote in *Close to the Knives: A Memoir of Disintegration*.[48] In place of a charcoal mark, we find a faint self-portrait of the artist in this print. Formed by Wojnarowicz's own reflection in the glass that once separated him from the museum's diorama, the artist's face can be seen hovering in the clouds above the overturned buffalo at center. The intentional inclusion of himself in this photograph is a small gesture, but one that Schneider noticed and worked diligently in the darkroom to keep. Schneider's recognition that the political and affective implications of this image would have been drastically altered had Wojnarowicz's self-portrait been lost in translation is telling of both his relationship with the artist and intimate understanding of Wojnarowicz's work.[49] In this rosy-hued print, the artist appears disembodied but ever present, helpless to stop the devastating events occurring below him but refusing to relinquish his role as a witness to their history.

In an essay Wojnarowicz titled "Postcards from America: X Rays from Hell," the 36-year-old artist wrote:

I found that, after witnessing Peter Hujar's death on November 26, 1987, and after my recent diagnosis, I tend to dismantle and discard any and all kinds of spiritual and psychic and physical words or concepts designed to make sense of the external world or designed to give momentary comfort. It's like stripping the body of flesh in order to see the skeleton, the structure. I want to know what the structure of all this is in the way only I can know it.[50]

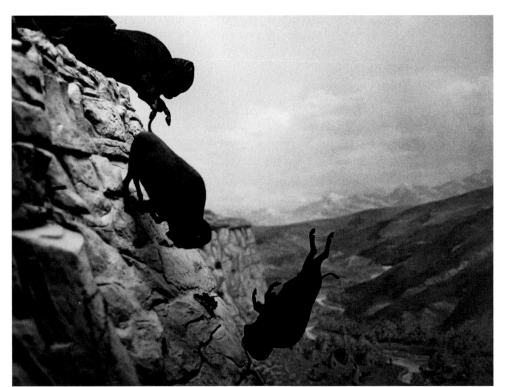

Fig. 9
David Wojnarowicz, *Untitled (Buffalo)*,
1988–89. Gelatin silver print, 50.5 ×
60.8 cm (19⁷⁄₈ × 23¹⁵⁄₁₆ in.). Harvard Art
Museums/Fogg Museum, Schneider/
Erdman Printer's Proof Collection, par-
tial gift, and partial purchase through
the Margaret Fisher Fund, 2016.143.

For Wojnarowicz, this metaphorical "stripping" of both
one's body and the body politic was symbolized through
the aesthetic of the X-ray and engendered through the
making public of private realities, which, he argued, would
disintegrate the notion of a "general public" from which he
was excluded and allow for "an examination of its founda-
tions."[51] "To turn our private grief for the loss of friends,
family, lovers and strangers into something public would
serve as another dismantling tool," he wrote. "It would dis-
pel the notion that this virus has a sexual orientation or a
moral code. It would nullify the belief that the government
and medical community has done very much to ease the
spread or advancement of this disease."[52]

Wojnarowicz's *Sex Series* employs the aesthetic
of medical X-rays to examine and critique the physi-
cal and psychological violence of AIDS, the American
government, and society at large (Figs. 10–17). When read
iconographically, the series as a whole comes to represent
Wojnarowicz's sophisticated way of building meaning in
his works. In his use of a train, the principal image in the
photomontage considered at length here, Wojnarowicz
sought to confront those in America's rural communi-
ties who believed themselves impervious to an illness
they thought thrived only in major cities (see Fig. 10).[53]
Speaking about this particular print, Wojnarowicz
asserted that the train's "impending collision" with the
cluster of magnified blood cells at lower left was intended
as a metaphor "for [his] own diagnosis and compressed

Fig. 10
David Wojnarowicz, *Untitled*, from the
Sex Series, 1989. Gelatin silver print,
40.6 × 50.8 cm (16 × 20 in.). Harvard Art
Museums/Fogg Museum, Schneider/
Erdman Printer's Proof Collection, par-
tial gift, and partial purchase through
the Margaret Fisher Fund, 2016.142.1.

Fig. 11
David Wojnarowicz, *Untitled*, from the
Sex Series, 1989. Gelatin silver print,
40.6 × 50.8 cm (16 × 20 in.). Harvard Art
Museums/Fogg Museum, Schneider/
Erdman Printer's Proof Collection, par-
tial gift, and partial purchase through
the Margaret Fisher Fund, 2016.142.2.

Fig. 12
David Wojnarowicz, *Untitled*, from the
Sex Series, 1989. Gelatin silver print,
40.6 × 50.8 cm (16 × 20 in.). Harvard Art
Museums/Fogg Museum, Schneider/
Erdman Printer's Proof Collection, par-
tial gift, and partial purchase through
the Margaret Fisher Fund, 2016.142.3.

Fig. 13
David Wojnarowicz, *Untitled*, from the
Sex Series, 1989. Gelatin silver print,
40.6 × 50.8 cm (16 × 20 in.). Harvard Art
Museums/Fogg Museum, Schneider/
Erdman Printer's Proof Collection, par-
tial gift, and partial purchase through
the Margaret Fisher Fund, 2016.142.4.

Last night I took a man home from the subway where he had been standing against a wall in the graffitti-covered car in black cowboy boots tight jeans and a shirt oppened to the third button and sleeves rolled up to reveal a workmans arms and a couple of blue ink tatoo's and when we arrived back at my place I sat on my bed and loosened his trousers with my teeth while pulling apart each button on his shirt with my fingers and I slid my hands beneath the edge of his T-shirt and let my hands slide over his hard and warm belly and as his T-shirt rode up my arms with that motion there were two birds revealed tatooed in blue ink flying the distances of his chest and my tongue moved back and forth tracing wet lines across his belly and I slowly stood up and moved my tongue over his pale sides as I lifted his T-shirt above his head and I could feel the smell of his underarms as my face rose up towards them; my tongue taking in the taste and then he laid me down on the bed and removed my shoes and pants while I played with his hard dick through his pants and he bent and licked the inside of my legs and thighs and under my balls and then laid on top of me pulling my arms up and around his neck and he kissed behind my ears and licked across my throat and across my face and down the bridge of my nose to my mouth where he put his warm tongue in and I have the secondary stages of Aids and the man on the T.V. who looks like he has a potatoe for a head is telling me and the rest of the country that I must supress my sexuality — he talks about me in words that makes me sound like an insect: "carrier"..."infected"...and when he shows pictures or films of me I am always bedridden and alone and on the edge of death and he says I must supress my sexuality whether I am a man or a woman whether I am homosexual or heterosexual. whether I have Aids or not...

the man on the T.V. is also the man in the newspapers. he has a replaceable head — one day he can be a man and on another day he can be a woman. he can have the face of a politician or the face of a doctor or the face of a research scientist or the face of a health-care 'professional' or the face of a priest with a swastika tatooed on his heart; and each and every one of these faces say they are concerned for you because of my existence. and it is ironic when he takes on the face of a family man who wants to protect his children because I am his child and I have Aids and I don't think having Aids is something heavy. it is the use of Aids as a weapon to enforce the conservative agenda that is what is heavy. Homosexuals and intravenous drug users are expendable in this society and Aids is treated in the same way that homosexuals and drug-users are and that is why there has been this legal and social murder on a daily basis

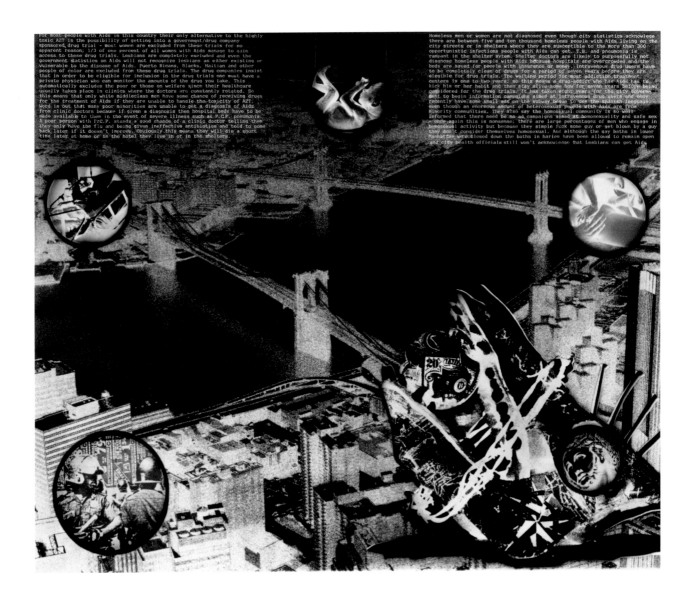

For most people with Aids in this country their only alternative to the highly toxic AZT is the possibility of getting into a government/drug company sponsored drug trial – most women are excluded from these trials for no apparent reason; 1/3 of one percent of all women with Aids manage to gain access to these drug trials. Lesbians are completely excluded and even the government statistics on Aids will not recognize lesbians as either existing or vulnerable to the disease of Aids. Puerto Ricans, Blacks, Haitian and other people of color are excluded from these drug trials. The drug companies insist that in order to be eligible for inclusion in the drug trials one must have a private physician who can monitor the amounts of the drug you take. This automatically excludes the poor or those on welfare since their healthcare usually takes place in clinics where the doctors are constantly rotated. So this means that only white middleclass men have some chance of receiving drugs for the treatment of Aids if they are unable to handle the toxicity of AZT. Word is out that many poor minorities are unable to get a diagnosis of Aids from clinic doctors because if given a diagnosis then hospital beds have to made available to them in the event of severe illness such as P.C.P. pneumonia. A poor person with P.C.P. stands a good chance of a clinic doctor telling them they only have the flu and being given ineffective antibiotics and told to come back later if it doesn't improve. Obviously this means they will die a short time later at home or in the hotel they live in or in the shelters.

Homeless men or women are not diagnosed even though city statistics acknowlege there are between five and ten thousand homeless people with Aids living on the city streets or in shelters where they are susceptible to the more than 300 opportunistic infections people with Aids can get. T.B. and pneumonia is rampant in the shelter sytem. Shelter doctors are likely to purposefully not diagnose homeless people with Aids because hospitals are overcrowded and the beds are saved for people with insurance or money. Intravenous drug users have to be completely clean of drugs for a period of seven years before they are eligible for drug trials. The waiting period for most addiction treatment centers is one to two years; so this means a drug-addict who has Aids has to kick his or her habit and then stay alive some how for seven years before being considered for the drug trials. It has taken eight years for the city government to begin information campaigns aimed at intravenous drug users and only recently have some small ads on the subway begun to use the spanish language even though an enormous amount of heterosexual people with Aids are from minority communities. They also say the homosexual community is so well informed that there need be no ad campaigns aimed at homosexuality and safe sex once again this is nonsense; there are large percentages of men who engage in homosexual activity but because they simple fuck some guy or get blown by a guy they don't consider themselves homosexual. And although the gay baths in lower Manhattan were closed down the baths in harlem have been allowed to remain open and city health officials still won't acknowledge that lesbians can get Aids.

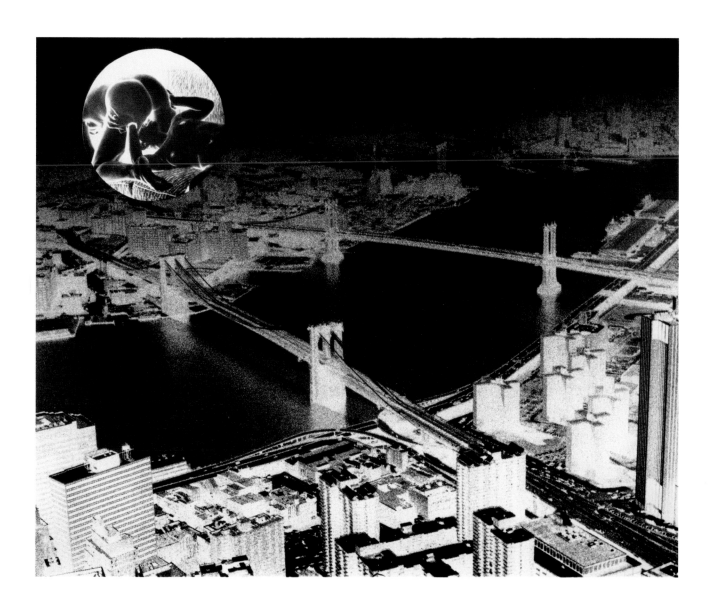

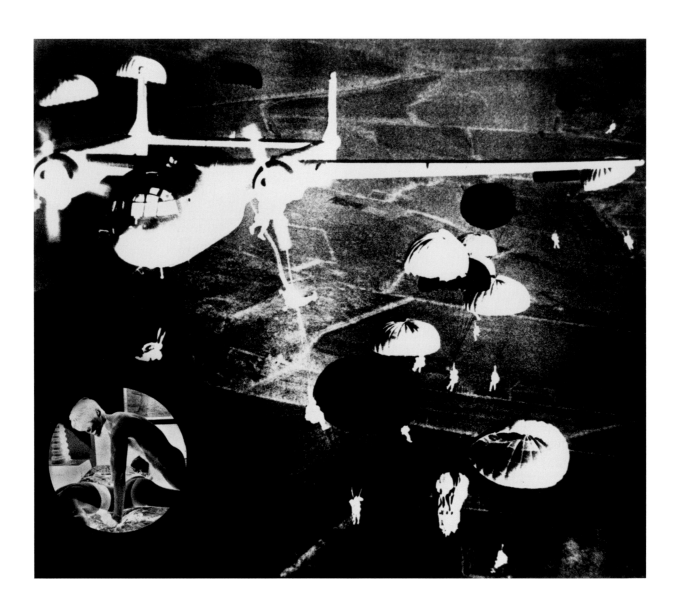

sense of mortality."[54] As the train barrels toward both the infected cells and the viewer, however, its collision and the viruses' imminent spread affirm the fact that the disease is everyone's concern. Above the clinical image of blood cells at left is an inset of a photograph Wojnarowicz himself took of nonviolent demonstrators being assailed by police while protesting the FDA's fatally slow release of medications. As two men engage in oral sex in the upper right corner of this print (sourced from Hujar's collection of pornography), a newspaper clipping directly beneath them relates the beating and stabbing of two men on Manhattan's Upper West Side who were suspected of being gay.[55] Through its aesthetic, imagery, and text, this photomontage from the *Sex Series* celebrates sexuality without sentiment, addresses the disease without guilt, and breaks the silence surrounding an epidemic that had, by 1990, killed more than 100,000 Americans.[56]

The Schneider/Erdman Printer's Proof Collection includes all eight of Wojnarowicz's *Sex Series* printer's proofs, each remarkable in its own way for the complexity of its making. Wojnarowicz created the initial 20 × 24 inch prints for this series by montaging a combination of color slides and negatives in the darkroom with a single enlarger, a herculean task that necessitated a number of intricate visual calculations.[57] Making slides of images that he wanted to appear inverted in the final prints and using negatives for images that he wanted to print out positive, Wojnarowicz worked through a carefully planned sequence of exposures in order to create these montages. For the first, the artist began by hand-making masks for each of the smaller images that he wanted to embed within his main image of the moving train. While there are many different types of masking that one can do in the darkroom, masks are, in general, used to selectively protect or expose the light-sensitive photographic paper from or to the light produced by the enlarger. Adept at stenciling, a technique he had experimented with extensively in his earlier works in other media, Wojnarowicz had learned

through conversations with his close confidant and collaborator Marguerite Van Cook that he could create a circular-shaped inset by crafting a new negative holder for his darkroom's enlarger.[58] After printing the image of the train, holding back light from the sections in which he wanted to insert his smaller images, Wojnarowicz then would have exposed the images for the vignettes in the areas he had initially kept free of light. At some point in his performance, Wojnarowicz exposed the text hovering in the sky above the mountains in the background, most likely using a transparency or slide. For areas in which the text is bright white, the transparencies would have been laid on the photographic paper before the image was exposed, remaining there for the duration of the printing process. Where the text is darker, the transparency was most likely laid down after Wojnarowicz exposed the work's principal image.

Because all eight of the *Sex Series* prints had been montaged in the darkroom, no negatives existed for the prints from which reproductions could be made. Each of the eight prints in the initial *Sex Series* was entirely unique. In comparison to Hujar's *Will*, this is a case in which an original did exist, or at least, in which there was a more obvious or accessible correlation between the initial 20 × 24 inch montaged prints and (what would become) their 16 × 20 inch counterparts. Under pressure to relinquish the unique set and knowing how important these works were, Wojnarowicz came to Schneider to see if it might be possible for him not simply to reproduce, but to translate them.[59] Whether or not the *Sex Series* could be *reproduced* was not necessarily the artist's concern, as any lab in Manhattan could have undertaken what would have amounted to copy work.[60] Wojnarowicz knew, however, that there was more to re-creating a print than simply reproducing its likeness. What he needed to be actualized was his *intention*, something that could easily be lost if the smallest detail was carelessly allowed to fall away. (Recall the importance of his spectral self-portrait in his photograph of the falling buffalo.) "One of the things that happened after my diagnosis is this feeling that this might be the last work I do," Wojnarowicz stated in an interview with Sylvère Lotringer in April 1989.[61] His attempts at "trying to focus everything and channel it into this square, or into this photograph, or into this thing," at working "to put that intention into a pictorial frame with all the anger, all the emotions, all the thoughts," is what motivated the artist's feverish work in his studio during this period.[62]

Wojnarowicz's concern that the meaning of his works be successfully carried through in their reproductions can be detected in the adamancy with which he defended his work when grossly misrepresented. In 1989, the sexual imagery from the upper right corner of the *Sex Series* print featuring the train was enlarged and reproduced out of context by the American Family Association in a pamphlet that sought to discredit the National Endowment for

Fig. 18
American Family Association, "Your Tax Dollars Helped Pay for These 'Works of Art,'" 1990. Offset flyer, 35.6 × 21.6 cm (14 × 8 ½ in.). Courtesy Fales Library and Special Collections, New York University.

the Arts (Fig. 18). "Your Tax Dollars Helped Pay for These 'Works of Art,'" the Christian fundamentalist organization declared in the pamphlet's title. Incensed that his work had been cannibalized and used for these purposes, Wojnarowicz took Reverend Donald E. Wildmon to court over his violation of the New York State Artist's Authorship Act.[63] During his testimony, Wojnarowicz was asked to explain why he thought the AFA pamphlet had damaged his reputation as an artist. He replied, "I think, in looking at it, it clearly attempts to portray my work as being nothing more than banal pornography. I think that through the use of selective editing, it essentially stripped all my work of its artistic and political content and the remaining images to me are basically empty, they do have a meaning, but not the sort of meaning that I'm interested in exploring in my work."[64]

Wojnarowicz's argument in court hinged on his belief that the images and fragments of his montages acted like individual words that, when removed from their original contexts, were emptied of his intention and made to mean something else. In his discussion of Benjamin's essay on translation, literary theorist Paul de Man argues that our experience of the "materiality of the letter" occurs through a similar disarticulation of meaning—a sentence becomes words, which themselves become syllables, which in turn become meaningless letters.[65] Though letters come together to form a word, de Man writes, the word itself (and its meaning) is not present in the individual components that comprise it.[66] De Man's consideration of language and the slippage of meaning is of interest here given Wojnarowicz's own description of his photographic practice: "To me, photographs are like words," Wojnarowicz wrote in Close to the Knives.[67] "I generally will place many photographs together or print them one inside the other in order to construct a free-floating sentence that speaks about the world I witness."[68] If Reverend Wildmon had intentionally dismantled the meaning of Wojnarowicz's works on a macro level, pulling entire images out of context for his bigoted pamphlet, Schneider would work to counter this aggressive disarticulation by, quite literally, attending to the individual letters that threatened to melt into these prints' deep shadows. In the lab, Schneider sought to translate Wojnarowicz's political and aesthetic intent for his series by considering both the texts that the artist had carefully stenciled into these images and their photographic equivalent: tonalities.

Schneider set to work editioning this series of eight individually montaged prints within a year of Wojnarowicz beginning the process of taking Reverend Wildmon to court for decontextualizing and misrepresenting his work. That same year, funding for the second exhibition in which four of the Sex Series prints were to be shown—Nan Goldin's Witnesses: Against Our Vanishing at Artists Space—was being threatened by a nervously run NEA.[69] Distilling and mobilizing Wojnarowicz's political intention for each of his pieces seemed more important than ever during this heightened period of controversy. Given the artist's relationship with Schneider and Erdman, it is no surprise that he turned to their lab to help him undertake this task. In the lab, Schneider used an 8 × 10 studio camera to create copy negatives for Wojnarowicz's original prints, from which he could then make new gelatin silver reproductions. Resizing Wojnarowicz's 20 × 24 inch prints to 16 × 20 inches posed innumerable challenges, as the process skewed the dimensions of the vignettes and threatened to render illegible the texts that the artist had intentionally included. In order to mitigate tonal distortions in each of the prints, Schneider made individual shadow masks for each of the images, which he then sandwiched with the negatives to create the exposures.[70] Making painstaking adjustments that would maximize details in

certain shadows while controlling highlights in others, Schneider heavily manipulated his versions of these works in the darkroom, exaggerating various aspects in order to build a tonal range specific to each print.

For example, for the text above the mountains in the background of the work with the moving train, Schneider made a shadow mask that allowed parts of the wording to fade slightly into black while retaining information in the lettering that rests in deep shadow. Because the text had been made even smaller in the process of resizing the image, Schneider was forced to try to retrieve information that had been submerged in Wojnarowicz's original print in order for some of the words to remain legible. This act brings to mind Benjamin's description of a successful translation's integral aspect, namely, the translator's reconciliation between fidelity and freedom.[71] "Unlike a work of literature," Benjamin writes, "translation does not find itself in the center of the language forest but on the outside facing the wooded ridge; it calls into it without entering, aiming at that single spot where the echo is able to give, in its own language, the reverberation of the work in the alien one."[72] While a straight, literal print from the negative Schneider had created from Wojnarowicz's original montaged work may have produced a seemingly adequate reproduction, such a print would have failed as a translation. Not only would the syntax of the image have been lost—the subtlety of tones that had to be rebuilt into the image in the darkroom—but the text Wojnarowicz had specifically included would have been rendered illegible. "I have Aids and I don't think that that is something heavy," reads the sentence in the upper right corner of this particular print, "it is the use of Aids as a weapon to enforce the conservative agenda that is heavy." Fidelity to the political truth that Wojnarowicz had wanted to impart was here dependent on Schneider's fidelity to the materiality of the letter. In many ways, fighting for these details in the darkroom was consonant with fighting against the silencing of an entire community that was, as the text in this print states, considered "expendable."

As their printer, Schneider aimed to catalyze the visions of Hujar and Wojnarowicz in his lab, a task that brought a small measure of justice to friends whose lives had been tragically curtailed by a disease the government had largely chosen to ignore. "It is exhausting, living in a population where people don't speak up if what they witness doesn't directly threaten them," Wojnarowicz wrote in the year leading up to his death.[73] Speaking to the violence perpetrated against queer bodies while also imparting value to the lives of those lost, Hujar's Will and Wojnarowicz's Sex Series, nearly three decades after their initial making, serve as monuments to the AIDS crisis and a reminder of the horrors that can be afflicted through censorship and apathy. In addition to delineating the urgency of making in the wake of both personal and material loss, these two case studies highlight

the complexities of printing and the various modes of translation Schneider mobilized in his task as a printer. Considering the task of Schneider/Erdman, Inc., as analogous to that of a translator affords us the opportunity to reevaluate the field—to bring to light photography's creative and collaborative histories of making and to consider the medium's social, material, and political histories anew. Situated "midway between poetry and doctrine," the task of the translator may be "less sharply defined," Benjamin tells us, "but it leaves no less of a mark on history."[74]

Jessica Williams is a Ph.D. candidate in the history of art and architecture at Harvard University and former Agnes Mongan Curatorial Intern in the Division of Modern and Contemporary Art at the Harvard Art Museums.

1
Robin Kelsey and Blake Stimson, foreword to *The Meaning of Photography*, ed. Robin Kelsey and Blake Stimson (Williamstown, Mass.: Sterling and Francine Clark Art Institute, 2008), xi.

2
Anne McCauley writes that "the success of photography within humanistic studies and its simultaneous omnipresence within art schools and museums hinge on the same paradoxical assumption: that one forgets about the technologies needed to actually make a picture but remembers that the photograph is indexical and thus always documentary. Something has been gained: Many scholars are looking closely at photographs and thinking about how they shape our view of the world. But something has been lost: Too many take them as given, as mental constructs removed from labor." See Anne McCauley, "Overexposure: Thoughts on the Triumphs of Photography," in ibid., 162.

3
Walter Benjamin, "The Work of Art in the Age of Its Technological Reproducibility, Second Version," in *Walter Benjamin: The Work of Art in the Age of Its Technological Reproducibility, and Other Writings on Media*, trans. Edmund Jephcott et al., ed. Michael W. Jennings, Brigid Doherty, and Thomas Y. Levin (Cambridge, Mass.: Harvard University Press, 2008), 20. For more on the notion of tacit knowledge, see Jennifer Quick's essay in this volume.

4
This is not to say that Benjamin was not interested in photography's technological histories. See, for example, his "Little History of Photography," in Jennings, Doherty, and Levin, *Walter Benjamin*, 274–98.

5
Joanna Sassoon looks to Walter Benjamin's discussion of translation in relation to photography in her essay "Photographic Materiality in the Age of Digital Reproduction," in *Photographs Objects Histories: On the Materiality of Images*, ed. Elizabeth Edwards and Janice Hart (New York: Routledge, 2004), 186–202. Though our concerns are different—she considers the broader implications of the institutional digitization of photographic collections while my interests lie in the task of the printer and the collaborative practice of making—I would be remiss not to cite her here.

6
Though this essay addresses works created by only two of the many artists represented in the Schneider/Erdman Printer's Proof Collection, it is intended to serve as a teaser for the exhibition's accompanying digital resource, which is similarly focused on processes of making. In addition to the works discussed here, the Harvard Art Museums' online Special Collection features case studies on photographs by Lisette Model, Richard Avedon, Robert Gober, Gilles Peress, and John Schabel (among others), as well as interviews with Schneider and those whose work he printed.

7
Hujar's influence during his lifetime and in the years following his death has only recently begun to receive more widespread recognition. See Stephen Koch, "Peter Hujar and the Radiance of Unknowing," *Double Take* 4 (1988): 68–75; and the most recent publication on Hujar's life and work, Joel Smith, ed., *Peter Hujar: Speed of Life* (New York: Aperture, 2017).

8
See Sigmund Freud, "Remembering, Repeating, and Working Through (Further Recommendations on the Technique of Psycho-Analysis II)," in *The Standard Edition of the Complete Psychological Works of Sigmund Freud*, vol. 12, trans. James Strachey, ed. James Strachey and Anna Freud (London: The Hogarth Press, 1950), 147–56; and Sigmund Freud, "Mourning and Melancholia," in *The Standard Edition of the Complete Psychological Works of Sigmund Freud*, vol. 14, trans. James Strachey, ed. James Strachey and Anna Freud (London: The Hogarth Press, 1950), 243–58. My reference to Freud and consideration of the lab as a place for working through mourning derives from conversations with Margaret and Joseph Koerner on the studio practices of William Kentridge.

9
For more detailed information on the meetings and relationships of Hujar, Schneider, Erdman, and Wojnarowicz, see Cynthia Carr, *Fire in the Belly: The Life and Times of David Wojnarowicz* (New York: Bloomsbury, 2012), 187–93.

10
In her discussion of Wojnarowicz's use of photography in his work, Lucy Lippard quotes the artist as saying that Hujar had helped him develop "an eye for printing and the possibilities in the print." Cynthia Carr quotes Schneider as saying that working with Hujar was how he "learned to see." See Lucy R. Lippard, "Passenger on the Shadows," in *David Wojnarowicz: Brush Fires in the Social Landscape*, ed. Melissa Harris (New York: Aperture, 2015), 23; and ibid., 188–89.

11
Thanks to the Peter Hujar Archive for providing access to a recorded interview in which Schneider speaks to these two particular prints.

12
Hripsimé Visser, "The Ambiguity of the Masquerade," in *Peter Hujar: A Retrospective*, ed. Urs Staghel and Hripsimé Visser (New York: Scalo Publishers, 1994), 15.

13
Ibid.

14
Only the gelatin silver printer's proof of Hujar's *Will* is reproduced here, as the nuances between it and the posthumously made pigmented ink printer's proof of the same image are difficult to read in reproduction. Images of the gelatin silver and pigmented ink printer's proofs of *Will* can be found on the museums' website, and both prints can be requested to be viewed in person, by appointment, in the Harvard Art Museums' Art Study Center.

15
Walter Benjamin, "The Task of the Translator," in *Illuminations*, trans. Harry Zohn, ed. Hannah Arendt (New York: Schocken Books, 2007), 70. For a more thorough consideration of the "original" as it relates to the larger history of photography, see Jennifer Quick's essay in this volume.

16
Benjamin, "The Work of Art in the Age of Its Technological Reproducibility, Second Version," 24–25.

17
The following information regarding Hujar's process is based on conversations that Schneider and the author had between October 2016 and May 2017.

18
Schneider had different working relationships with each of the photographers for whom he printed. Hujar's practice and Schneider's collaboration with him differed, for example, from his relationship with Avedon, who wanted each of his prints to be "identical" and who sent intricately diagrammed prints to the lab to aid in this endeavor. Schneider openly admitted that producing identical prints was impossible in a physical practice that hinged on seconds and required the delicate balancing of chemicals. For more information on Schneider's work with Avedon, see the case study on Avedon's portrait of John Lennon in the accompanying online resource, available at http://www.harvardartmuseums.org/collections/special-collections. For more information on Schneider's notion of a "functioning" print, see his piece on printing for Hujar in this volume.

19
Benjamin, "The Work of Art in the Age of Its Technological Reproducibility, Second Version," 24–25.

20
This is something that Schneider learned from conversations with Hujar and through working with Lisette Model as her printer later in her life. For more information on Schneider's relationship with Model, see the case study dedicated to her photograph *Fashion Show, Hotel Pierre* in the accompanying online resource.

21
Burning and dodging are imperative to the process of printing in that they allow a printer to build greater tonal range or contrast into what might otherwise be a flatter image. See the glossary in this volume for a more thorough discussion of these techniques.

22
Though the paper was not officially discontinued by Agfa until 2001, the failures of the paper's new formula reverberated throughout the photographic community years before then. Indeed, in memoriams to the paper were being written in *American Photo* as early as 1995. For more information, see "Agfa Discontinues Portriga," *Photo Trade News Magazine* 65 (6) (June 1, 2001); and Frank Van Riper, "Agfa and the Fine Art Paper Chase," *The Washington Post*, October 14, 1994. Schneider discusses Hujar and Portriga in greater detail in his interview with Penley Knipe in this volume. For more information on this and other photographic printing papers, see the glossary.

23
Benjamin, "The Task of the Translator," 71.

24
Ibid., 72.

25
See Schneider's piece on printing for Hujar in this volume.

26
In his interview with Knipe, Schneider mentions that Portriga Rapid was Hujar's "favorite paper with his later prints."

27
The Schneider/Erdman Printer's Proof Collection contains a letter that Sally Mann wrote to Schneider on the back of two prints regarding the loss of Agfa Portriga Rapid and her struggles with other papers to achieve a similar aesthetic. For more information, see Knipe's interview with Schneider in this volume.

28
For a detailed discussion of photographic papers in particular, see Paul Messier, "Image Isn't Everything: Revealing Affinities across Collections through the Language of the Photographic Print," published as part of the Museum of Modern Art's online project *Object:Photo. Modern Photographs: The Thomas Walther Collection 1909–1949*, available at https://www.moma.org/interactives/objectphoto/assets/essays/Messier.pdf.

29
Though the differences in tonalities will appear in reproduction here, it is important to note that the textures, weights, and sheens of these two black and white printing papers also differ. These and other prints in the Schneider/Erdman Printer's Proof Collection are available to view in person, by appointment, in the Harvard Art Museums' Art Study Center. For more information on Ilford Galerie and Agfa Portriga Rapid, see the glossary in this volume.

30
See Schneider on printing for Hujar in this volume.

31
Benjamin, "The Task of the Translator," 75.

32
Though Schneider could have printed Hujar's images on any black and white paper he wanted, he refused to take such flagrant license with his mentor's work. In this way, he escapes the pitfalls described by Benjamin, who reminds us of how appallingly literature and language are affected "by the unrestrained license of bad translators." Ibid., 78.

33
Ibid., 76.

34
Ibid., 78. Benjamin writes: "Fragments of a vessel which are to be glued together must match one another in the smallest details, although they need not be like one another. In the same way a translation, instead of resembling the meaning of the original, must lovingly and in detail incorporate the original's mode of signification, thus making both the original and the translation recognizable as fragments of a greater language, just as fragments are part of a vessel."

35
See Shimon Sandbank, "The Translator's Impossible Task: Variations on Walter Benjamin," *Partial Answers: Journal of Literature and the History of Ideas* 13 (2) (June 2015): 217; and ibid., 80.

36
Benjamin writes, "The intention of the poet is spontaneous, primary, graphic; that of the translator is derivative, ultimate, ideational. For the great motif of integrating many tongues into one true language is at work." Benjamin, "The Task of the Translator," 76–77.

37
Film served as the intermediary in the production of both the gelatin silver and the pigmented ink printer's proofs of *Will*.

38
Benjamin, "The Task of the Translator," 73.

39
Ibid.

40
An authority on Wojnarowicz, Cynthia Carr writes about this period of his life in much greater detail in *Fire in the Belly*.

41
David Wojnarowicz, *Close to the Knives: A Memoir of Disintegration* (New York: Vintage Books, 1991), 117.

42
Schneider's task with the *Sex Series* moved beyond the translation of the intention of a single image (as in the task of printing *Will*) and toward the necessity of having to craft a cohesive narrative that would work across a larger group. Though I am able to address only one of the *Sex Series*' eight photomontages at length here, I make an effort to gesture toward the way in which this series operates semantically in its entirety. In addition to the complete *Sex Series*, the Schneider/Erdman Printer's Proof Collection contains a number of other works by Wojnarowicz that would provide a rich basis for research into his particular merging of photography and text. Among these is *When I Put My Hands on Your Body*, the last work Schneider printed for the artist before his death in 1992.

43
Wojnarowicz, *Close to the Knives*, 28.

44
See Carr, *Fire in the Belly*, 403–6. For a more thorough discussion of the role of photography in Wojnarowicz's oeuvre, see Lippard, "Passenger on the Shadows."

45
Gary Schneider, "Working with David Wojnarowicz," in Harris, *David Wojnarowicz*, 81.

46
Carr, *Fire in the Belly*, 404–6. Thek was an American artist and, at one point, Hujar's lover (see p. 182 of Carr's book). The Schneider/Erdman Printer's Proof Collection includes 12 color prints of images that Hujar made in Thek's studio, as well as a number of Hujar's black and white portraits of him. For more information regarding the discovery of these images, see Matthew Israel, "Finding Thek's Tomb," *Art in America* 98 (10) (November 2010): 118–27.

47
Though Schneider printed the initial 30 × 40 inch edition of *Untitled (Buffalo)*, the Schneider/Erdman Printer's Proof Collection contains the printer's proof for the later memorial edition of this work, created after Wojnarowicz's death. This particular print is printed on Guilbrom, a paper manufactured by the Paris-based company Guilleminot. Guilbrom (marketed as Brilliant in the United States) was a black and white photographic paper that Schneider, Erdman, and others had hoped would be able to replace Agfa Portriga Rapid following its reformulations in the late 1980s. It is largely because of these two now-defunct paper's similarities that Hujar's gelatin silver printer's proof of *Will* and Wojnarowicz's photograph of falling buffalo share somewhat analogous warm, muddy tones. The additional soft rosy hue that permeates Wojnarowicz's image was created by Schneider's careful polytoning of the print in the darkroom.

48
Wojnarowicz, *Close to the Knives*, 122.

49
In a short piece written for Aperture's *Brush Fires in the Social Landscape*, Schneider discusses printing the 30 × 40 inch edition of Wojnarowicz's *Untitled (Buffalo)*: "The wonderful thing about printing for David was that he really believed in the notion of collaboration. When I print, I see my part as being a catalyst for another artist's ideas. David wanted me to *reinvent* the work at the larger scale. I asked if I could use his elegant 16-by-20-inch print of *Untitled (Falling Buffalo)* (1988–9) as a guide when I was printing it at 30 × 40 inches, but he wouldn't let me. He said: 'Make another one in the best possible way.' I have had this kind of remarkable relationship with only a few other artists." Schneider, "Working with David Wojnarowicz," 81.

50
David Wojnarowicz, "Postcards from America: X Rays from Hell," republished in Wojnarowicz, *Close to the Knives*, 116.

51
Ibid., 121.

52
Ibid.

53
Wojnarowicz writes: "This is a country of trains, planes, and automobiles. AIDS is accelerating in small towns and small cities because the inhabitants of those places believe a number of things: one. That this virus has a sexual orientation and a moral code. two. That the virus obeys borders and stays within large urban centers. three. That if the person you fuck is sweet and kind and sexy, they could not possibly have AIDS or the HIV virus. four. That only wild or reckless people get this disease." Wojnarowicz, *Close to the Knives*, 133–34.

54
Wojnarowicz addresses this particular print in his 1989 court testimony against Reverend Donald E. Wildmon and the American Family Association, discussed in more detail later in this essay. An edited transcript of his testimony can be found in Giancarlo Ambrosino, ed., *David Wojnarowicz: A Definitive History of Five or Six Years on the Lower East Side* (Cambridge, Mass.: MIT Press, 2006), 213–25.

55
The article that Wojnarowicz used was written by Constance L. Hays and titled "2 Men Beaten by 6 Youths Yelling 'Fags.'" It appeared in *The New York Times* on August 24, 1988, and can be read in its entirety at http://www.nytimes.com/1988/08/24/nyregion/2-men-beaten-by-6-youths-yelling-fags.html.

56
Annual reports from the CDC specify 100,813 American deaths from AIDS-related illnesses between 1982 and 1990. It should be noted, however, that the CDC's yearly totals include only those deaths that were reported to the agency. The CDC's yearly HIV Surveillance Reports can be accessed online at https://www.cdc.gov/hiv/library/reports/hiv-surveillance.html.

57
The following discussion regarding Wojnarowicz's process of creating the *Sex Series* photomontages and Schneider's process of reproducing them is derived from a number of conversations that Schneider and the author had between January and May 2017.

58
Carr writes that Wojnarowicz initially got the idea for using color slides with black and white printing paper from Van Cook, who told him "about a photo series she'd made by using color slides in the enlarger—a positive would become a negative, though the red light in the darkroom would knock out a certain portion of the light spectrum coming through the slide. So the prints would look like negatives but be a little 'off.'" Van Cook was a curator, filmmaker, and writer with whom Wojnarowicz closely collaborated on a range of projects. Along with her husband, James Romberger, she opened and ran the East Village's now-iconic Ground Zero Gallery. See Carr, *Fire in the Belly*, 408–9. See also Lucy R. Lippard, "Out of the Safety Zone," *Art in America* 78 (12) (December 1990): 130–39; and Barry Blinderman, "The Compression of Time: An Interview with David Wojnarowicz," in *David Wojnarowicz: Tongues of Flame*, ed. Barry Blinderman (New York: Distributed Art Publishers, 1990), 49–63.

59

See Carr, *Fire in the Belly*, 408–12. Schneider and Erdman were introduced to Wojnarowicz through Hujar and had been processing Wojnarowicz's film for him in exchange for the occasional work since 1984. When Wojnarowicz approached the couple with this series, the three decided that they would co-own the slightly smaller prints produced by the lab in exchange for the labor-intensive work that would go into making them. The collaboration resulted in an edition of prints co-owned by Wojnarowicz, Schneider/Erdman, and PPOW Gallery. The original contract and notes pertaining to making the prints are included in Schneider/Erdman's business records, now part of the Harvard Art Museums Archives.

60

See the glossary in this volume for more on copy prints.

61

Ambrosino, *David Wojnarowicz*, 189.

62

Ibid. Wojnarowicz wrote: "I joke and say that I feel I've taken out another six-month lease on this body of mine, on this vehicle of sound and motion, and every painting or photograph or film I make, I make with the sense that it may be the last thing I do and so I try to pull everything into the surface of that action. I work quickly now and feel there is no time for bullshit. Cut straight to the heart of the senses and map it out as clearly as tools and growth will allow." Wojnarowicz, *Close to the Knives*, 109.

63

This case and the disputes that have collectively come to be referred to as the culture wars have been discussed in detail elsewhere. For a broader and more recent consideration of these debates, see Andrew Hartman, *A War for the Soul of America: A History of the Culture Wars* (Chicago: University of Chicago Press, 2015). For more insight into Wojnarowicz's case in particular, see David Cole's contribution in Harris, *David Wojnarowicz*, 173–77.

64

Ambrosino, *David Wojnarowicz*, 223.

65

Paul de Man, "'Conclusions' on Walter Benjamin's 'The Task of the Translator,' Messenger Lecture, Cornell University, March 4, 1983," trans. William D. Jewett, in *50 Years of Yale French Studies: A Commemorative Anthology, Part 2, 1980–1998* (New Haven, Conn.: Yale University Press, 2000), 30.

66

Ibid.

67

Wojnarowicz, *Close to the Knives*, 144.

68

Ibid.

69

Wojnarowicz's *Sex Series* was first exhibited in his solo show *In the Shadow of Forward Motion*, which ran from February 3 to March 4, 1989, at PPOW. Four of the eight prints from the series were then shown in *Witnesses: Against Our Vanishing* from November 16, 1989 to January 6, 1990. Artists Space had received a $10,000 grant from the NEA to help fund both the *Witnesses* exhibition and its catalogue. After learning of Wojnarowicz's essay and the content of the show, however, John Frohnmayer (chairman of the NEA) wrote to Susan Wyatt (executive director of Artists Space): "Given our recent review, and the current political climate, I believe that the use of Endowment funds to exhibit or publish this work is in violation of the spirit of the Congressional directive.... On this basis, I believe that the Endowment's funds may not be used to exhibit or publish this material. Therefore Artists Space should relinquish the Endowment's grant for the exhibition." Quoted in Carr, *Fire in the Belly*, 453. Carr writes at length about this period and Artists Space's struggle with the NEA in *Fire in the Belly*, 442–61.

70

For more information on the process of masking, see the accompanying online resource—in particular, the case study on Robert Gober's *Untitled, 2008*.

71

Benjamin, "The Task of the Translator," 79.

72

Ibid., 76.

73

Wojnarowicz, *Close to the Knives*, 261.

74

Benjamin, "The Task of the Translator," 77.

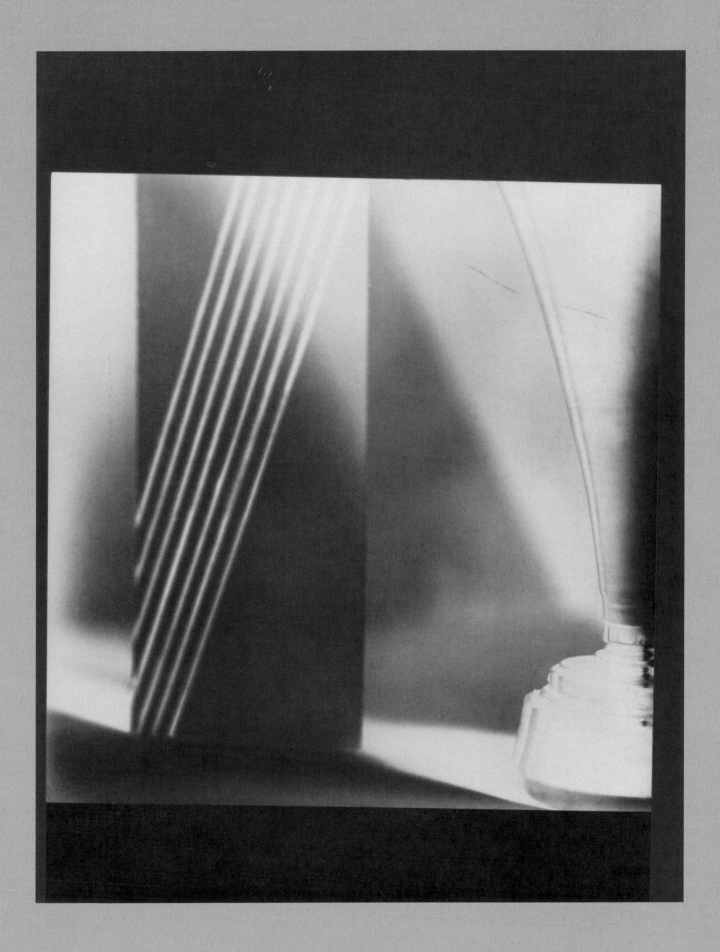

JENNIFER QUICK

PRODUCING MULTIPLES/ PERFORMING PRINTS:

REENACTING CZECH MODERNISM IN THE 1990s

The notion of originality has long haunted photography. As a consequence of their reproducibility, photographs trouble the concept of the singular, hand-wrought art object, an idea rooted in Renaissance humanism and embodied by the Romantic tradition's portrayal of the artist as heroic individual. Practitioners and theorists have thus had to confront, in an especially complicated and fraught way, the fact that photography contradicts long-held beliefs about the nature of art as conceived in the Western tradition. Is there such a thing as an original photograph, or are all photographic images merely mechanistic copies? Does the medium's reproducibility dilute its artistic impact, or does that quality give photography a certain purchase on producing aesthetic and cultural meaning? One could write a history of photography by charting out responses to these questions, from artists' attempts to create a photographic original through hand intervention, as in early 20th-century pictorialism, to more recent critiques—in conceptual art, for example—of the original's very existence.

In the 1980s and '90s, the decades in which Schneider and Erdman established and expanded their printing business, the status of the photographic multiple became a key point of discussion in the art world. By this time, the medium of photography had become fully ensconced in the market, the academy, and the museum. The first art photography auctions occurred during this period, universities began to teach history of photography courses, and collectors and institutions sought to build photography collections. The emergent category of the vintage print, or the print made by the photographer close to the time the photograph was taken, epitomizes the institutional cultivation of the medium's value as art. While the art world increasingly prized photography for its aesthetic qualities, in other circles artists and critics focused on the medium's capacity for cultural critique, especially given the proliferation of photographic images in mass media culture. Whether by virtue of its rising cachet in the market or heightened visibility in the art world, it seemed that photography had at long last overcome its status as "the handmaiden" of art, as Baudelaire scathingly called it in his 1859 review of the Paris Salon.[1] As a printer whose principal job was to make editions, Schneider was well aware of the market's growing taste for the photographs he supplied. He was also versed in the critical art practices in which many artists of the time—himself included—were trained, and brought this background to bear on his printing career, whether in making prints for reproduction or editions for artists. For Schneider, reproducibility was not an incidental fact of photography; indeed, it was at the forefront of his daily activities, factoring into his conversations with clients, his choice of papers, and his proofing methods. Schneider's printing practice, in other words, entailed a long-standing, ever-evolving engagement with the photographic multiple.[2]

In the early 1990s, Schneider was brought onto a project especially invested in considering the material, theoretical, and historical nature of the photographic original and copy. Commissioned by curator and historian Jaroslav Anděl and published in 1994, *Reconstructing the Original: Czech Abstractions 1922–1935* comprises 12 gelatin silver photographs by František Drtikol, Jaroslav Rössler, Jaromír Funke, Eugen Wiškovský, and Hugo Táborský (Figs. 1–13). A scholar of Czech modernist art, Anděl conceived of this portfolio as a means to disseminate the legacy of these important photographers working in Czechoslovakia in the 1920s and '30s, who, unlike their counterparts in the German, French, and Russian avant-garde, were largely unrecognized by American academics and museums. He faced a conundrum, however: vintage prints (as well as later copies) by these artists were either destroyed, lost, or housed in collections in the Czech Republic. (Czechoslovakia split into the Czech Republic and Slovakia in 1993, while the project was under way.) Anděl's solution to this dearth of Czech photographs was to curate a collection of "reconstructed" prints, issued in an edition of nine with three artist's proof sets.[3] Each reconstruction was a modern print made to resemble closely the photographer's own prints. As an early reviewer of the project noted, these reconstructions, present-day prints made to evoke the photographer's printing style, were also "archival," meaning that they were specifically made with durable, technologically up-to-date materials that would facilitate their longevity.[4] Anděl considered *Reconstructing the Original* a pedagogical object, a neatly packaged portfolio that would provide U.S. museums with a high-quality collection of Czech modernist photography upon which to establish larger holdings of these photographers' work.

The ambitious project was fraught with difficulties: it was highly expensive, logistically complex, and time-intensive, with only a few ultimately placed in museums. In retrospect, however, the idiosyncratic publication has proved to be an important intervention in the practice and theorization of photography in the 1990s. In this essay, I argue that a close examination of the portfolio yields important historical insight into the status of the photographic multiple in the market, in institutions, and in the printer's studio. Part of its significance derives from Anděl's historically savvy framing of the project. His introductory essay for *Reconstructing the Original* evinces a sophisticated understanding of Czech modernism as well as of debates and discussions around the vintage print and its relationship to originality, authenticity, and history. Another theoretical and historical contribution of this project lies in its making. Schneider's training as an artist and vast printing experience, in addition to his knowledge of Czech photography from his own collecting practices, positioned him well to collaborate with Anděl on the portfolio. A close look at Schneider's

work on *Reconstructing the Original*, especially his printing of Rössler's photographs, reveals that he brought to the project not only technical expertise and knowledge of materials, but also a sophisticated conception of printing and of the photographic multiple. By remaking 20th-century modernism in the present through the act of printing, Schneider emerges as a practitioner who functioned as a historical actor at a significant moment in the medium's evolution.

CZECH AVANT-GARDE PHOTOGRAPHY: HISTORY AND RECEPTION

Though photographers such as Drtikol and Rössler have become better known since Anděl embarked on his project, Czech photography of the 1920s and '30s remains a relatively underexplored chapter in the history of modernism. Centrally located in Europe (bordered by Germany, Austria, Hungary, and Poland), Czechoslovakia was at the crossroads of key modernist movements, such as cubism, futurism, New Objectivity, surrealism, and constructivism, as well as strategies like abstraction, the photogram, and photomontage.[5] Early exhibitions of fauvism, cubism, and futurism in Prague enthralled young Czech artists, who saw this work as a revolt against Viennese Art Nouveau and therefore a sign of the capital's emancipation from the Austro-Hungarian Empire. In an 1895 manifesto of Czech modernism published in the journal *Rozhledy*, a group of young artists rejected the idea of a nationalist, folkloric art, calling instead for freedom and experimentation. Many of these artists were associated with the emerging Young Czech political party, which would push for the democratization of both government and public life.

The principal Czech avant-garde group, Devětsil Artistic Association (1920–31), briefly united different strains of the post–World War I avant-garde. Karel Teige, the leading figure in Devětsil, championed photography and film as the most contemporary of art forms. Like László Moholy-Nagy, who advocated for a "new vision," he considered photography to be particularly well suited to representing the contemporary age. Photography, Teige wrote in his manifesto *Foto—Kino—Film*, had the mechanistic beauty of an airplane, ocean liner, or electric bulb. Illustrated with publicity photos from American films, stills from Charlie Chaplin movies, and Man Ray photographs, the book played an important role in the formation of photographers such as Rössler and Funke. Devětsil also published a journal, *ReD (Revue Devětsilu)* (1927–31), showcasing the work of key figures in the visual arts, architecture, design, and poetry, including El Lissitzky, Jean Arp, Constantin Brancusi, Le Corbusier, and Stéphane Mallarmé (Fig. 14).[6] Czech artists were also involved in *Film und Foto*, the landmark 1929 exhibition dedicated to New Vision photography. Though the Czech artists in *Film und Foto* mainly exhibited photomontage, the show's run in Stuttgart caught the attention of young film critic Alexander (Sasha) Hackenschmied.[7] With the assistance of Funke and Rössler, Hackenschmied organized two New Photography exhibitions in Prague, one in 1930 and the other in 1931. As the 1930s wore on, modernist photography, along with professional photography societies, continued to flourish. Between the wars, Czechoslovakia remained a relatively democratic and open society, hospitable to a thriving avant-garde; these movements, though, were largely suppressed with the onset of World War II and a communist coup d'état in 1948.

In *Reconstructing the Original*, Anděl focused on strategies of abstraction, one of the principal ways in which the "new vision" manifested in interwar Czech art. As stated in his essay in the portfolio, he was not attempting to present a holistic or chronological account of Czech modernism, but rather to "tell a story of geometric abstraction." Numbering each photograph, he placed a work by Drtikol first, but noted that it was dated later than the photographs by Rössler and Funke. Following the Drtikol are three photographs each by Rössler, Funke, and Wiškovský, plus two by Táborský. Beginning with Drtikol's diminutive photograph of a constructivist-style sculpture and ending with Táborský's up-close shot of coffee beans, the portfolio offers a broad interpretation of abstraction in the work of these photographers.

The three Rössler photographs alone indicate the range of abstract strategies represented in the portfolio. Rössler, who trained with Drtikol, had early contact with abstract art via his encounters with cubism and futurism in Prague. Exposure to a rich variety of approaches to abstraction—from Alvin Langdon Coburn's vortographs, photographs of reflective surfaces made with a kaleidoscopic device, to František Kupka's colorful, rhythmic paintings—inspired Rössler to begin experimenting with the photography of light and shadow around 1921. *Abstraction* (see Fig. 4) and *Photograph I* (Fig. 5) represent his growing interest in montage and the use of hand-constructed paper backgrounds, which he photographed with objects but also on their own. For *Abstraction*, he merged and overlapped two montages of identical negatives. Later he would make prints of similar images using the bromoil technique.[8] According to captions that Anděl provided for the portfolio, Rössler used the carbro process to create *Still Life with Loudspeaker*, a composition that foregrounds the titular device in front of one of his geometric constructions (see Fig. 3). He likely also printed this image with a pigment process, as he did for other works in this vein. Unlike his contemporaries, Rössler continued to use pigment processes throughout his career. Other photographers began to abandon the soft, painterly effects of this technique when Drahomír Josef Růžička, an amateur who learned of the influential photographer

Clarence White while living in the United States, brought back copies of the journal *Camera Work* as well as prints by White, Edward Steichen, Alfred Stieglitz, and Doris Ulmann when he returned to Europe. In this way, Růžička spurred an interest in what Stieglitz called "straight photography," an approach that eschewed pictorial effects in favor of emphasizing clarity, precision, and directness.[9] While Rössler was involved with Devětsil, he was fairly independent in his working methods and left behind few works of art or documents. As scholar Vladimír Birgus has pointed out, many of Rössler's works, which he did not show during his lifetime, are held in private collections (if not lost or destroyed), and thus are little seen or studied.[10] The first retrospective of his work took place only in 2001, seven years after Anděl published *Reconstructing the Original*.

Faced with the task of arguing for this work's importance in the history of art, Anděl in his essay situated Czech photography within broader and more familiar currents of modernism, from "abstract art and Cubism to the emergence of Constructivism and its various functional and experimental uses of the photographic medium."[11] His words suggest a desire to legitimize Czech photography by linking it to canonical modernist movements. Anděl knew that the portfolio would be more attractive to museums if he could successfully argue, through his essay and the selection of works, that Czech photographers were experimenting just as boldly and compellingly with the medium as their more well-known contemporaries. Like other early champions of underrepresented artists, Anděl likely felt that he needed to situate these figures within established avant-garde paradigms. He had taken a similar approach in one of the first major exhibitions of Czech modernism in the United States, organized by the Museum of Fine Arts, Houston. In his essay for the accompanying catalogue, Anděl wrote, "[P]erhaps in no other country was avant-garde photography so well developed and so multifaceted as in Czechoslovakia in the 1920s and '30s, where more than half a dozen groups specialized in photography."[12] After opening in Houston in 1989, the exhibition traveled in medium-specific groups to four locations: painting and sculpture were shown at the Brooklyn Museum; film at the Anthology Film Archives, New York; and photography at the International Center of Photography in New York and the Akron Art Museum in Ohio. David Lazar, writing in *Aperture*, noted that the show—while timely and important—tended to downplay the historical and political dimensions of Czech art.[13] Nonetheless, the exhibition stands as a significant early landmark in the reception of the Czech avant-garde.

The Museum of Fine Arts, Houston, was one of the first U.S. institutions to build a focused collection of Czech photographs. A protégé of Drtikol's had organized an exhibition of the artist's work there in 1932. In 1979,

Anne Tucker, a curator at the museum, began acquiring vintage Czech photographs, and it was she who assembled the curatorial team, including Anděl, for the 1989 exhibition. In addition to Houston, a few U.S. galleries, such as that of Howard Greenberg, likewise began to feature Czech photography as early as the 1980s.[14] Today, it is far more common to see a work by Rössler or Josef Sudek in the stalls at major photography fairs. In recent years, scholars outside of the Czech Republic have done important work on these photographers, as their art has become more accessible and known to the rest of the world. Matthew Witkovsky, for example, has eloquently argued that Rössler's career constitutes an important case study for the fashioning of artistic identity in the interwar period, specifically with regard to the relationship among the categories of professional, amateur, and avant-garde.[15]

Like artists at the Bauhaus, Rössler saw his experimental work and professional assignments as distinct yet equally fulfilling. Even so, he did not share that group's inclination toward functionalism, nor was he driven by political motivations like the constructivists. His career therefore does not fit comfortably into the various "isms" of the interwar avant-garde, despite his use of similar visual strategies, such as abstraction and photomontage. As Witkovsky argues, Rössler carved out his own niche by transforming the concept of the "professional" into a mode of art-making. Having learned the value of props, staging, and illusion in Drtikol's studio, Rössler inverted the processes of photographic illusionism, picturing "reality as an open-ended sequence of illusions." Noting the artist's dedication to printmaking and to experimentation with photographic processes, Witkovsky writes that Rössler's modernism "proceeds from the image made, not the image taken. . . . [W]hether soft-focused bromoils or dynamically fragmented montages, whether abstract photograms or product advertisements, all evince a delight in staging experiments."[16] Rössler used the tools of the professional photographer to picture the insular environment of his studio, in which discrete realities could be constructed, arranged, and photographed.

With works such as Rössler's, Anděl made a compelling case for the inclusion of Czech abstract photography in an expanded history of modernism. To communicate this legacy, he and Schneider collaborated to make prints that spanned the temporal and spatial gaps between the studios of Czech photographers in the 1920s and '30s and a printing lab in New York's East Village in the '90s. In theory and in practice, these reconstructions, rooted in history but reflective of their own moment, effectively tell the story not only of the avant-garde in Czechoslovakia, but of the time of their making—a story revealed in both Anděl's framing of the project and Schneider's execution of it.

IN THE EYE OF THE BEHOLDER: PHOTOGRAPHY AND THE ORIGINAL

Anděl's portfolio of "reconstructions" got to the heart of pressing contemporary dialogues—and diatribes—on vintage and modern prints. Clearly aware of what was at stake in his project, Anděl articulated in his essay a theory of the photographic original and copy that spoke to the intellectual formulation of the portfolio, but also mounted a peremptory defense to objections and questions he knew it would raise. Most importantly, he addressed the issue of content: what exactly did it mean not to copy the original, but to "reconstruct" it? What types of photographs did the portfolio contain?

Anděl described his venture as an "aesthetic archaeology," a historical investigation and recovery of art objects; and he, Schneider, and Erdman approached the job with an exactitude deserving of that phrase. Anděl was tasked first with obtaining negatives—no easy feat, given that most of the negatives were located in the Czech Republic. After gaining permission to print the artists' work, he then had to transport the negatives out of the country, something that is virtually unimaginable today in the wake of increased security around the movement of cultural objects. Letters in the Records of Schneider/Erdman, Inc., in the Harvard Art Museums Archives indicate that the team appealed to multiple parties to gain permission to reproduce the works. In order to obtain permission to print the Wiškovský photographs, for example, Anděl, Schneider, and Erdman wrote joint letters to the Ministry of Culture and to the Moravian Gallery in Brno, which managed the artist's estate. By ensuring the full cooperation of the rights holders, Anděl would avoid the types of controversies that had been erupting over the making of copy prints. In the early 1990s, for example, a dispute arose between the executors of André Kertész's estate and the French government, to whom Kertész had left his negatives upon his death in 1985. The estate argued that the government owned only the physical negatives, not the reproduction rights as claimed.[17] Anděl took pains not only to acquire permission, but to visually signal these rights in the portfolio: along with Schneider and Anděl, the artist or a representative of his estate signed the verso of each print. In the captions, Anděl noted the original date of the photograph, the printing source, and the location of any known extant prints, as well as the details of the types of paper, toners, and other materials used. He also clearly explained his process of procuring permissions in his essay.

Anděl's thorough explanations and documentation were not only necessary to prove the portfolio's ethical status and historical merit, they were also meant to acknowledge contemporary debates on the emerging category of the vintage photographic print. The title of an early review of the portfolio—"The Clash between Vintage, Later, Posthumous, and Aesthetics"—captures the issues at play in this discussion.[18] "Vintage" was by then a familiar though still controversial term in the market and on the gallery circuit. The creation of a special designation within the broader category of the photographic multiple addressed anxieties surrounding photography's complicated relationship to originality and authorship. To be accepted as art, photography—an inherently reproducible medium that depends upon mechanical apparatuses and chemical intervention—had to show some sign of authorial imprint and intentionality. Executed by the photographer close to the time when the negative was made, the vintage print presumes temporal and material closeness to the moment of creation, when the image is burned into the film by the action of light. Because vintage prints knit together the negative and the print and ensure continuity between the two, one could argue that they most accurately represent the photographer's ideas and aesthetic. Photographers, dealers, and artists' estates began to use markers such as stamps and signatures to confirm the vintage print's authorial legitimacy and to solidify its status as an art object, expressive of an author's vision.

Beginning in the 1970s, collectors and institutions began to prioritize the acquisition of vintage over later prints, including posthumous prints by an authorized printer. Galleries mounted exhibitions that highlighted a photographer's vintage prints and in some cases directly—and unfavorably—compared them to less successful modern or later prints. As enthusiasm for vintage prints grew, so did the ambiguities and contradictions that this category introduced. For example, when it became common practice for photographers to edition their work—that is, to put out a defined, limited set of prints—collectors began to worry that prints would continue to be made outside of those editions, thus decreasing the value of the photographs they had purchased. There were also questions as to what it means to own a photograph. As Erdman remembers, collectors would sometimes assume that purchasing a vintage print meant that they would receive the photographer's negative, too, which would at least theoretically prevent more printing of the image and limit how many multiples were produced. In a similar vein, dealer Deborah Bell recalls collectors inquiring if they would receive the copyright when purchasing a print.[19] It was also unclear how many years could separate the negative and the print before the print was no longer considered vintage, resulting in the invention of terms such as "mid-vintage," generally meant for prints that were made later but not substantially so (though there was little clarity as to just who was authorized to make that judgment). Some even questioned the growing primacy of the vintage print altogether, or at least cautioned that vintage prints were not always superior to later versions.

In a review of several 1998 exhibitions pitting vintage against modern prints, Margarett Loke noted that each photograph must be considered on a case-by-case basis, even when comparing an artist's early and later work.[20] In a Brett Weston exhibition, for example, many vintage prints proved to be of higher quality, but according to Loke there were also instances in which vintage and modern versions of the same image were almost indistinguishable.

While some of these ambiguities could be resolved by considering each photographer's oeuvre on its individual merits, questions and uncertainties remained. If more prints can be made from any given negative, what is the vintage print's value? Can photographs, like paintings, make convincing claims to originality and authenticity in the face of the medium's reproducibility? Further confusion arose with the contemporaneous increase of photography forgeries. One of the most infamous cases of this type of deception involved a cache of Lewis Hine prints, which fetched extraordinarily high prices at auction in the 1990s. Hine's *Mechanic and Steam Pump*, for example, sold for a record $90,500 at Christie's the year that the Czech portfolio was published.[21] Experts raised alarms when the photographs were tested and revealed to be made with materials manufactured only after Hine's death in 1940.

Given the development of this new terminology for photographic prints, Anděl had to choose his words with care. Steering clear of the language of vintage and modern, he instead emphasized the interpretive work at play in his project. His "reconstructions" were essentially hybrid objects, meant to embody each photographer's aesthetic as translated into contemporary (and more stable) materials. In his essay, Anděl explained that this experimental project allowed for a critical examination of the concept of the vintage print. He opened by boldly pointing out the vintage print's contingent nature, declaring that its judgment lies "in the eye of the beholder." As Anděl argued, since photography is an inherently changeable and unstable medium, it follows that the concept of the vintage print is also changeable and unstable. Since photographs fade, silver, and discolor over time, it is difficult to know for sure which qualities are "original" to the print and which are the results of age. Popular notions of a photographer's vintage prints could be tied to what they looked like 10, 20, even 50 years later after the fact. Anděl's awareness of photography's temporality, especially its fugitive nature, colors his explanation of his project. Further, his use of language associated with the natural sciences—referring to discontinued photographic papers as "extinct," for example, or calling the job at hand "archaeology"—indicates the urgency he felt, the need to make prints to preserve the legacies of these important artists. At the same time, he was clear that his prints were not vintage photographs, and that he did not mean to pass them off as such. He highlighted, for instance, the use of modern and more technologically advanced materials as a key tenet of his project, a sign that these were adamantly other than the photographers' vintage prints.

Anděl's conception of the photograph's contingency challenged prevailing interpretations of the vintage print's authenticity and singularity. His goal was not to produce facsimiles, but rather, through an aesthetic archaeology, to understand and replicate what he called the "inner logic" of each image, as expressed through papers, toners, and photographic processes.[22] His notions of the Czech originals were synthetic, formulated through his many years of studying photography from that country and by seeing the prints in person. Because he could not bring those prints to Schneider to use as referents, he had to use this knowledge to describe in words the effects he desired in each print, working with Schneider until the photograph appeared as he envisioned. Anděl acknowledged this process by describing the photographs as "interpretations." He also took into account the fact that many of the featured photographers printed different versions of the same image.[23] The original that he aimed to construct, therefore, was an accretion of ideas and concepts rather than a singular print to be copied. Each print represented a distillation of each photographer's work as it evolved over time.

Anděl's conception of the original reflects his awareness of avant-garde art, which challenged the prevailing institutions and modes of art-making. In 1989, he curated an exhibition on the avant-garde book at New York's Franklin Furnace in which he explored how artists ranging from Herbert Bayer to El Lissitzky experimented with and embraced the multiplicity, potential for wide distribution, and communicative possibilities of the book format.[24] While the Czech portfolio served a much different purpose than these books, the way that Anděl conceived of the prints reflects a similar conception of the multiple. Instead of seeking to delimit the photograph's reproducibility, as the vintage print does, he embraced the medium's ability to make multiples. In his reconstructions, he took account of the aesthetic and conceptual possibilities that this capacity engendered for Czech avant-garde artists. *Reconstructing the Original* sought to examine critically the nature of the photograph and of the multiple as much as it aimed to disseminate the legacy of Czech modernism.

The word "reconstruction," which suggests a reenactment of something from the past using available evidence, captures well the purposes of the project and the steps Anděl undertook to execute it. While he provided the instructions necessary to make the prints and furnished a theoretical conception of the original, Anděl also realized that he needed to work with a printer who would be open to his methodology—someone willing to discern and follow the "inner logic" of each image—in order to reenact the photographs in the lab. In Schneider, he found the ideal collaborator.

MAKING THE CZECH PORTFOLIO: PRINTING AS TACIT KNOWLEDGE

By the early 1990s, Schneider/Erdman had grown into an active printing business.[25] Schneider had put his own art career on hold and was fully immersed in printing. In addition to providing services for film processing and printing for reproduction, the lab was known as a "bespoke" printing studio for artists, as Lorna Simpson remembers.[26] Schneider also had an excellent reputation for copy work, based on projects he had done with Richard Avedon and Kertész's estate. By the time Anděl came to him with the idea for *Reconstructing the Original*, Schneider had also received a commission for one of his most technically complex collaborative projects: printing Steven Meisel's photographs for Madonna's book *Sex* (1992).

The intricacies of making editions were, by this time, very familiar to Schneider, who had developed a philosophy of printing that governed his work. As he explains elsewhere in this book, the conversation he had with prospective clients before agreeing to print an edition included the promise that "each print will be unique, but they'll all function." The idea of the functional print, not the matching print, served as Schneider's guiding principle in making editions. Every commission, however, called for a tailored approach based on close collaboration with his clients, with the result that prints in each edition had a specific relationship to the source materials (including the negative and vintage print, if any existed). Avedon, for example, preferred that each photograph in the edition match, and Schneider executed the artist's prints accordingly. In his work for most other clients, however, each print reflected, in nuanced ways, slight changes in chemistry, light, and other darkroom conditions. In seeking out the functional print, Schneider had to navigate a host of technical and conceptual quandaries, such as what to do when a preferred

type of paper ceased to be produced, or when an image proved nearly impossible to print as a multiple. When he printed for Louis Faurer, for example, he worked with Bell, the artist's dealer, to make modern prints from negatives. Bell remembers that Faurer's *Bowing for VOGUE Collections, Paris, 1972* was especially difficult to print in multiples because the photographer had used seamless paper for the background and nuanced stage lighting (see p. 109). Additionally, the only extant vintage print had airbrushing that had yellowed over time. To achieve a print that could stand up to the demands of reproduction, Schneider made a print that Bell retouched, then re-photographed that print and created the edition from the resulting negative.[27] Through experiences such as this one, Schneider, like Anděl, was familiar with conversations and controversies surrounding different types of photographic prints.

Artists such as Robert Gober, Matthew Barney, and Lorna Simpson, on the other hand, took a vastly different approach to what Schneider called a print's functionality. In many cases, these artists worked across media and did not conceive of themselves strictly as photographers. As a result, they inverted or entirely disregarded terms and standards from the field of photography, including the edition or the vintage print. As Gober explains in his interview in this book, his collaborations with Schneider pertained to photographs meant for larger projects, which involved sculptures, drawings, and other media. For example, Schneider first printed Gober's *Untitled, 2008* for a card announcing one of the artist's exhibitions at the Matthew Marks Gallery.[28] Gober decided only afterward, as he did in several other cases when working with Schneider, to produce a small edition, and Schneider made two proofs, one in silver and one in ink, for Gober to review. (The artist ultimately chose the ink print.) Another work by Gober, *1978–2000* (see pp. 153–63), instead involved several stages of printing and reprinting and translations between media. Gober had the images made with old contact sheets, from

Fig. 1
Title page from the portfolio *Reconstructing the Original: Czech Abstractions 1922–1935*, 1994. 40.6 × 50.8 cm (16 × 20 in.). Harvard Art Museums/Fogg Museum, Schneider/ Erdman Printer's Proof Collection, partial gift, and partial purchase through the Margaret Fisher Fund, 2011.453.1–12.

Fig. 2
František Drtikol, *Untitled*, c. 1930. Gelatin silver print, 9.1 × 10.5 cm (3⁹/₁₆ × 4¹/₈ in.). Harvard Art Museums/Fogg Museum, Schneider/Erdman Printer's Proof Collection, partial gift, and partial purchase through the Margaret Fisher Fund, 2011.453.1.

Fig. 3
Jaroslav Rössler, *Still Life with Loudspeaker*, 1922. Gelatin silver print, 23.6 × 23.6 cm (9⁵/₁₆ × 9⁵/₁₆ in.). Harvard Art Museums/Fogg Museum, Schneider/ Erdman Printer's Proof Collection, partial gift, and partial purchase through the Margaret Fisher Fund, 2011.453.2.

Fig. 4
Jaroslav Rössler, *Abstraction*, c. 1923. Gelatin silver print, 25.1 × 24.6 cm (9⁷/₈ × 9¹¹/₁₆ in.). Harvard Art Museums/Fogg Museum, Schneider/Erdman Printer's Proof Collection, partial gift, and partial purchase through the Margaret Fisher Fund, 2011.453.3.

Fig. 5
Jaroslav Rössler, *Photograph I*, 1923–25. Photomontage, 37.2 × 31.4 cm (14⁵/₈ × 12³/₈ in.). Harvard Art Museums/Fogg Museum, Schneider/Erdman Printer's Proof Collection, partial gift, and partial purchase through the Margaret Fisher Fund, 2011.453.4.

Fig. 6
Jaromír Funke, *Untitled*, 1923–24. Gelatin silver print, 21.6 × 29.8 cm (8¹/₂ × 11 3/4 in.). Harvard Art Museums/Fogg Museum, Schneider/Erdman Printer's Proof Collection, partial gift, and partial purchase through the Margaret Fisher Fund, 2011.453.5.

Fig. 7
Jaromír Funke, *Composition: Glass Plates*, c. 1923. Gelatin silver print, 22.4 × 29.6 cm (8¹³/₁₆ × 11⁵/₈ in.). Harvard Art Museums/Fogg Museum, Schneider/ Erdman Printer's Proof Collection, partial gift, and partial purchase through the Margaret Fisher Fund, 2011.453.6.

Fig. 8
Jaromír Funke, *Untitled (Spiral)*, c. 1929. Ferrotyped gelatin silver print, 50.4 × 41 cm (19¹³/₁₆ × 16¹/₈ in.). Harvard Art Museums/Fogg Museum, Schneider/ Erdman Printer's Proof Collection, partial gift, and partial purchase through the Margaret Fisher Fund, 2011.453.7.

RECONSTRUCTING

THE ORIGINAL:

CZECH ABSTRACTIONS

1922-1935

Reconstructing the Original: Czech Abstractions 1922-1935
consists of twelve gelatine silver prints in an edition of nine
copies and three proofs. Edited by Jaroslav Andĕl and printed
by Gary Schneider. Produced by AV Editions (Tompkins
Square Station, P.O. Box 20502, New York, NY 10009)
and Schneider/Erdman, Inc. (32 Cooper Square,
New York, NY 10003).

Copy /9

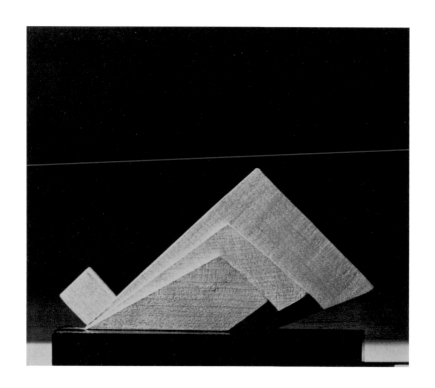

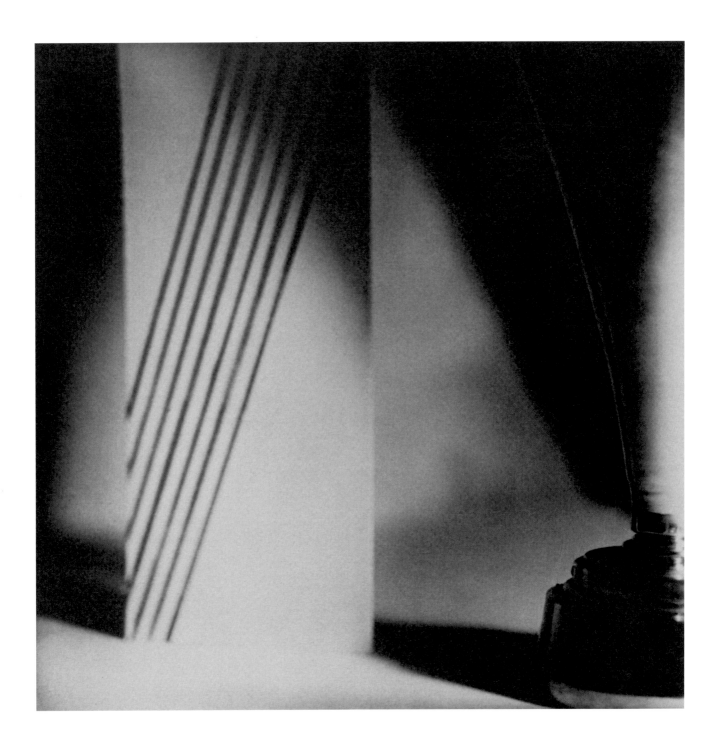

photographs he had taken in the 1970s (pp. 165–66). In their first iteration, the montaged photographs appeared as reproductions in a book displayed at the 2001 Venice Biennale, where Gober represented the United States. Schneider used these reproductions later to make larger, editioned prints of the same images. For Gober, the original and the reproduction were flexible and unstable concepts, open to interpretation and revision. Rather than printing editions from a negative or source photograph, he experimented with the fusing and blurring of original and reproduction across media and over time. Schneider's work with Gober exemplifies his willingness to modify his processes and push the boundaries of his skills in order to realize each artist's goals.

Many artists who turned to photography during these years were heirs to conceptual art, a term that emerged around 1970 to describe a wide variety of art practices unified by dedication to ideas over objects. Picking up on the notion of what critic Nancy Foote called the "anti-photographer," an idea associated with conceptual art, they conceived of themselves as users of photographic images rather than creators of them.[29] As Foote wrote in 1976, this model of photography was directly linked to the medium's ascendancy as art: "[P]hotography's status in the art world remains problematic. . . . [F]or every photographer who clamors to make it as an artist, there is an artist running the grave risk of turning into a photographer."[30] These artists, in other words, eschewed the vintage print's premium on authenticity and originality, instead conceiving of photographs as readymades, an idea that originated with French artist Marcel Duchamp and became a key reference point for conceptual art in the United States. Duchamp's readymades took the form of everyday objects that he selected, gave a title, and displayed in museums as works of art. Emphasizing the artist's choice, linguistic determination, and the institutional context over the aesthetics of the objects, Duchamp declared readymades to be in opposition to "retinal art" aimed at the

visual senses.[31] The photograph as readymade took many forms: mass media images culled from magazines and newspapers, pictures taken not by the artist but by a hired professional, or the documentation of a performance or action. Rather than prizing the photograph's aesthetics or material qualities, these artists deployed it as a tool of critique or record of information.

Of the many different trajectories that emerged from conceptual art, one that was especially important for photography was the Pictures Generation. Art historian and critic Douglas Crimp coined the term in his 1977 exhibition *Pictures*, held at Artists Space in New York. The name came to refer not only to the five artists in the exhibition—Troy Brauntuch, Robert Longo, Jack Goldstein, Sherrie Levine, and Philip Smith—but also to those working with similar strategies, such as Cindy Sherman and Richard Prince.[32] These artists, Crimp wrote, critically mined the image culture that defined contemporary experience. In later texts, Crimp identified these artists' strategies with postmodernist art, which he saw as both a response and a critique of modernism. If the vintage print (a modernist concept) was prized for its originality, singularity, and authenticity, "pictures" (a postmodern idea) were images to be appropriated, scrutinized, and deconstructed.[33] Levine, for example, used the work of other photographers, including Edward Weston and Walker Evans, to examine artistic and cultural hierarchies of value. In Crimp's analysis of her 1981 work *Untitled (After Edward Weston)*, in which Levine re-photographed Weston's famous series of his son, Neil, the critic recounted an anecdote that Levine had related to him about a friend's reaction to the series. When the friend responded that the works only made him want to see Weston's originals, Levine answered that he would then want to see the little boy that they portrayed, "but when you see the boy, the art is gone."[34] It is only in the absence of the original object—in this case, the boy—that an image can be made. The desire to attain the object that the original portrays is impossible to fulfill, the

Fig. 9
Eugen Wiškovský, *Still Life*, 1929. Gelatin silver print, 27 × 24.5 cm (10⅝ × 9⅝ in.). Harvard Art Museums/Fogg Museum, Schneider/Erdman Printer's Proof Collection, partial gift, and partial purchase through the Margaret Fisher Fund, 2011.453.8.

Fig. 10
Eugen Wiškovský, *Insulator*, 1933. Gelatin silver print, 38 × 28.2 cm (14¹⁵⁄₁₆ × 11⅛ in.). Harvard Art Museums/Fogg Museum, Schneider/Erdman Printer's Proof Collection, partial gift, and partial purchase through the Margaret Fisher Fund, 2011.453.9.

Fig. 11
Eugen Wiškovský, *Insulator II*, 1935. Gelatin silver print, 35.5 × 27.6 cm (14 × 10⅞ in.). Harvard Art Museums/Fogg Museum, Schneider/Erdman Printer's Proof Collection, partial gift, and partial purchase through the Margaret Fisher Fund, 2011.453.10.

Fig. 12
Hugo Táborský, *Reflector*, 1933. Gelatin silver print, 22 × 31.1 cm (8¹¹⁄₁₆ × 12¼ in.). Harvard Art Museums/Fogg Museum, Schneider/Erdman Printer's Proof Collection, partial gift, and partial purchase through the Margaret Fisher Fund, 2011.453.11.

Fig. 13
Hugo Táborský, *Coffee Beans*, c. 1934. Gelatin silver print, 13.6 × 18.6 cm (5⅜ × 7⁵⁄₁₆ in.). Harvard Art Museums/Fogg Museum, Schneider/Erdman Printer's Proof Collection, partial gift, and partial purchase through the Margaret Fisher Fund, 2011.453.12.

Fig. 14
Cover of *ReD (Revue svazu moderní kultury Devětsil)* 1 (1) (October 1927); edited by Karel Teige and published in Prague by Odeon. 23 × 18 cm (9 × 7⅛ in.). The Wolfsonian—Florida International University, Miami Beach, Florida, The Mitchell Wolfson, Jr. Collection, XC1993.182.1.

original always deferred. Where modernist art valued the original object of art, postmodernist art, such as Levine's, embraced a "plurality of copies."[35]

Throughout the latter half of the 20th century, many critics and artists, not only the Pictures Generation, continued to grapple with conceptual art's impact on photography's role in and as art, even as the market for and valuation of art photography expanded. In a 1995 essay on the subject, Jeff Wall argued that conceptual art instituted a turning point in photography's long "pre-history" as a medium of art.[36] In framing the photograph as a critical tool, conceptual artists posed difficult questions about photography's role in contemporary society, its function in an art context, and its rapid institutionalization and rise in the market. Photography's role in art continued to evolve in many different directions into the 1980s and '90s, as the printer's proof collection demonstrates. From James Casebere's photographs of building models, to David Maisel's aerial images of strip-mined landscapes, to Barney's photographs from the *Cremaster Cycle*, the collection vividly witnesses the multiplicity of ways that artists engaged photography in those years, and the latitude with which they defined and approached the multiple.

These two contexts—Schneider's knowledge of the photography world and his experience with diverse networks of artists—indelibly influenced his approach to printing the Czech photographs.[37] Generally, Schneider

began by printing a handful of proofs from negatives or other source images that Anděl brought back from estates, artists, or institutions in the Czech Republic. Schneider would then invite Anděl to his studio to study the proofs and offer feedback. Anděl might ask Schneider to make a print cooler or warmer in tone, or to adjust the surface's gloss. It is worth reiterating that these exchanges were based on Anděl's descriptions of each artist's work; that is, Schneider was not working from actual prints (except in the case of the Drtikol photograph [see Fig. 2]; Anděl had managed to secure a print of that work). In order to attain prints that Anděl deemed acceptable, Schneider often made as many as 30 or more proofs.

From there, Schneider's work became specific to each print. The process used to print Rössler's photograph *Still Life with Loudspeaker* sheds light on the technical and conceptual gymnastics required for the project.[38] As noted in the portfolio caption, a carbro print of the image existed in a Prague museum, and the Bibliothèque Nationale in Paris and the Moravian Gallery in Brno had two later gelatin silver prints. Since he listed the carbro print in the caption for *Still Life with Loudspeaker*, Anděl surmises that he likely asked Schneider to "respond to and reflect on" Rössler's use of the carbro technique.[39] The final print also evokes the pigment process that Rössler frequently used in photographs involving object compositions and abstractions (of which *Still Life with Loudspeaker* is one). In each variation, Rössler

accentuated the image's distinct shadows and highlights, spatial construction, and sense of illusionism.

Behind the printing of this single photograph, then, there existed different versions of Rössler's work and also his diverse printing techniques, which functioned as points of reference for Schneider in the process of making a contemporary gelatin silver version of *Still Life with Loudspeaker*. In the caption, Anděl described this photograph as printed from "an inter-negative using the original negative." The term "inter-negative," commonly used in movie film production, usually refers to a negative print made from a positive image.[40] In this case, however, it seems Anděl used it as shorthand for a longer, more complex process too involved to sum up in a few lines. In recalling his process, Schneider guesses that he must have begun with a damaged Rössler negative, which meant that he had to produce his own negative from an interpositive (that is, an intermediary print) made from the original negative (Fig. 15). The negative indicates that Schneider cropped the print on three sides. As Anděl recalls, this was likely because an extant print that he had in mind showed this specific cropping. Schneider also etched the base of his negative where there was emulsion loss, so that when printed he could then retouch the final print by spotting it with a very fine brush, removing signs of age and wear. These gestures represent the types of editorial decisions implied by Anděl's use of the word "interpretations" to describe the prints. Instead of replicating losses and damage, Anděl elected to correct them, as a means of erasing time's effect on the photograph. He thus aimed to exclude exactly the signs of wear that would appear on a vintage version of *Still Life with Loudspeaker*.

In his print, Schneider managed to evoke the look of Rössler's pigment prints while also translating the artist's investment in the materiality of the image and his interest in pictorial illusionism. He described the steps of making the print as involving a "building in" of information, a layered, controlled process that involved carefully regulating the necessary levels of light and dark, diffuseness and detail. Instead of working from a blueprint, however, Schneider relied upon Anděl's research, his own knowledge of Rössler, and his printing know-how to work backward from Anděl's description of the end product.[41] To achieve the diffuse look and rich tonalities that his collaborator sought, Schneider elected to make two masks, one for contrast and one for shadow (Figs. 16, 17).[42] Masking allowed him to control the printing of light and dark through selective exposure. The advantage of the contrast mask was that Schneider could also use a higher contrast paper—in this case, the single graded paper Luminos Charcoal R—to create richer and more complex highlights and midtones. With this combination of materials, he was able to render the deep shadows that define the edges of the speaker and the cut paper while maintaining the softened surfaces resulting from Rössler's slightly out-of-focus lens.

Schneider began this process by punching holes in the film to correctly register the masks with the negative. He made the contrast mask by placing Kodak Pan masking film, emulsion face down, in the contact printer, followed by grainless diffusion paper, which he placed on top of the film, and finally the negative, with the emulsion facing upward. As Schneider explains, this sandwiching process separated the emulsions, thus ensuring that the mask would print out of focus and that no film grains would be visible. (He wanted to focus the grain of the negative instead.) In addition to controlling the contrast of the negative, the high contrast paper and mask helped create complex tonalities characteristic of many Rössler prints. For the shadow mask, Schneider used a contact printing process, placing the negative in registration, its emulsion back-to-back with the emulsion of a direct positive film called LPD4. With this direct positive, high contrast film, Schneider was able to render maximum detail in the shadows.

When it came time to print the photograph, Schneider again used a sandwiching process, exposing the paper twice (once for each mask). First, he placed the contrast mask and negative in pin registration in the enlarger to print the highlights and midtones in a rich range of grays, keeping the shadows open and muddy. Next, he placed the negative plus the shadow mask in the enlarger, then exposed the paper again, this time to print detailed and rich shadows. Once the exposures were complete, Schneider used a bleach redevelopment solution that he had devised to split tone the print, thus giving it a rich, layered tonality, with cool shadows and warm highlights that came through on the warm paper.[43] Finally, he finished the print with selenium toner to facilitate its stability and longevity, a principal goal of the project.

All of the prints created for *Reconstructing the Original* involved a similar process of research, experimentation, and development of steps necessary to build information into each print, which consumed many hours in the darkroom. Throughout this undertaking, Schneider drew upon his arsenal of knowledge regarding the techniques and materials of silver photography. In many instances, he looked to methods he had used in previous ventures. This tactic allowed for the successful printing of Wiškovský's *Insulator II*, produced from a negative lent by the artist's estate (see Fig. 11). Anděl specified that the print should have a glossy surface, but he also liked the warm tonality of Agfa's Portriga Rapid paper, which lacked the desired sheen. Eventually, Schneider came up with the solution of steaming the print with an industrial steamer, a method he recalls having learned from Todd Watts, who printed for Berenice Abbott. Erdman procured a steamer, and Schneider used the tool in the last stage of printing, warming the gelatin to achieve a glossy appearance. Funke's *Untitled (Spiral)* also called for a shinier surface (see Fig. 8). Anděl specifically requested that this photograph be printed on Kodak Elite, a very thick, sturdy

paper. Schneider originally planned to ferrotype the print using large metal plates, which the lab ordered from Germany at the cost of $1,500 (roughly the equivalent of $2,500 today).[44] When the plates failed to arrive in time, Schneider instead repeated the steamer method. As he learned when the plates did finally come, the equipment would have made the process much easier, since no heat was involved. This kind of innovation and trial and error were characteristic of Schneider's working methods.

In other cases, Schneider pulled from his knowledge of the artist's work to make printing decisions. He struggled with a work by Funke whose orientation Anděl had been unable to verify in his research for the portfolio (see Fig. 6). Relying on his familiarity with Funke's work, which he had come to know well in the course of printing this project, Schneider eventually elected to print the image with one section of cardboard oriented like a set of stairs at the right, with another section cutting diagonally across the left side of the image. Months later, when a vintage print surfaced at auction, Schneider was relieved to see that the orientation of that print matched the one in the portfolio. Anděl, too, remembers feeling a sense of "astonishment" when vintage prints of the works in the portfolio surfaced, pleased by "how much we had been able to capture the spirit of the image embodied by one or more vintage prints."[45] His statement reflects his conception of the synthetic original, the print that embodied an overall sense of the photographer's styles and methods.

The Czech portfolio represents a special case in Schneider's practice, in that it involved the production of a very specific type of object: a historical original to be modeled and reenacted in contemporary prints. At the same time, Schneider's approach to this idiosyncratic project mirrored the way he tackled other printing ventures, whether working with living artists or making prints for reproduction.[46] While Anděl's research and verbal instructions drove the portfolio's production, it was Schneider's printing that activated and materialized Anděl's knowledge in the form of photographic prints. This work, as is evident from the processes he applied to print Rössler's work, involved a great deal of technical prowess, but also something else less tangible and more intuitive, something intertwined with his immersion in the materiality of the printing process. In other words, as Ansel Adams wrote when describing printing, this work involved both "mechanical execution and creative activity," or the combination of technical skill and imaginative labor.[47]

This combination of the technical and the creative, activated in process and expressed through the body, amounts to what philosopher Michael Polanyi called "tacit knowledge."[48] In his 1966 work dedicated to the production of scientific knowledge, Polanyi explored the ways in which technical skills involve "knowing both intellectual and practical." In the book, he extended his discussion to other types of practical, technical knowledge, including the skills of artisans. As Polanyi explains, in activities that require tacit knowledge, the mind and the body work together to perform tasks. Tacit knowledge also has a specific temporal texture, as it accrues over time and through repetition of specific gestures or movements, which the practitioner internalizes so that they become virtually second nature. Moreover, tacit knowledge is difficult to articulate, because it involves verbalizing "know-how" that exceeds the intellectual dimension. Because tacit knowledge is so resistant to articulation, in many cases practitioners resort to the language of emotion and intuition to describe their processes, as Schneider did when recounting his work with Funke's photograph. Similarly, when interviewed about his work with photographers such as Mary Ellen Mark and Danny Lyon, printer Chuck Kelton noted that "interpreting someone's image into gelatin silver prints is about listening and interpreting through the use of materials to the finished print.... Not only am I hearing what people are saying, I'm feeling what people are saying."[49] Kelton's words, too, resonate with Schneider's idea of locating the intention of his clients, discussed elsewhere in this volume. For both of these printers, collaborative work involved more than choosing papers, deploying darkroom techniques, and mixing chemicals. There is another, more subterranean layer to printing that involves an intuitive, embodied enactment of the client's desires and goals, an ability to print what another envisions. Understanding the printer's practice as knowledge—more than feeling, and more than even creativity—rightly captures the practitioner's contribution to making works of art and to shaping their meaning.

Polanyi's concept of tacit knowledge also calls attention to the crucial role of the practitioner's body. For Schneider, printing constitutes an embodiment, or enactment, of an artist's ideas as much as it involves an intellectual mastery of techniques and darkroom chemistry. Printing, after all, requires substantial physical work: bending over darkroom trays, mixing chemicals, leaning over to closely scrutinize prints, working with tools like an industrial steamer. Schneider's recollections of his time in the lab, with his back often giving out from constant bending over trays and his eyesight weakened by so many hours in the dark, indicate that the physical dimensions of his work are etched into his memories and experience of printing. There is also the back-and-forth involved in working with clients—the visits to the lab, countless proofing sessions and conversations—which takes on the quality of a dance, as Ruth Fine described it in her book on the print studio Gemini G.E.L.[50] This is precisely why Adams's metaphor of printing as performance has always resonated so deeply with Schneider, whose career as a printer has been defined by the performative recital of the negative in the darkroom.[51]

Reconstructions made from available evidence, the Czech prints were realized through a process of

Fig. 15 (and essay frontispiece)
Negative from an interpositive made
from the original negative of Jaroslav
Rössler's *Still Life with Loudspeaker*,
1994. 25.4 × 20.3 cm (10 × 8 in.). Center
for the Technical Study of Modern Art,
Harvard Art Museums, Promised gift of
John Erdman and Gary Schneider.

Fig. 16
Shadow mask for Jaroslav Rössler's
Still Life with Loudspeaker, 1994. 25.4 ×
20.3 cm (10 × 8 in.). Center for the
Technical Study of Modern Art, Harvard
Art Museums, Promised gift of John
Erdman and Gary Schneider.

Fig. 17
Contrast mask for Jaroslav Rössler's
Still Life with Loudspeaker, 1994. 25.4 ×
20.3 cm (10 × 8 in.). Center for the
Technical Study of Modern Art, Harvard
Art Museums, Promised gift of John
Erdman and Gary Schneider.

reenactment staged in and through the body. Working with the photographers' historical negatives, Schneider attempted to reproduce their own performances of their prints, seeking a correlation between their darkroom choreography and his. In the case of this project, Schneider's deployment of tacit knowledge took on a historical dimension, as it required using that knowledge to reconstruct works from the 1920s and '30s. Interpreted in contemporary materials, the prints recover a forgotten narrative of modernism and retell that story in the present. Moreover, the metaphor of printing as performance connects to the contemporary context of Schneider's involvement with avant-garde theater and his immersion in the performance art world via Erdman. With the centrality of performance in art practices of the 1980s and '90s (indeed, many artists in the printer's proof collection, such as David Wojnarowicz, did video and performance work), it is not surprising that Schneider cultivated a performative approach to printing photographs.

In making the Czech portfolio, Schneider acted as practitioner and historian, excavating a material history of each work in the darkroom. In the process, he reached across the temporal gap between that photographer's work and his own moment. Rössler's work especially harbored significant parallels to Schneider's personal methods of printing and his immersion in photography's materiality and processes.[52] Witkovsky writes that Rössler, while of his own moment, also recalled the earliest practitioners of photography, in that he fashioned his self-image as a "technician of light."[53] Rössler was a studio practitioner, an artist who delighted in the "alchemical satisfaction" of photography—a joy that Schneider, too, experienced in his practice as a printer. By weaving the material history of the photograph into his printing, Schneider made a reconstruction that also constituted a reenactment, and a re-presentation, of Rössler's work in the present.

"ENORMOUS COLLECTION OF FORMS": RECONSIDERING THE ORIGINAL AND THE COPY

As is common when a technology wanes, today there is nostalgia for the darkroom and a tendency to elevate its "magic" as compared with digital methods. This essay makes a case for the importance of understanding the nature and meaning of printing photographs in the darkroom; however, it does so not to romanticize the darkroom, but rather to point toward a material history of the photographic print that is richly revealing with regard to questions of multiplicity, intent, temporality, and, ultimately, the meanings of photographs. In addition to allowing for more technically and materially precise discussions about photographs, studying this history opens

up fresh ways of thinking about the greater context of photography and about key terms that have defined how we think about, write about, and perceive the medium.

The Czech portfolio invites a reconsideration of the photographic original and copy as those terms, always relevant throughout photography's history, circulated on the market and in critical theory in the 1980s and '90s. The original could be misunderstood within the market context, as Anděl noted, and in theory can come across as one-dimensional. But in the Czech portfolio and in Schneider's practice more generally, the original is not so easily definable, nor is the reproduction so straightforward. Like Crimp, Anděl and Schneider understood the degree to which the original is dynamic, fluid, and even inaccessible. Copies, framed in the portfolio as reconstructions of images, are likewise material objects, each inflected by the physicality and environmental vagaries of the darkroom. Through excavating material histories of the photographs and reenacting the process of making them in the present, Anděl and Schneider acknowledged that behind any conception of the photograph there lies a "plurality of copies," a host of proofs, versions, and even of ideas that go into the making of any given image.

Throughout the 1980s and '90s, photography and its capacity to produce copies took center stage in theories of postmodernism. Because of its importance in generating the masses of images increasingly available in an expanding consumer culture, photography seemed to embody what theorists took to be the postmodern condition. Jean Baudrillard, for example, wrote that the world now seemed defined by simulacra, or copies of copies, merely signs behind which there was no original or authentic object.[54] In his writing on the Pictures Generation, Crimp looked to theorists such as Baudrillard to elucidate photography's role in the work of this new crop of artists. Yet as early as 1859, writers such as Oliver Wendell Holmes already grasped the role that photography would play in shifting our conception and organization of reality. In "The Age of Photography," Holmes wrote:

There is only one Colosseum or Pantheon; but how many millions of potential negatives have they shed— representatives of billions of pictures—since they were erected! Matter in large masses must always be fixed and dear; form is cheap and transportable. We have got the fruit of creation now, and need not trouble ourselves with the core. Every conceivable object of Nature and Art will soon scale off its surface for us. Men will hunt all curious, beautiful, grand objects, as they hunt the cattle in South America, for their *skins*, and leave the carcasses as of little worth. The consequence of this will soon be such an enormous collection of forms that they will have to be classified and arranged in vast libraries, as books are now.[55]

The "enormous collection of forms" available to us via photography, which Holmes pinpointed a century before the emergence of postmodern theory, is even more vast today thanks to the proliferation of digital technology. Yet these reproductions, or "skins," as Holmes called them, still have some material residues, some connection to bodily experience.[56] Schneider's printing work likewise acknowledges this physicality from the point of view of practice: that is, the way in which the making of photographs in the darkroom resides in the corporeal realm of tacit knowledge. If photographs are akin to "skins" of objects, then the printing of photographs, as Schneider practiced it, might be said to imbue each photograph with vestiges of the printer's body—the movements and motions involved in the making of each print. In an era preoccupied with the immateriality of images, Schneider's printing practice testifies to the fact that every picture has its origins in the material world.

1

The term is sometimes translated as "servant." See Charles Baudelaire, "Salon of 1859," reprinted in Vicki Goldberg, *Photography in Print: Writings from 1816 to the Present* (New York: Simon and Schuster, 1981), 125.

2

Throughout this essay, I use the terms "multiple," "reproduction," and "copy," all of which are related but have different connotations. "Multiple" is a broad term that applies to the results of any reproducible media. It can describe a sculpture, a print, or a photograph—any object of which more than one is made (a set of multiples is usually referred to as an edition). "Reproduction" is also a general term that refers to a duplicate, copy, or representation. Generally, though not always, it has a more mechanistic connotation. In Schneider's practice, the term usually denotes prints made for media sources, such as *LIFE Magazine*. A "copy," which can act as a synonym for a reproduction, often has the more negative connotation of something slavishly produced. In photographic printing, the term "copy print" is used when a printer photographs an extant print to produce a negative, which is then used to make a new print. See the glossary for more on this term as well as the corresponding term "copy negative." The concept of the copy, in the context of this essay, is also especially relevant in the critical practices of art associated with postmodernism.

3

Erdman noted where each of the portfolios ended up in the lab's records notebook, now part of the Records of Schneider/Erdman, Inc., in the Harvard Art Museums Archives. For example, edition 1/9 was given to the Moravska Gallery, which represented Wiškovský. Edition 2/9 was sold to the Institut Valencià d'Art Modern in Valencia, Spain. The James Danziger Gallery took 3/9, with the intention of donating it to the Museum of Modern Art, New York. Erdman's more detailed notes on the Danziger Gallery sale indicate that the price for the portfolio was $5,000 and that sales could be made only to public institutions. Anděl took 4/9 through 7/9 to give to the photographers' estates. Schneider and Erdman took editions 8/9 and 9/9, and gallerist Deborah Bell eventually sold edition 8. The artist's proofs (AP) portfolios were divided as such: each print in AP 1 went to the respective artist's estate, Anděl took AP 2, and Schneider and Erdman took AP 3. It is AP 3 that is now in Harvard's printer's proof collection.

4

"The Clash between Vintage, Later, Posthumous, and Aesthetics," *The Photograph Collector Newsletter* 15 (October 15, 1994): n.p. There is a copy of this article in the Records of Schneider/Erdman, Inc., in the Harvard Art Museums Archives.

5

See Vladimír Birgus, "From Pictorialism to Avant-Garde," in *Czech Photographic Avant-Garde, 1918–1948* (Cambridge, Mass.: MIT Press, 2002), 35–41; and Jaroslav Anděl, "Modernism, the Avant-Garde, and Photography," in *Czech Modernism, 1900–1945*, ed. Jaroslav Anděl et al. (Houston: Museum of Fine Arts, 1989), 87–112.

6

The Cooper Hewitt, Smithsonian Design Museum, in Washington, D.C., has an excellent collection of Czech book and journal covers. See Stephen H. Van Dyk, "Czech Book Covers of the 1920s and 1930s," 2004, http://www.sil.si.edu/ondisplay/czechbooks/intro.htm.

7

The work of Hackenschmied, later known as Alexander Hammid, is also in the printer's proof collection. In fact, when Schneider made prints for Hammid, he drew upon his work with this project and his knowledge of other Czech modernist photographers from his own collecting. See Davida Fernandez-Barkan's case study on Hammid in the accompanying online resource, available at http://www.harvardartmuseums.org/collections/special-collections.

8

See the glossary for an explanation of this technique.

9

Critic Sadakichi Hartmann popularized the term in his article "A Plea for Straight Photography," originally published in *American Amateur Photographer* 16 (March 1904): 101–9; reprinted in *Photography: Essays and Images*, ed. Beaumont Newhall (New York: Museum of Modern Art, 1980), 186.

10

Vladimír Birgus, "Rössler's Art Photography, 1919–35," in *Jaroslav Rössler: Czech Avant-Garde Photographer*, ed. Vladimír Birgus and Jan Mlčoch (Cambridge, Mass.: MIT Press, 2004), 7.

11

Jaroslav Anděl, ed., *Reconstructing the Original: Czech Abstractions 1922–1935* (New York: AV Editions, 1994), n.p.

12

Anděl, "Modernism, the Avant-Garde, and Photography," 87.

13

David Lazar, "The Other Side of the Century," *Aperture* 117 (Winter 1990): 82–83.

14

In her interview included in this book, Deborah Bell notes that Rudolf Kicken traveled to Czechoslovakia and brought back work for his gallery.

15

Matthew S. Witkovsky, "Experiment in Progress," in Birgus and Mlčoch, *Jaroslav Rössler*, 40–45.

16

Ibid., 45.

17

For more, see Weston Naef, ed., *André Kertész: Photographs from the J. Paul Getty Museum* (Malibu, Calif.: J. Paul Getty Museum, 1994).

18

"The Clash between Vintage, Later, Posthumous, and Aesthetics," *The Photograph Collector Newsletter* 15 (October 15, 1994): n.p. There is a copy of this article in the Records of Schneider/Erdman, Inc., in the Harvard Art Museums Archives.

19

See Bell's interview in this book.

20

Margarett Loke, "Photography Review; Vintage Prints Superior, Eh? Not Always," *The New York Times*, October 9, 1998.

21

For a summary of the Hine controversy, see Richard B. Woodward, "Too Much of a Good Thing," *The Atlantic*, June 2003, https://www.theatlantic.com/magazine/archive/2003/06/too-much-of-a-good-thing/302751 (accessed May 29, 2017).

22

Jaroslav Anděl, email to the author, May 28, 2017.

23

This is not an act unique to these Czech photographers, but a common practice for many practitioners, and something that should be taken into account when considering the notion of original or vintage prints.

24

Jaroslav Anděl, *The Avant-Garde Book, 1900–1945* (New York: Franklin Furnace, 1989).

25

While the lab did not want for customers, making ends meet financially proved to be more difficult because of the long and often expensive projects that they printed. Schneider took on many of these projects, but they did have to hire (and budget for) assistants.

26

Lorna Simpson, phone conversation with the author, January 27, 2017.

27

Schneider printed the work in two sizes, 14 × 11 inches and 16 × 20 inches, each in an edition of 20.

28

There is a copy of this card in the Records of Schneider/Erdman, Inc., in the Harvard Art Museums Archives.

29

Nancy Foote, "The Anti-Photographers," originally published in *Artforum* 15 (September 1976): 46–54; reprinted in *The Last Picture Show: Artists Using Photography, 1960–1982*, ed. Douglas Fogle (Minneapolis: Walker Art Center, 2003), 24.

30

Ibid., 24.

31

For more on Duchamp, the readymade, and retinal art, see Calvin Tomkins, *Duchamp: A Biography* (New York: H. Holt, 1996). For Duchamp's impact on conceptual art, see Benjamin H.D. Buchloh, "Conceptual Art 1962–1969: From the Aesthetics of Administration to the Critique of Institutions," *October* 55 (Winter 1990): 105–43; Jeff Wall, "'Marks of Indifference': Aspects of Photography in, or as, Conceptual Art," in Fogle, *The Last Picture Show*, 32–44; Helen Molesworth, "Work Avoidance: The Everyday Life of Marcel Duchamp's Readymades," *Art Journal* 57 (Winter 1998): 50–61; and John Roberts, *The Intangibilities of Form: Skill and Deskilling in Art after the Readymade* (London: Verso, 2007).

32

Douglas Crimp, *Pictures: An Exhibition of the Work of Troy Brauntuch, Jack Goldstein, Sherrie Levine, Robert Longo, Philip Smith* (New York: Committee for the Visual Arts, 1977). For a good historical overview of Pictures artists and their influence, see Douglas Eklund, *The Pictures Generation: 1974–84* (New York: Metropolitan Museum of Art, 2009).

33

In an essay reflecting on the *Pictures* exhibition, Crimp discusses the vintage print, as well as the limited edition, as part of what he called "the recuperation of the aura," or the attempt to re-impart photography with a sense of subjectivity and authenticity that had been depleted by the onset of mass mechanical reproduction. See Crimp, "The Photographic Activity of Postmodernism," *October* 15 (Winter 1980): 91–101.

34

Levine, quoted in ibid.

35

Ibid.

36

Wall, "Marks of Indifference," 44.

37

The following analysis of Schneider's process is based on several conversations that Schneider and the author had between October 2015 and May 2017.

38

The following information is derived from many conversations that the author had with Schneider about the portfolio throughout Fall 2016 and Spring 2017.

39

Jaroslav Anděl, email to the author, May 30, 2017.

40

See the page "INSK: Internegative, Silent, Color" in the Preservation section of the National Archives website, https://www.archives.gov/preservation/products/definitions/insk.html (accessed May 13, 2017).

41

Schneider and Erdman began to collect modernist photography in the 1980s.

42

More information on the technical terms used here can be found in the glossary.

43

For more on bleach redevelopment, see the glossary in this volume.

44

One of these plates, still unused, is now part of the Harvard Art Museums' Center for the Technical Study of Modern Art.

45

Jaroslav Anděl, email to the author, May 28, 2017.

46

This aspect of Schneider's work is beyond the scope of this essay. Printing for reproduction was an important part of the lab's operations. As when printing for artists, Schneider considered the function of the print when making prints for reproduction, aware that they would be consumed by viewers flipping through magazines. This type of printing requires a different way of thinking about how and by what means prints communicate. Many photographers became increasingly aware of this as they worked for mass printed publications. Irving Penn, for example, noted that for the modern photographer, the end product is the printed page, not the photographic print: "The modern photographer is very conscious of the time element in the viewing of his work. He knows that his communication must be made quickly. He knows that his picture may as often be seen hurriedly in a dentist's waiting room as in a soft chair after dinner. In consideration of this time element, the modern photographer has learned the economy of means of a graphic artist. He has digested this economy and made it almost an instinctive part of his craft." Irving Penn, speech as part of the "What Is Modern Photography?" symposium at the Museum of Modern Art, New York, October 20, 1950; quoted in the Art Institute of Chicago's Irving Penn Archives, http://www.artic.edu/aic/collections/exhibitions/IrvingPennArchives/still-lifes.

47

Ansel Adams, *The Print* (New York: Little, Brown and Company, 1983), 1.

48

Michael Polanyi, *The Tacit Dimension* (Chicago: University of Chicago Press, 1966), 1–30.

49

As quoted in Rena Silverman, "Hearing and Feeling What Photographers Are Saying," *The New York Times*, March 25, 2015.

50

Ruth Fine, *Gemini G.E.L.: Art and Collaboration* (Washington, D.C.: National Gallery of Art; New York: Abbeville Press, 1984), 21.

51

Adams, *The Print*, 2. See also Ansel Adams, *The Negative* (New York: Little, Brown and Company, 1981).

52

Indeed, it was Schneider himself who suggested Rössler as a fitting case study to explain the project's technical dimensions.

53

Witkovsky, "Experiment in Progress," 44.

54

Jean Baudrillard, "Simulacra and Simulations," in *Jean Baudrillard: Selected Writings*, ed. Mark Poster (Stanford, Calif.: Stanford University Press, 1988), 166–84.

55

Oliver Wendell Holmes, "The Age of Photography," *The Atlantic* (June 1859): 738–48.

56

This is true even with digital technology, as Schneider attests in his discussion of printing for Peter Hujar. For a discussion of the materiality of digital images, see Julia Breitbach, "The Photo-as-Thing: Photography and Thing Theory," *European Journal of English Studies* 15 (March 2011): 31–43.

III

ORAL HISTORIES

PRINTING PETER HUJAR

GARY SCHNEIDER AND JOHN ERDMAN

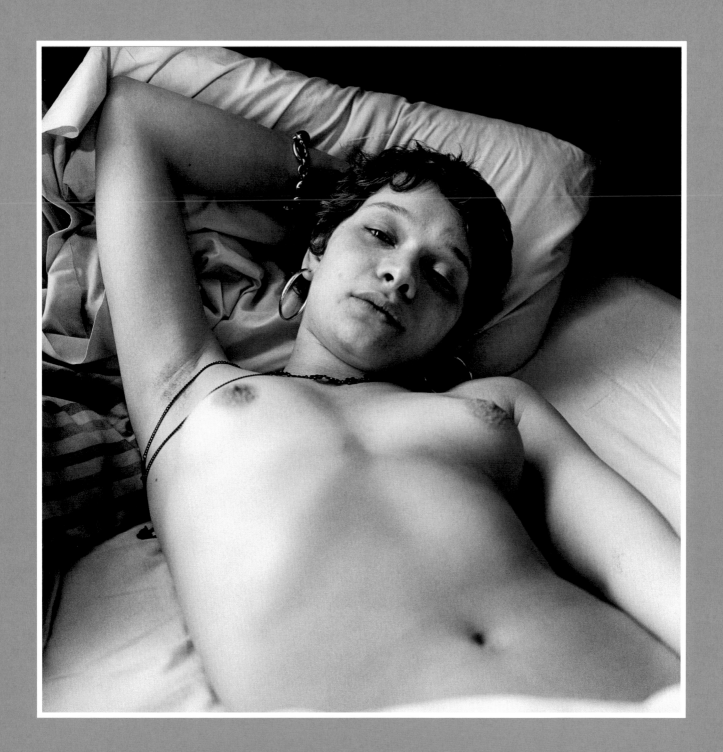

Peter Hujar was a major influence on our lives. John first met him in 1969, and I immediately bonded with him when I later met him through John in 1977. Peter sometimes used us as subjects to explore new portrait ideas, and I was often his location assistant. He got me a job at a photo lab; soon after that, I started processing his film. It was Peter who pushed us to open our own photo lab. It was also Peter who insisted that we keep expanding the lab—a big mistake, since none of us were businessmen.

Peter was very proud of his own printing. He didn't match prints of the same image, but each had to function, and the story of the image had to be told in each print. He often said that scholars would later study the variations in his prints to trace his visual thinking process. This way of performing an image is what I learned from Peter. I believe this is what made me sought after as a printer.

When I was printing in the darkroom, each print was affected by subtle changes in the enlarger lamp, changes in the developer, and fluctuations in chemistry temperature. The challenge was that each print had to retain a unique tonal dynamism. I bring this now to pigmented ink printing. I *need* the adventure of rediscovering the image, proofing it in each session to arrive at the finished print. If there is a long delay between sessions, inks, papers, and printers shift over time, and I may have to make extreme adjustments. Peter inspired the conversation I had with each potential client: when I print out editions, I told them, each print will be unique, but they will all function. There were a few instances in which the artist insisted that each print in the edition match. For these clients, I had to work differently. In the work I did for Richard Avedon, for example, it is very difficult to tell the difference between the final proof and my edition prints.

When we were helping Peter select prints for a show, or choosing one for our personal collection (the exchange for processing his film), the discussion always revolved around how differently one print functioned from the next. It was my early experience of these conversations that allowed me to understand immediately Lisette Model's objectives when she described the prints she wanted me to make for her (see p. 45). When she first approached me, I was young and felt too inexperienced to take on the job. Peter got very excited and insisted that I work for her. He convinced me to view it as an opportunity to learn print narrative from the great master.

Peter died in 1987. In 2006, at the request of his estate, I attempted to make a silver print of his portrait of T.C. (Fig. 1). After more than a year of testing every available silver paper, I achieved some satisfactory results on Ilford Multigrade Warmtone, tea staining the paper to bring it closer to his color. The unfortunate aspect of this version is that it lacks the eccentric tonality of the prints Peter himself made on his favored—and now extinct— silver paper, Agfa Portriga Rapid. We did not produce an edition, and this test is now a study print in the Harvard Art Museums' Center for the Technical Study of Modern Art.

I kept experimenting, and by 2009 I was finally satisfied with my results and began co-publishing editions with the Hujar estate. The portrait of *Will* was among the first images that I completed. I used a digital file scanned from Peter's negative, printing it in pigmented ink on Harman Gloss Baryta. When John saw the print, he was so impressed with the results that he finally agreed to close up the darkroom.

I had made a lifetime print of *Will* in 1987 (see Fig. 2 for the inscription on the back of this print and p. 43 for the image). Though I had been processing his film since 1979, it was not until after he was diagnosed with AIDS in 1987 and stopped going into the darkroom, nervous about exposure to the chemicals, that he would call me when he needed a print made. Peter did not normally produce editions of his work; this 1987 printing of *Will*, intended as gifts for the doctors who were treating him without asking for payment, was an exception. Since so many prints were to be made at the same time, we came up with a guide print that reflected all of his ideas about the image. When I presented the final prints to Peter, we both agreed that they were successful. It bothered him nonetheless to see a full edition of one of his images printed out, but he was too ill for it to be done any other way.

Since 2009, when I print Peter's work I don't print out the editions. This is advantageous, as more and more examples of his prints come out of the woodwork. I study all the prints that I have access to, further learning his intentions for each image. My research is complicated by the dramatic differences between versions of the same image made at various stages of his life. I study reproductions of his work as well, no matter the quality, because the relative relationships of tones expose Peter's thinking. My 2009 ink print of *Will* is distinct from the 1987 silver print I did in collaboration with Peter. In the almost twenty years between those two printings, and again in the seven years between my 2009 print and one I made in 2016, I studied different versions of *Will*, and the range in his prints informed me of his different interpretations of the image.

Another consideration when printing is how the museum, gallery, or collector might be lighting the work. Peter saw his prints only in daylight and/or under incandescent lamps. I now also have to keep in mind when printing that they may be viewed under halogen, LED, or sometimes fluorescent lights.

Even before his diagnosis, Peter knew it was likely that he would eventually develop a physical resistance to darkroom chemistry. Twenty years my senior, he was grooming me to print his work. It was wonderful to anticipate that as we grew older he would pass his printing on to me. Of course, this was not meant to be; Peter had just

turned 53 when he died. My 33rd birthday was the day before his death. It moves me to realize that I am now 10 years older than he was when I last saw him.

In his last year, when I began printing for Peter, he would walk the eight blocks from his loft on Second Avenue and 12th Street to our place on Cooper Square. As his health failed, we'd meet around his blue kitchen table instead. One day, when he was too ill to get out of bed, he sent me into his darkroom to get a negative. I entered and saw his 16 × 20 inch trays still in the sink, their contents dried into a layer of crystals. There was no smell of chemistry. I became frozen in place, over-whelmed by the sight, until his screams for me to get out of there brought me back to reality. I had often been in his darkroom with him, but in that moment we both realized that we would never return there together again.

Fig. 1
Peter Hujar, *T.C.*, 1975. Gelatin silver print, 50.8 × 40.6 cm (20 × 16 in.). The Peter Hujar Archive.

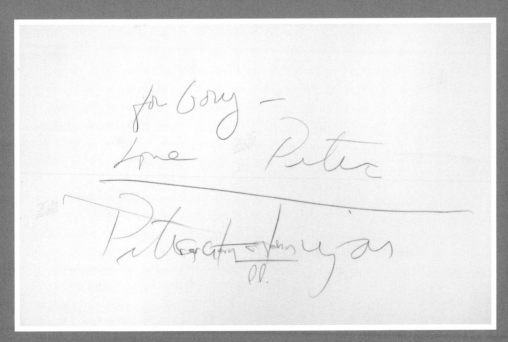

Fig. 2
Peter Hujar, *Will* (verso), 1987. Gelatin silver print, 50.8 × 40.6 cm (20 × 16 in.). Harvard Art Museums/Fogg Museum, Schneider/Erdman Printer's Proof Collection, partial gift, and partial purchase through the Margaret Fisher Fund, 2016.176. Above the artist's signature, the inscription reads "For Gary—Love Peter." The note "For Gary & John P.P." is in Gary Schneider's hand. This is the printer's proof selected by Schneider and Erdman.

PRINTING DAVID WOJNAROWICZ'S *SEX SERIES*

GARY SCHNEIDER AND JOHN ERDMAN

John and I first became aware of David Wojnarowicz in 1980, when we went with Jim Fouratt to a reading that David was doing at the Abbey Theater in the East Village, a few blocks from where we lived. Jim and David worked together at the nightclub Danceteria. We were overwhelmed by David's texts and by his performance. A year or so later, Peter Hujar took us to see David's punk rock band, 3 Teens Kill 4; during the show, David made stenciled wall drawings in the background. He and Peter had grown very close, and through Peter we became friendly with David ourselves. I began processing film for him in 1984.

David was Peter's most constant nurse in his last few months, and we were all relieved that he was able to keep Peter's loft after he died in 1987. Within days of Peter's death, David walked into the lab to give us a portrait he had made of Peter, printed in Peter's darkroom on Peter's paper. With the exception of his *Rimbaud* series, it was only after David inherited the loft and its darkroom that he started making standalone photographs.[1] Peter's darkroom was set up with 16 × 20 inch trays. John and I remember that the original *Sex Series* had some handling issues as a result of David needing to maneuver the 20 × 24 inch prints in the smaller trays. Those eight unique black and white montages were remarkable and of course sold immediately when he exhibited them at PPOW Gallery in his 1989 show *In the Shadow of Forward Motion*.

One day, we were having lunch at the lab, ordered in from Zen Palate, something we often did when David picked up or dropped off work. His show was closing soon, the *Sex Series* had been sold, and David was distraught that he was losing work that meant so much to him. I said: "Give me two of your prints and let's see what I can produce. We could change the size and make an edition, separate from the unique set." I re-photographed the montages to see if I could make copy prints, and to David's excitement and relief, it worked. We co-published with PPOW ten editions of the eight images plus four proof sets at 16 × 20 inches. In June 1989, we wrote up a contract: David would receive two artist's proofs, the gallery would receive one, and Schneider/Erdman would receive a printer's proof set (see pp. 49–56). David insisted that we equally split the proceeds from the sale of the ten editions in three ways.

By the time I attempted the copy work on the *Sex Series*, I was quite confident that I could succeed at such a task. I had a Toyo-G 8 × 10 inch studio camera specifically for that purpose. To remake the images, I printed on Ilford Multigrade and sandwiched the negatives with contrast masks, which gave me more control over the tonalities and resolution. (See Fig. 1 for a detail of the print log.)

My working method as a printer is simple but deliberate. It takes me a while to fully understand the story of any image and to begin the journey to reveal it in

Fig. 1
John Erdman's notes on printing David Wojnarowicz's *Untitled (Sex Series)*, 1990–91. Records of Schneider/Erdman, Inc., Harvard Art Museums Archives, ARCH.2017.4.12.

the print. I make a proof and study it over many days in various lights, making lots of corrections before the artist sees it. At each stage, John and I discuss how the image reads. We sometimes have differing perspectives, so I have learned to use his interpretations as a counterpoint to my own. I have a fear of failure, an insecurity that might explain why I became a printer. In the darkroom, I can spend as much time as I need to arrive at the final print. No one ever needs to know how many proofs it took to get there; I will present it only when I am certain I can no longer improve upon it.

David was open to the printing philosophy that I had inherited from Peter: that no two prints of the same image needed to match, but each print needed to function. David insisted that I not use his unique *Sex Series* prints as guides. Determining how to render the images became my problem to solve. Because of the reduction in scale, I needed to adjust how the icons would advance or recede in relation to the ground and other icons. I achieved this by adjusting the contrast and resolution and density. In many of the photographs, there were passages of text that needed to be resolved differently in the new size in order to be readable. At the same time, it was essential to maintain David's carefully constructed montages in order to tell his very specific stories. A set of prints were completed in time to be shown in *Witnesses: Against Our Vanishing*, organized by Nan Goldin at Artists Space that November.

Until publishing the *Sex Series*, we received art rather than money in exchange for our work with David—an arrangement we'd also had with Peter. When we first began processing David's film, John and I expected to receive a drawing or possibly a small painting as payment, but David walked into the lab one day with a large painting on an old pull-down school map. Peter later told us that he had convinced David to give us this work, since it was one of a very fragile series, and we were the people most likely to conserve it so that at least one would survive.

Over the years, we became close to David and his partner, Tom Rauffenbart, sharing meals and travels. In 1989, David introduced me to his gallery, PPOW, and I started showing my own work again. David was a realist. In the depths of his illness, he understood that the lab might not continue, that we might need money and have to sell his work. His only request was that we wait until after he died. It was very moving that he was so considerate to give us permission at that moment. It is meaningful to us that we were able to keep together our collection of his photographs, now protected as part of the archive and study collection at the Harvard Art Museums.

1
There are two photographs from the *Rimbaud in New York* series in the printer's proof collection.

DEBORAH BELL

Deborah Bell's professional career as an art dealer began at the Sander Gallery, New York, in 1984. In 2001, after 13 years as a private dealer, she opened her first public gallery at 511 West 25th Street in Chelsea, where she remained for 10 years. Bell closed the gallery to join Christie's New York, serving as head of the photographs department for two and a half years. In 2014, she reestablished Deborah Bell Photographs, and in April of the following year moved the gallery to its present location on Manhattan's Upper East Side.

In a telephone conversation on March 10, 2017, Jennifer Quick interviewed Bell about the changes she has witnessed in the field of photography, including its academization and evolving role in the art market, from the 1970s through today. Bell also reflected on her experiences working with Schneider/Erdman, Inc.—most notably, their collaborative process in printing the work of photographer Louis Faurer, whom she represented at the time. The following excerpts have been lightly edited for clarity and tone.

ON BELL'S BACKGROUND AND TRAINING IN PHOTOGRAPHY

Jennifer Quick: Would you start by briefly describing your early experiences with art, and photography specifically?

Deborah Bell: I feel very fortunate to have worked at the Walker Art Center in Minneapolis when I was a teenager. I started there when I was 17, a junior in high school, in a tour guide training program. I lived in a suburb of St. Paul, and I heard about the program through my position as entertainment editor for my high school newspaper. I used to call the museums and ask them for press releases and reproductions—in those days, you called them "8 × 10 glossies"—of anything that was in an exhibition that I could print in our school newspaper. The head of the Walker's publicity department gave my name to the head of the education department, who was training a group of high school students to give tours of the museum when the new building opened up. This was back in 1971. . . . I got to do that for six years, working in the bookstore as well and in other departments of the museum as a sort of assistant-at-large.

Meanwhile, I started going to the Minneapolis College of Art and Design. I got a B.F.A. there in 1976. The first year was a basic foundation program—a Bauhaus-style curriculum. The second year, I took photography. I had always loved photography and photographs, and I was aware of who many photographers were because I was constantly looking through the magazines at the drugstore across the street from my house; but once I took that photo class in my second year of school, I was hooked. I majored in photography and took all sorts of different photography classes—darkroom, studio, everything. In art school, I had a couple of teachers who are well-known in the field, Tom Arndt and Stuart Klipper. . . . They were great, great teachers.

After graduating, I stayed in Minneapolis for a year and worked for the largest commercial photographer in the city, Joseph Giannetti. But I wanted to move to New York. I moved here in 1978 and worked freelance, mainly for fashion photographers at the time—a day here or a day

there, a few days printing, helping in the studio, whatever needed doing. I also spotted photographs for Irving Penn for a few days. It was a wonderful experience, because he was very involved. When I was in art school, it was more of a Garry Winogrand–era of photography. In the '70s, there was this reaction in photography against perfection; instead, the emphasis was on shaking things up a little.

I got a full-time job printing for the photographer Arthur Vitols, who had taken over an old establishment called Helga Studio, which specialized in photographing artwork for auction catalogues and galleries. He had an account printing for the Museum of the City of New York. That was really fun for me, because I got to print from copy negatives (and sometimes originals) of great photographs in the collection. Some of them were by Berenice Abbott.

JQ: Once you decided you were interested in photography, what kind of training did you pursue? How would you describe your education in the field?

DB: I decided that I wanted to go back to get a master's degree in art history, in part because I wanted to study the subject, but also because I thought that I would pursue a curatorial position. I went to Hunter College, where they had a night program for an M.A. in art history. I had some great teachers there, too. There was one class that was taught by John Elderfield, the great curator who spent many years at the Museum of Modern Art. Hunter didn't offer any history of photography at the time—this was between 1981 and '84. I took three classes with Rosalind Krauss, who is fantastic in the classroom. She was a great teacher. Even though photography was not part of the curriculum, she talked about Degas's monotypes and showed some of his photographs, and I went wild for those. I ended up doing my master's thesis on his photographs.

When I was at Hunter, there was a notice on the bulletin board about an internship at Sander Gallery; six weeks after seeing the ad, I started working there on Saturdays. That was in 1984, when I was finishing my master's thesis at Hunter. After my internship at Sander Gallery, I quit my day job and worked there for a year. Then I received an offer to go to Marlborough Gallery to work in the prints and photographs department. I stayed at Marlborough for almost a year.

At Sander Gallery, we showed the work of Marcel Broodthaers, and his widow, Maria Gilissen Broodthaers, invited me to come to Brussels for a few weeks that summer. It was right when I was leaving Marlborough, in the summer of '86, so I went that summer and then in the summer of '87 for another two or three weeks to work with her on organizing all of Broodthaers's photographs. That meant spotting them, stamping them, and organizing them with Maria and her daughter, Marie-Puck. It was a fantastic opportunity.

My life as a dealer began with Louis Faurer. He was one of my favorite photographers, and the year after I moved to New York, a former classmate of mine, Jan Juracek, and a good friend of mine, Sid Kaplan, said: "He lives in New York. In fact, he lives in Westbeth [artists' housing]. Just call him up!" I called him, and that was the start of a long friendship. He was represented by Light Gallery when I met him in '79. In 1988, sometime in the fall, I committed to being his dealer. I was a private dealer from 1988 to 2001.

In November 2001, I opened my Chelsea gallery at 511 West 25th Street, between 10th and 11th Avenues. I had that gallery for just about 10 years. Toward the end of my lease, I made the switch to Christie's, where I was head of the photographs department for two and a half years, before leaving at the end of 2013. For most of 2014, I was again looking for gallery space. It took me about a year to find a space that I thought was right for me. I've been here at 16 East 71st Street, between Madison and Fifth Avenues, for two years now. One of my favorite galleries—and I know that it was one of Gary and John's favorites, too—used to be right across the street. It was called Prakapas Gallery. It was run by Dorothy and Eugene Prakapas, whose interest in modernist art shaped their program. It wasn't just photography—they specialized in international work from between World Wars I and II. They uncovered a lot of great Dutch modernism and were among the first dealers in the United States to show works by Lázsló Moholy-Nagy and György Kepes.

ON THE SHIFTING ROLE OF PHOTOGRAPHY IN THE ACADEMY, MUSEUM, AND MARKET IN THE 1960s, '70s, AND '80s

JQ: Over your career, how have you seen interest in photography change?

DB: The 1960s into the '70s and '80s are what I think of as the discovery period for photography. In art school, I was taught by photographers about other photographers, but there was no established program on the history of photography. Since there was no formal curriculum for the history of photography, when I moved to New York I went to all of the shows that I could possibly attend. I went to Light Gallery, to Witkin Gallery, to Marge Neikrug's and Daniel Wolf's galleries, and then—jumping ahead a little bit—to Pace/MacGill. When I started working for Gerd Sander, I was introduced to the whole German photo scene. Ann and Jürgen Wilde had the first photo gallery in Germany, which they opened in 1972 in Cologne. Then, in 1974, Rudolf Kicken and Wilhelm Schürmann started their photography gallery, Kicken-Schürmann, in Rudolf's parents' house in Aachen. They later moved to Cologne. Everybody was learning from each other. Rudolf was going

to the Czech Republic and getting material firsthand from photographers who were living, or from their estates. We're going through a generational shift now in our field: photography has become institutionalized, in the sense that just about every museum has a photography department and collection. Today, the history of photography is taught in most universities. But at that time, people were still learning about the history and making of photographs through personal connections and exploration. A lot of the seminal photographers were still alive in the '60s and '70s, so it was possible to know many of them.

I would go to auction previews, too, where you could see unframed prints. The auction market for photography was brand new. It all started in the late 1960s and '70s, which is when the literature on collecting photography began in earnest as well. I still use Lee Witkin and Barbara London's *The Photograph Collector's Guide*, which was published in 1979. The '70s were just so rich with discoveries and reintroducing photographers. Louis Faurer has said that when he came back to New York from Europe in '74, to his astonishment, the photographer had become an artist. All of these photographers were suddenly being sought after for their personal pictures. That was happening to people who are household names now—Robert Frank, Harry Callahan, Faurer. There were all of these different pockets or areas of interest in photography. In 1977 and '78, Marlborough Gallery was also showing photographers, including Richard Avedon and Irving Penn. It was an exciting period to be in New York.

ON WORKING WITH SCHNEIDER/ERDMAN, INC., AND PRINTING LOUIS FAURER

JQ: How did you come to know Gary Schneider and John Erdman?

DB: I had seen Gary and John at auction previews, museum events, and gallery openings. We were always friendly, but I didn't really talk to them until one day when we were at a preview of a photo sale at Swann Galleries. Gary expressed interest in printing Louis Faurer's work. I said that we had some pictures that we had been wanting to print, but that Louis didn't have the negatives anymore. Gary said that they were working on perfecting copy negatives and would be interested in trying to print Faurer's work that way. I found the best existing print of the bowing lady (Fig. 1). There is only one vintage print of it, and it is covered in airbrushing that has turned yellow. But we had another version, because Chuck Kelton had made one or two successful prints from the 35mm negative. Even with the original negative, it was such a hard print to make. It was difficult because of the background—the model was photographed in front of seamless paper in a studio in

Paris, and the seamless paper had been patchworked in certain parts, so there were lots of lines, making dodging and burning just a nightmare. The paper was white, so there were dark marks from the model's shoes, and the left side was lit much more brightly than the right. You could get one or two good prints, but God help anybody trying to get more than that to look alike.

Louis and I had done some retouching together on one of the good prints of *Bowing*; we took it to the famous photo retoucher Bob Bishop, and he did some airbrushing that got it so that we liked the way that it looked. Then Louis and I added graphite to emphasize the drapery. Gary and John made their copy negative from that print and then made that edition in 11 × 14 and 16 × 20. I worked on that picture with Gary in the darkroom. He also printed Faurer's *Family, Times Square* (Fig. 2).

ON THE CONCEPT OF THE PHOTOGRAPHIC PRINTER'S PROOF

JQ: Had you heard of printers retaining a printer's proof before working with Gary and John? How did you arrange that with Faurer?

DB: I hadn't heard of photographic printers doing it before, but it sounded perfectly normal to me, because I knew the practice existed in the world of printmaking—for example, with silkscreens and lithographs—where printer's proofs were really common. In fact, there was also the HC (the *hors commerce*, or "not for sale") and the BAT (the *bon à tirer*, or "okay to print"), so I was familiar with a variety of similar terms. I think that people who printed for Louis—like Chuck Kelton, when he was with 220 Print—were allowed to retain signed prints, but I don't know if they had the formal "PP" mark on the back. I think that Louis just signed the prints for them. I was certainly familiar with the concept. I thought it was a great thing to do, because it really tied together the whole edition. Until I started representing Louis, he hadn't editioned his prints, so I thought that one thing that we could do to introduce a system would be to number them. Also, with new prints I began to add the date on the verso—for example, "printed 1990." I didn't do this immediately on the first three or four or five prints that we sold. I liked the idea of Gary's prints being designated as "PP," because it made it clear that these were done by Gary at that particular time.

It was relevant, too, because Louis didn't print consistently anymore. He, like many other photographers of his generation, just made a print when he needed one. The whole idea of multiples—whether they had edition numbers or not—was a new thing for photographers. It was problematic in that a lot of times the editions were never completed, so the numbers actually become sort of irrelevant.

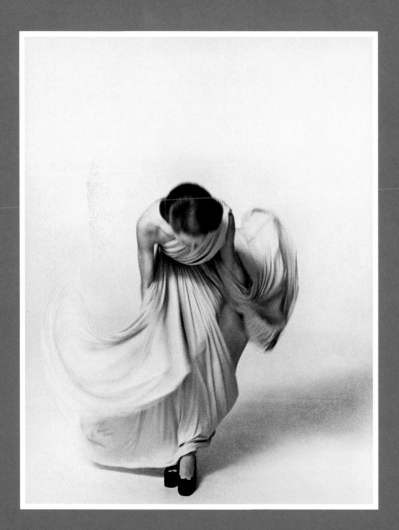

Fig. 1
Louis Faurer, *Bowing for VOGUE Collections, Paris, 1972*, 1972. Gelatin silver print, 50.2 × 40.5 cm (19¾ × 15¹⁵⁄₁₆ in.). Harvard Art Museums/Fogg Museum, Schneider/Erdman Printer's Proof Collection, partial gift, and partial purchase through the Margaret Fisher Fund, 2016.187.

Fig. 2
Louis Faurer, *Family, Times Square*, 1950. Gelatin silver print, 27.9 × 35.6 cm (11 × 14 in.). Harvard Art Museums/Fogg Museum, Schneider/Erdman Printer's Proof Collection, partial gift, and partial purchase through the Margaret Fisher Fund, 2011.185.

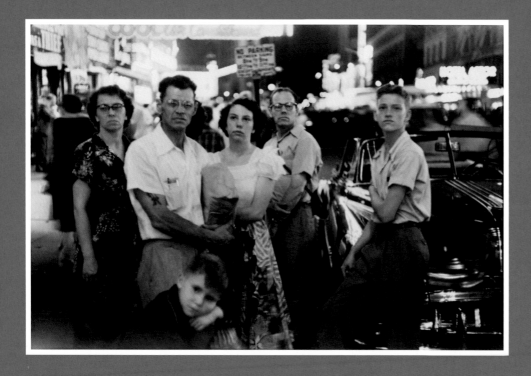

It was also a challenge to figure out how big the edition should be. One hundred prints? Fifty? I knew photographers who thought, "I'll make the edition one hundred." Then they only ended up printing a few. It means that you have to know how each photographer works, and you have to take their work on a case-by-case basis. All the more reason that Gary should create a printer's proof, because it makes that act complete. As far as I know, Harry Callahan didn't edition his prints, and Lee Friedlander only editioned his prints if they were in the form of a book, or if it was something special that was by its nature a multiple. Many photographers thought, "Well, I've never editioned before, why should I start now?" That's another way that the market and the field has changed.

ON THE RISE OF VINTAGE PRINTS

JQ: Gary and John remembered that in the early days of vintage prints, collectors would sometimes ask if they'd get a negative along with their print. Did you ever experience that?

DB: No, but collectors would sometimes wonder if they would get the copyright with the print, and I would have to tell them, "No, the photographer has the copyright." Then they would say things like: "Well, is the negative going to be retired then? Because you could print so many more if you wanted to."

JQ: When was it that people really started to look for vintage prints?

DB: I think that it started as soon as modern prints started being made. For example, when Light Gallery was preparing the "Light suite" of Faurer photographs—something they did with other photographers, too, like Garry Winogrand—a big question came up as to the distinction between "vintage" and "printed later." Then the idea of "mid-vintage" was introduced for prints that weren't printed *that* much later—André Kertész photographs from the 1930s printed in the '50s, for instance. It got to be more complicated, and more layers were added. People wanted to define what a vintage print was, but there was disagreement over the exact definition. Is a vintage print made three years after the fact, five years max? What I think it's come down to now is that you have to take each photographer on an individual basis. There are just so many permutations of the print. For example, people have recently started testing papers, but for some photographers, it was common practice to save papers for a long time, so a picture dating to 1950 could be printed on paper from 1938. In the end, it does depend on knowing, if possible, the specific working methods of each photographer.

JAMES CASEBERE

James Casebere is a visual artist whose practice includes building and photographing tabletop models of architectural structures such as homes and prisons in his studio. After attending the Whitney Independent Study Program in New York, Casebere studied in the Post Studio graduate program at the California Institute of the Arts (CalArts) in Valencia, California, where he worked with conceptual artist John Baldessari and lived for a time in a Hollywood loft previously rented by performance artist Laurie Anderson.

There, Anderson had built a sound studio and a darkroom that he used. On March 4, 2017, Casebere sat down with Jennifer Quick at the Sean Kelly Gallery in New York to discuss the nearly 30 works of his that are now part of the Harvard Art Museums collections, including printer's proofs made in collaboration with Schneider/Erdman, Inc. Excerpts of that interview presented here have been lightly edited for clarity and tone.

ON CASEBERE'S EARLY CAREER, INCLUDING PHOTOGRAPHS IN THE PRINTER'S PROOF COLLECTION

Jennifer Quick: Let's start with the early years of your career. Where were you working at the time?

James Casebere: In the fall of 1979, my friends Jenny Holzer and Mike Glier told me about a storefront on Ludlow Street, right next to the famous Katz's Deli, that I could rent as a studio. A number of artists associated with a group called Colab had moved into that particular part of the Lower East Side. I rushed over to see it and within days signed a 10-year lease. Most of my black and white photos from 1980 through 1986 were shot there, including *Storefront* (Fig. 1). *Portuguese Beachfront* was done there, too (Fig. 2). Most (but not all) of the prison exteriors, including *Sing Sing* and probably *Panopticon Prison*, and the first two prison interiors, *Prison Cell with Skylight* and *Cell with Toilet*, were also shot in that space.

In 1985, a group of other artists from that neighborhood and I bought a vacant, burnt-out building on 8th Street between Avenues B and C as part of a citywide program to provide affordable housing for moderate-income artists. We finished the renovation and moved in three years later. I lived there but kept the Ludlow Street storefront as a studio for a while. *Industry* was shot on Ludlow Street. I remember shooting *Prison at Cherry Hill* and the interiors *Tunnels*, *Toilets*, and *Asylum* on 8th Street.

JQ: How big was that space?

JC: The storefront was about 20 × 50 feet, or 1,000 square feet. The 8th Street studio was maybe 1,100 square feet. I also rented a big loft in Dumbo in Brooklyn to make larger sculptural projects for *Sonsbeek '86*, an exhibition in Arnhem, Holland; for a public park project in downtown Atlanta; and for a show at the Michael Klein Gallery in the Cable Building at Broadway and Houston.[1] I shot some photographs there, too. I also spent one summer in Minneapolis, where I built a large sculpture for a show at the Walker Art Center that traveled to [the Museum of Contemporary Art] in Chicago. All of [the photos in the printer's proof collection] were from this general period. I had come back from teaching at CalArts in 1984–85, and these came off of the tail end of the Western series. *Pulpit* (Fig. 3) was

Fig. 1
James Casebere, *Storefront*, 1982.
Gelatin silver print, 99.5 × 74.3 cm
(39³⁄₁₆ × 29¼ in.). Harvard Art Museums/
Fogg Museum, Schneider/Erdman
Printer's Proof Collection, partial gift,
and partial purchase through the
Margaret Fisher Fund, 2011.140.

Fig. 2
James Casebere, *Portuguese
Beachfront (close-up)*, 1990. Gelatin
silver print, 75.2 × 100.8 cm (29⅝ ×
39¹¹⁄₁₆ in.). Harvard Art Museums/Fogg
Museum, Schneider/Erdman Printer's
Proof Collection, partial gift, and partial
purchase through the Margaret Fisher
Fund, 2011.142.

shot in Los Angeles in the fall of '84, in a little bungalow above a garage there that I rented in Beverly Hills.

While I was in L.A., I was looking back to and exploring my own cultural background in Protestant New England. There's a long lineage of Presbyterian ministers on my mother's side of the family. Then I did a studio swap with an L.A. painter who moved into Ludlow Street for six months beginning in January 1985. I used his storefront studio in Mid-City, on Washington Boulevard, near Pico [Boulevard], which was similar to my studio in New York, only bigger. It was there that I shifted to the Western theme with *Arches* (Fig. 4), another image called *Needles*, and *Covered Wagons*. I did this whole body of work having to do with the Hollywood image and myth of the American West. And then I showed it in the fall of 1985 at Richard Kuhlenschmidt Gallery in Los Angeles. Gary Schneider printed those photographs.

JQ: What about the works with the gates [*Dark Table with Gate* (Fig. 5) and *Kitchen Window with Corral* (Fig. 6)]? Where did you shoot those?

JC: When I returned to New York from L.A., I was going to a Rinzai Zen temple on 68th Street on a regular basis. There's a series of images in Zen Buddhism called the Ox Herding series, and the gate, corral, and empty bowl are references to that. These images were all shot in the larger warehouse space that I rented in Dumbo.

After making a number of images that had to do with the differentiation of European institutions during the Enlightenment, I landed on prisons as a subject. I was hesitant and avoided it at first because of the whole connection to Michel Foucault, who dominated the conversation at the time.[2] But then I started thinking about the architectural history of prisons and how it developed in America, so I started with the exterior and the different plans, and then moved inside, thinking about the history of incarceration in America and the Quakers and the relationship to the monastery. *Barrel Vaulted Room* was about that (Fig. 7). I had started spending time at the Eastern State Penitentiary in Pennsylvania and was inspired by my experience of that very monastic space. The visual source that I used for the arches and the structure was an Alberti church in Mantua, Italy.[3] I was trying to draw a connection between religion, divine light, and incarceration. The idea was that as a prisoner you would develop a relationship with God in solitary confinement, change your ways, and come out reformed.

Fig. 5
James Casebere, *Dark Table with Gate*, 1989. Gelatin silver print, 75.4 × 100.7 cm (29¹¹⁄₁₆ × 39⅝ in.). Harvard Art Museums/Fogg Museum, Schneider/Erdman Printer's Proof Collection, partial gift, and partial purchase through the Margaret Fisher Fund, 2011.150.

Fig. 6
James Casebere, *Kitchen Window with Corral*, 1987. Gelatin silver print, 75.3 × 100.6 cm (29⅝ × 39⅝ in.). Harvard Art Museums/Fogg Museum, Schneider/Erdman Printer's Proof Collection, partial gift, and partial purchase through the Margaret Fisher Fund, 2011.152.

Fig. 7
James Casebere, *Barrel Vaulted Room*, 1994. Dye destruction print, 75 × 59.8 cm (29½ × 23⁹⁄₁₆ in.). Harvard Art Museums/Fogg Museum, Richard and Ronay Menschel Fund for the Acquisition of Photographs, P1998.54.

JC: I did *Home* (Fig. 8) in Albuquerque. It's a waterless lithograph. I put it together with *Prison* (Fig. 9), but they could also be taken separately. At times they were a diptych.

JQ: Had you often used the technique of waterless lithography before that?

JC: No. I did a series of prints one summer, experimenting with different materials, papers, and printing techniques. It was fun. [Waterless lithography uses] a very fragile toner from copy machines for the blacks, resulting in a really deep black with a kind of powdery surface. I would like to do more things like that.

Barrel Vaulted Room is a Cibachrome print. I did the first show of prison interiors at the Michael Klein Gallery on Wooster Street in 1995 all with Cibachromes that size. For me, *Barrel Vaulted Room* was kind of the pivotal image in the show, because it pointed to that connection between religion and incarceration. I only showed five images: *Barrel Vaulted Room*, *Tunnels*, one called *Empty Room*, *Asylum* (which is a horizontal image—it's just a slab on the wall), and *Toilets*. It was an important show for me. The Cibachromes have lasted better than some of the C-prints.[4] Later, I face mounted C-prints and showed them unframed on the wall, and those haven't held up so well over time. I've been reprinting a lot of them using inkjet prints, in a size of up to 48 × 60. Bigger than that I still have to make C-prints. I'm not face mounting them anymore; I'm framing them and putting them behind a UV protective glazing so that they'll last longer.

JQ: Are you doing the printing out in western Massachusetts, where you have your studio now?

JC: No, I've been printing mainly with Charlie Griffin. But a lot of the prints that I'm redoing were done at [Laumont Photographics in New York], so I print there, too.

JQ: I've heard a lot about Laumont. It seems like they have a good reputation and really know their stuff.

JC: Definitely. Esteban Mauchi is a great printer. I did all of the Cibachromes there and most of them have held up well.

JQ: So the shift now is to ink jet?

JC: Well, you can't do Cibachrome anymore. The last show that I did here at the Sean Kelly Gallery was a result of printing out my exhibition prints as Cibachromes. It was the last batch of Cibachrome paper and chemistry that they would get at Laumont. I usually keep one artist's proof for myself, so I printed them out from the series of flooded interiors, mainly, and showed six or seven of them downstairs.[5] I just wanted to get it done before it was too late, and that was it. That was the end of it.

JQ: Changes in materials and technology, as well as how artists deal with those changes, are a big through line of the *Analog Culture* show as well. There's no more Agfa Portriga Rapid, for instance.

JQ: Are you working exclusively with digital photography now?

JQ: Do you miss film? The 4 × 5 format?

JC: Gary is more sensitive to that than me. I certainly had favorite papers, but Gary has a better memory of exactly what they were.

JC: This [Spring 2017 show at the Sean Kelly Gallery] is the first show in New York that I've done that is entirely shot digitally. The last time I showed new work at Sean Kelly was in 2010. Those were the *Landscapes with Houses*. They were all shot with 4 × 5 film, then scanned and printed digitally. It wasn't until a year ago that I bought my own digital camera. For a couple of years, I had just been renting different digital cameras and I would change equipment with every image, just to test out different cameras. But I've finally made the shift.

JC: It's been a long transition. I still don't feel comfortable shooting alone with a digital camera. I need a tech there. The last picture in the show—the photo of the orange wall—I shot myself, but I had one of my team members on the phone while he was on vacation in Toronto. The call was all about the focus bracketing; you can get such extended depth field, and I'm still not comfortable with the process. My brain isn't wired for the computer.

ON BLACK AND WHITE VERSUS COLOR AND CASEBERE'S USE OF LIGHT BOXES

—

JC: Most of these, like the *Portuguese Beachfront* images, were done at the same time that I was working on sculptural projects. I was also making and showing light boxes of some of these things. When I started making the prison images, technology affected the process. The company 3M discontinued the black and white transparency material that I used in the light boxes. I had to shift to a color transparency material for the final print, and it was difficult to get the results that I wanted using the black and white original negative. There was a red-green cross that was hard to control. So I started shooting color film for the first time with the prison exteriors. When I did that, I discovered that I liked the way the Cibachrome test prints looked. Suddenly, I was no longer motivated to make a transparency for the back-

Fig. 8
James Casebere, *Home*, 1993.
Waterless lithograph, 47.7 × 56 cm
(18¾ × 22⅛ in.). Harvard Art Museums/
Fogg Museum, John Coolidge Gift
for the Purchase of Contemporary
Architectural Photographs, P1998.55.

Fig. 9
James Casebere, *Prison (Sing Sing)*,
1993. Waterless lithograph, 47.7 ×
56 cm (18¾ × 22⅛ in.). Harvard Art
Museums/Fogg Museum, John
Coolidge Gift for the Purchase
of Contemporary Architectural
Photographs, P1998.56.

lit light box at all. In some cases, I shot black and white film as well as color chromes, so the Harvard Art Museums have a rare black and white print version—*Prison*—from that first series where I shot both (see Fig. 9).

JQ: So at the time, there was both a black and white and a color print for each image?

JC: Yes, there was a little bit of an overlap while I was making the transition, and then I just kept shooting the color because I liked the results. And I stopped making black and white prints. It also had to do with the subject because, for me, black and white had always seemed to refer to the past, recalling the age of black and white television or black and white film. On the other hand, when I started doing the prisons, I felt like they were about sensory deprivation, and the pictures that I saw in black and white were missing something. Ironically, I needed to turn up the sensory volume on something that was about the absence of sense. When I shot the interiors, it was with that in mind. *Barrel Vaulted Room* was the first image where that became important, so I printed it with a blue cast. I wasn't trying to make it black and white. I wanted to appeal to the viewer in a more seductive way, to let the viewer enter into the space of the image.

JQ: You were using black and white for a while. Would you say you felt attached to it?

JC: I wasn't attached to the black and white—it had to do with the light box. I started printing in color because of the discontinuation of black and white printed material for transparencies. I had to use a color transparency material if I was going to do a light box. Working from a black and white 4 × 5 negative, I started making black and white 8 × 10 positives to print on the color transparency material. It was just really hard to get the right balance. I couldn't get black and white, basically. It was red and green. And it was really agonizing. That's why I started shooting color film. I really liked the little intimation of color, so I started to play with that subtle variation. And again, I looked at it as a way to seduce the viewer into an image that was about deprivation.

JQ: The light box story is fascinating. You came up against that problem we discussed earlier, when a material is discontinued, and then you found another path. Do you know why they stopped making black and white transparency material?

JC: Lack of demand. Color photography came into fashion.

ON PRINTING

JC: I printed my own work until the Sonnabend Gallery show in 1982. I worked with a printer for that exhibition. I did a show of photographs at Franklin Furnace before that, but I believe I printed that myself. I printed the first Artists Space show in California myself, in the darkrooms at CalArts, but once I started working with regular printers in New York, that was it. I always thought that Gary was really good. Looking back, I think that sometimes I printed things too dark. Like *Pulpit* in particular. A few years later, I returned to that image with Gary and printed it lighter. All of the detail is there [in the earlier version], it's just hard to see. I don't know, maybe it was a dark moment in time. But eventually, I lightened it up. I printed it as a transparency for a light box, too. When you do that, you see more. The light boxes I made had dimmers so that they could be adjusted to the context. The conventional silver prints tended to be dark. I remember reprinting *Pulpit*, and occasionally others, with Charlie Griffin more recently. Charlie's a great black and white printer, too, and still does all of [Hiroshi] Sugimoto's black and white work. Occasionally, we'll go back and reprint something or finish an edition.

It's interesting, the way that technology changes. For a while, I had my own Epson printer in the studio. I printed complete editions for the [Institute of Contemporary Art] in Philadelphia, among other venues. But I felt that I couldn't maintain the printer. I was creating too much dust in the studio with my sculptural work and couldn't run it every week, so eventually I sold it. Now that my studio is outside the city, I'm asking myself what it might mean to make my own prints again. But I don't know if I'm ready to do it. I like working with Charlie and Laumont, because they know what they're doing and they can maintain the equipment. On the other hand, I've been assembling a team of people in the area who possess the necessary skills.

1

Dumbo is an acronym for "down under the Manhattan Bridge overpass."

2

The work of French philosopher Michel Foucault had by the 1980s become well-known in artistic and cultural circles in the United States. Foucault was important in the development of structuralist and post-structuralist philosophies. In 1975, he published *Discipline and Punish: The Birth of the Prison*, in which he examined the emergence and history of the prison system and the ways the state wields power through it. Foucault's discussion of the Panopticon, an architectural structure designed in the 18th century by British philosopher Jeremy Bentham for maximum surveillance and control of imprisoned individuals, became one of the more influential portions of his book. Casebere has referenced the Panopticon in his works, in some cases even using the term in his titles.

3

Leon Battista Alberti was a Renaissance architect, author, poet, humanist, and philosopher. The church in Mantua, called Sant'Andrea, was built in the 15th century to house a relic supposedly containing drops of Christ's blood gathered at the cross. A notable work of Renaissance architecture, it embodies the integration of Classical design into a Christian context.

4

Chromogenic prints, or C-prints, are color prints made from color transparencies or negatives. The print material has at least three emulsion layers, each of which is sensitized to the three primary colors of light: blue, green, and red. Cibachromes are direct positives made from color slides, exposed in an enlarger to make a print. For more, see Richard Benson, *The Printed Picture* (New York: Museum of Modern Art, 2008), 200, 204.

5

For more on the concept of the artist's proof, see the introduction to this volume.

GARY SCHNEIDER

The interview excerpted here focused on a set of technical materials that Schneider and Erdman gifted to the Harvard Art Museums. Part of a companion collection to the printer's proofs, these materials range from photography tools to experimental prints that Schneider made to test the effects of different papers. The collection now resides in the museums' Center for the Technical Study of Modern Art, where it will be available for research and study, per Schneider and Erdman's wishes. Schneider also discussed documents that are now part of the Records of Schneider/ Erdman, Inc., in the Harvard Art Museums Archives.

The interview took place at the Harvard Art Museums on January 12, 2017, and was conducted by Penley Knipe, the Philip and Lynn Straus Senior Conservator of Works on Paper and Head of the Paper Lab in the museums' Straus Center for Conservation and Technical Studies. A video recording of their discussion is available in the online Special Collection that accompanies this volume.[1] In the version reproduced here, Schneider edited and expanded his commentary to clarify and refine descriptions of his technical processes. These excerpts have also been lightly edited for clarity and tone.

ON BURNING AND DODGING

Penley Knipe: I thought that we would start with the tools you provided for us: these two—presumably handmade—items, burning and dodging tools (Fig. 1).

Gary Schneider: Very handmade. John found the two dodging tools when we were recently disassembling the photo lab; they had fallen behind my enlarging table. They are simply pieces of wire and black masking tape cut to various shapes and sizes. I would often build variations of them to solve a particular printing problem. I would hold the tool under the lamp of the enlarger, and it would make a shadow on the print. By holding back light, I could open up the image and build information into a shadowed area. The closer I got to the paper, the more hard-edged the shadow would be; the closer I got to the lens, the more soft-edged it would be. So the smaller end could be used to open an eyeball, for instance. You'd have to keep moving it, otherwise you would get what I call "sticks," or straight-lined shadows, which of course would be a slightly lighter area on the print.

This [referring to a tool created immediately prior to the interview for purposes of demonstration] is a burning-in tool I just built.[2] I've never built one out of acid-free cardboard, but I just found some pieces here. It would be used for placing more light onto an area of the paper. You could also use your hand with the tool between the enlarger lamp and the paper and make a tiny aperture by shaping the hand over the hole for burning in a small area—or a broad opening for burning in, say, a sky. What's curious about [the software program] Photoshop is that it still uses these same terms. It's like saying "horseless carriage" to describe a car. Adobe might eventually make its own language, but it's curious that it still uses the language of the darkroom: "burning and dodging."

Fig. 1
Gary Schneider's dodging tools.
Center for the Technical Study of
Modern Art, Harvard Art Museums, Gift
of John Erdman and Gary Schneider,
2017.97.8–9.

PK: Is this your negative that was used to print the photographs?

GS: Unfortunately I don't remember whose it is, probably a student's. I think that I made these prints when I first started teaching photography in 1987. I taught an advanced master class at the International Center of Photography for a couple of years—it was a black and white darkroom. We still teach darkroom at my school at Rutgers [Mason Gross School of the Arts at Rutgers University, New Jersey], but it's Photo 1 now and only for one semester.

PK: Were there other classes you used it for or is that it?

GS: That's it. I think that the darkroom is still very much a magical place. We still teach black and white because it slows young photographers down, and this helps teach them visual literacy. And also, we still have silver materials available; Ilford still makes papers.

PK: Are they the only ones?

GS: They're the only ones that have been consistent for decades.

PK: Can you tell us about these prints?

GS: I made them in a classroom to demonstrate multiple printing. What's weird about them is that we can now achieve this so easily (and seamlessly) in Photoshop. So we have two negatives, and I would have placed them in two separate enlargers. This one is a photograph of a factory building—that's why I think it was a student's negatives, because young photographers often like to photograph derelict buildings. It's a photograph of a factory building with a blank sky (Fig. 2a). And the second negative is an image of a landscape with a very detailed, cloudy sky (Fig. 2b). To put them together into one print, the final print looks like that (Fig. 2c). There are various versions of it—this (Fig. 2c) is a dark version, and this (Fig. 2d) is a lighter version of that multiple printing. The factory would have been printed first, and I would have made proofs to get the right density for the final combined print. In the second enlarger, I would have made a print of the sky, and then would have built a mask—probably a Rubylith mask. Rubylith is a red-colored gel on a Mylar base. In a classroom setting, since I had a limited amount of time, to make the mask I would have laid the Rubylith on the easel and projected the image onto it, and scored it to the building and its landscape. I'd score it to the shape of what I was masking, and then I would have removed the areas of the Rubylith that I wanted to burn in—in this case, the sky.

If I were to have done this multiple printing in my studio, I would have made a print, dried it, then I would have

laid the Rubylith over the print and scored the gel to the shape of the building and its landscape. To get to a final print, in any refined way, would have taken a full day's work, or at least six hours in my own darkroom alone. But I never made a multiple printing for a client; I used only Rubylith as a dodging/burning tool. Also, there was a ruby liquid that I used to paint directly onto my copy negatives to add density to a highlight area or to open up details in a shadow. John was reminding me recently that I used Rubylith masking really often.

PK: That sounds like pretty precise work.

GS: It could be really precise. Let me try to describe in more detail how I would have made this combined print, step by step.

The image of the building was projected onto the easel, without photographic paper, and the black easel blades were set to define the rectangular border of the final print. A sheet of Rubylith was then laid over the full easel. After scoring the outline of the building and landscape and removing the unwanted gel, I then made registration marks on the cut Rubylith mask, to match the registration marks I had already made on the easel blades. This allowed me to align the cut cell so that I could mask out the building and its landscape when I was burning in the clouds during the exposure of the second negative.

To make the print, the unexposed silver paper was inserted into the easel. The building image was exposed first. During this exposure, I would have dodged the edge of the building and its landscape. I then printed the clouds in concert with the Rubylith mask, to mask out the building and its landscape. Because this was a multiple printing, the easel was moved from enlarger to enlarger, with the paper undisturbed for the duration of all my manipulations and exposures. Since the sky above the building is blank in the first negative, the negative density would have been sufficient to protect that area of the paper from being exposed to enlarger light in the sky area.

And then, on the second exposure, once I had proofed the clouds, I would be able to place the Rubylith approximately in the area where the building was on the first exposure, using the registration marks. You can see this halo where I was making a mistake in a proof (Fig. 2e).

PK: There's not perfect alignment.

GS: I would have been vibrating the Rubylith on the unprocessed paper. So I would have to vibrate the mask (Fig. 3) so you wouldn't see the hard edge of the mask in the print. We can see where I wasn't able to get it to work. What's really happening is that the mask is lightening up some edges of the sky around the building. Remember, I had dodged the edge of the building in order to burn in the sky. I would then have tried to burn the halo areas

Fig. 2a–e
Prints used by Gary Schneider in
teaching demonstrations. Gelatin
silver prints, each: 24.1 × 35.6 cm
(9½ × 14 in.). Center for the Technical
Study of Modern Art, Harvard Art
Museums, Gift of John Erdman and
Gary Schneider, 2017.97.4.

Fig. 3
Re-creation of a Rubylith mask used
by Gary Schneider in teaching demon-
strations. 30.5 × 40 cm (12 × 15¾ in.).
Center for the Technical Study of
Modern Art, Harvard Art Museums,
Promised gift of John Erdman and Gary
Schneider.

back in on a very low-contrast filter to compress the tones. After a few tries, I would have noticed how I was performing the combination printing and that I couldn't solve the halo. I would then have set up a third enlarger without a negative. I could then take the unprocessed, exposed paper and burn in blank light to fill in areas where I wasn't able to achieve a good match.

I was trying to work out something that wasn't transparently my hand, my inelegant manipulation. During the printing process, I would be learning a sequence of moves and I'd have to dodge that area in order to burn it back in on a lower contrast filter, or flash it in with blank light. I did this in order to arrive at a less apparent manipulation. I should also mention we used a safe-light filter that was a similar red to Rubylith; it was a light masking red.

PK: How long were these exposures? How much time elapsed while you were working?

GS: I have no recall for exactly how long it took me to print, but time was never my issue. It was normal for me to spend a very long time under an enlarger, manipulating, in order to make one print. I'd be learning a performance. What I needed to do—after each try and after each processing cycle—was look to see where I had made mistakes and then try and remember the mistakes and try not to make them the next exposure cycle.

PK: For the overall exposure of this, do you have an idea of how long it took?

GS: Well, those were the first two tests. The first two tests gave me the basic beginning exposure, and then in each subsequent printing I would try it with a different combination of exposures. So the building is much lighter here, the building is much darker there, there are two final versions that are OK, but they are very different interpretations. A dark interpretation and a light interpretation.

PK: Do you have a notebook next to you while you're working?

GS: I don't.

PK: You just remember?

GS: Yes. I know some people put pencil notes on the back of their prints. For me, maybe I have an eccentric visual memory; I would have to *feel* the steps. It's not about remembering, it's about understanding how the light was working, the chemistry was changing, and my understanding of the image was shifting. This way, I could be refining that decision-making, because in each cycle, each step would be slightly different. There are so many variables in the darkroom . . . like less time in the developer would make the print slightly grayer, more time would make it more "contrasty," and so on. You could build contrast and reduce contrast in many ways, too. The useful thing about the burning in with the blank light is that I was reducing an area by compressing the tones so

that it becomes visually less distracting. That's why I like talking to conservators: it's all about problem solving. Is that a decent way to describe it?

PK: Yes, it's similar in conservation. We're trying to reduce damage so that it's less distracting.

GS: Yes, you don't need to make it disappear, you just need to be able to look at the print without the problems being distracting. It was really curious to discover these prints recently, after Photoshop.

PK: That was another of my questions: how long would that take in Photoshop?

GS: I could literally do this in five minutes, maybe.

ON FILM DEVELOPERS, PROCESSING, AND THE LAB'S ORGANIZATIONAL STRUCTURE

PK: I wonder if we can now move on to this group, which has a photograph of John that you shot (Fig. 4). Why are these important for what they're showing?

GS: In order to compare all the 35mm films that our photographers might use, I photographed John in a carefully composed still life. This study gave me the ability to compare the different films: their tonality, including skin tone, plus a gray, out-of-focus area to compare grain from film stock to film stock. Working with Stacy Zaferes, an assistant, we exposed all the films according to their manufacturer's suggested exposure ratings, their sensitivity to light (ISO). Stacy then cut short pieces off each roll, processed these strips in various developers, and made prints. I compared the enlargements made from these negatives, and I used these negatives and prints in my consultations with clients and in teaching darkroom to students.

PK: So these were for you to teach your assistants the different possibilities?

GS: Yes, and it was also for me to understand the various possibilities, in order to have conversations with clients.

PK: Were these done in the early years of the business?

GS: I think so. A prospective client, recommended by a close mutual friend, walked into the lab with hundreds of rolls she had exposed. I asked her to select any roll so that I could run a test. She was insulted that I had implied that she didn't know what she was doing, that her film wasn't "normal." We had no "normal" at our lab; I had no idea what normal was. I was always anxious about screwing up anyone's negatives. I tried to explain this, but she refused to select a roll. I didn't process her film. She later became a friend and brought in the negatives for me to print. They were bullet proof, which is a colloquial way of saying too dense, overexposed and overdeveloped.

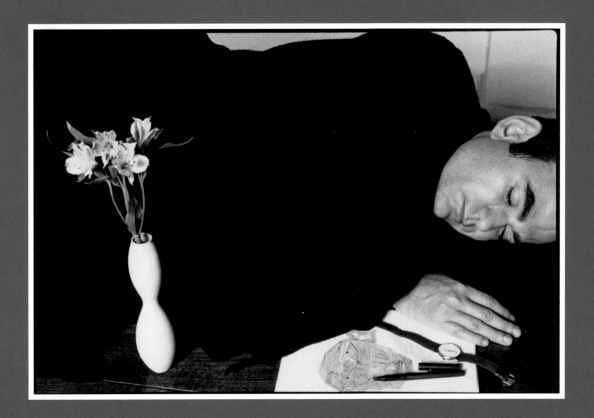

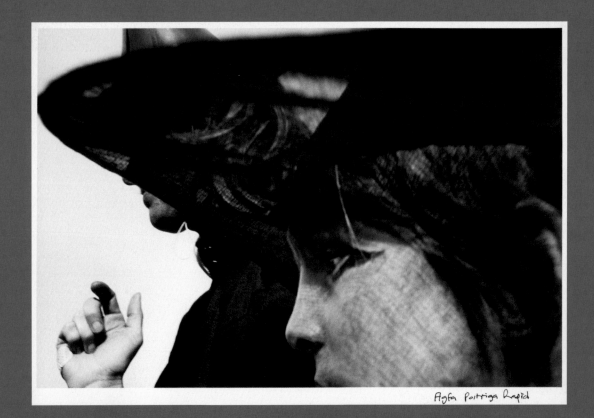

There were ways that I could compensate even further. Mary Ellen Mark liked to overexpose her Tri-X film, and I would process her in Kodak Microdol-X, a developer that reduced the density of the film but maintained all the details without losing brightness in the tones. Mary Ellen exposed for the shadows, and I processed to be able to print the highlights. Microdol-X also softened the edges of the silver grains so that the prints were very beautifully gray without looking grainy. Most of our artists required such special attention. I encouraged this particularity.

When Kodak made its new film Technical Pan available, it required Technidol, a special developer that could process only one roll at a time. Ray Mortenson and I collaborated to work out that Tech Pan could be processed in Agfa's Rodinal in an extreme dilution of one part developer to one hundred parts water, allowing me to take the processing time from Kodak's recommended five minutes upwards to twelve minutes, which made it possible for me to do bulk processing. In the early 1980s, Schneider/Erdman was given a free ad in *Photo District News*—our only ad ever—and it advertised that we processed Kodak Technical Pan. This led [photographic cooperative] Magnum Photos to us. Technical Pan could be exposed at an ISO of 16, very slow; this also meant that it was almost grainless. By contrast, Kodak Tri-X, the most popular film, had an ISO of 400. John Schabel shot his *Passengers* [see pp. 173–74] on the most high-speed film, Kodak TMZ P3200, with an ISO of 1600 that could easily be pushed to 3200.[3] John shot in low light, and the extreme graininess of the film becomes foregrounded in these images.

Our stock developer was a Kodak D76 replenishing film developer. This setup I had taken with me when I left the Klaus Moser lab. Later, Gilles Peress had me experiment with Kodak's newly formulated Xtol replenishing film developer that worked well for many films. He and I still discuss the beauty of these negatives. It's important to understand that each photographer made many choices: which camera, what lens, what film stock, and so forth. Also, photographers made decisions about how to expose their film based on choices affecting more or less detail in the shadows and highlights. There was always "the price to pay." Underexposed film had to be push-processed and would build grain and contrast. Overexposed film would "burn" the film's silver and make the negative grainier and flatter. It could be pulled in the developer, but this would make it flatter and *still* grainy.

PK: How many worked at the lab? How many assistants did you have?

GS: There was always me in the darkroom. There was John in the front with Libby [Turnock], who was sort of like a manager. Then in the back there was Walter [Newalis] processing film, and two commercial printers.

PK: So about six of you?

GS: Right. Walter processing films, Wally [Koetzner] doing very commercial work, which we always prayed for—like corporate annual reports. He was really good and fast. Then Stacy mostly making contact sheets and some prints.

ON PHOTOGRAPHIC PAPERS AND WORKING WITH GILLES PERESS

GS: I was always wanting to experiment, so for these prints I borrowed a really tough image of Gilles Peress (Fig. 5).

PK: Because it's so black.

GS: Because there are so many different blacks—it's all about the blacks. And to me, that was the big distinction between the papers. How does texture affect black? How does smooth paper affect black? How does it work with different manufacturers? Ilford is a bright black; Kodak is a softer black. These are general characterizations.

PK: What was the competition [that inspired these prints]?

GS: It was for a *Photo District News* fair at the [Jacob K.] Javits Center in Manhattan. You had to guess what each paper was, and if you were right you would win a camera supplied by the organizers. I don't think that anyone got it, because once a print is behind glass, how do you look at the surface?

PK: Their differences would be lost.

GS: Yeah, their differences would be more difficult to read.

PK: I envision this group of prints as being for the clients. Did you ever use this in the studio later to say, "This is the effect of this paper, which is so different from this?"

GS: I must have, but also as a teaching tool. Because, at that point in time, these were the papers that were available.

I loved Agfa Portriga Rapid. . . . There are five different images in the Czech modern portfolio printed on Portriga Rapid, because it was a chlorobromide paper available in two surfaces and it was so malleable; you could do anything with it.[4]

PK: Would you say that was a favorite paper during that time?

GS: It really was. It went out of production in '87, which was when Peter Hujar died. It was his favorite paper with his later prints. He had also printed on Ilford Galerie, but then he abandoned that for Portriga because you could literally do anything with it. And he used it very differently from someone like, say, Diane Arbus, who used it for its mid-tone luminosity. He actually turned the mid-tones into gray tones and made the highlights and shadows more graphic. He burned in the blacks, for example.

PK: And he did all of his own printing?

GS: He did all of his own printing until the last year of his life, when he gave it over to me [see p. 98]. But a lot of the papers—like Kodak Ektalure—are here for their surface texture. Also Ilford Galerie Matte, which one of the Peress images is printed on, went out of production and became Ilford Multigrade Matte, which could not produce the rich blacks of the graded paper it replaced. And part of the reason why I love Hahnemüle 308, and most of my own work is printed on it, is that when I started printing ink, the Hahnemühle 308—which is a slightly textured matte paper—truly absorbs light, so that you can get very rich tonalities, especially in the blacks, that you couldn't get in silver. And that was a huge revelation to me and John: that I could achieve such beautiful tonality in ink that I could no longer get in silver.

PK: Is there anything else you'd like to say about these papers?

GS: Well, the range is just amazing.

PK: You'd have to actually look at them.

GS: You'd have to actually look at them next to each other. So, for example, one of these is on a paper called Brilliant . . . a paper I was introduced to by Gilles Peress very early. He's French and knew of the factory in Paris that made this niche paper called Guilbrom. It was a factory in the center of Paris called Guilleminot. When the paper started being imported into this country, it was called Brilliant, and later Bergger made a version of it after they had bought the paper formulas.

PK: How would you describe Brilliant?

GS: It could be toned plum. So what you've previously called purple, I call plum. Looking at prints in the fluorescent light here, the color is distorted.

PK: It's much more poetic.

GS: If you look at the David Wojnarowicz *Buffaloes* that's now in your collection and also printed on Brilliant [see p. 48], it is partially polytoned in order to achieve a slight split toning with warm shadows and cool highlights. I do love that color. All of the Peress competition prints are selenium toned. All silver prints have to be toned for stability. For this Peress project, I removed more

eccentric toning possibilities. So, the color differences in the bromide glossy papers are often subtle—if we compare the Brilliant to the Oriental Seagull, it's about comparing a compression of blacks in the Oriental Seagull to dimensional separations in the blacks in the Brilliant. That's really why Gilles loved Brilliant so much.

PK: Why?

GS: A lot of his images rely on details in the blacks. The mysterious somberness of this image lies within the black area of the print. The image is not hanging on the highlights, it's not buoyed by the highlights; they're lifted up through the blacks, in a way. If we compare Brilliant to the Kodak papers, Kodak is slightly more green, with much softer tonality . . . especially Elite. Kodak Elite was the paper used for printing Brian Lanker's project *I Dream a World* (Fig. 6).[5] Kodak sponsored the project to showcase the new T-Max film and Elite paper. They based Elite on earlier bromide papers that had *huge* silver grain and thought it would be successful, since black and white photography had become so popular. It didn't do very well. Elite is a really thick paper, and it was double the price of anything else. And what's amazing about the Peress on the Elite is, I could reduce the contrast of the hair here and print really soft, rich tones.

PK: It's almost silver there.

GS: It looks very silvery. And there were no other bromide papers at that moment available that could do that. You could only do a similar tonal compression with a chlorobromide like this Peress on Agfa Portriga Rapid.

PK: This one [on Agfa Portriga Rapid] seems much browner to me.

GS: Yes, it's because it's a chlorobromide emulsion on a warm base.

PK: It's so interesting to see all of these together, especially since they were available around the same time.

GS: There were other papers, but these are the 10 papers that I was using.

PK: Are any of these still available?

GS: Ilford Multigrade—and it pretty much hasn't changed. What's interesting about it is that many of the printer's proofs that are now in your collection, like all of the John Schabel photographs . . . are on Ilford Multigrade, as well as the cycle of Robert Gober [*1978–2000*; see pp. 153–63]. It's a really good, solid paper, and it's what we use to teach with. What's amazing is that Ilford decided that even with losses in the market, they would become the go-to paper, which has actually proved to be a really good decision on their part. In fact, they now make a silver paper that can be laser exposed (i.e., digitally exposed)

but chemically processed. Many current black and white exhibitions are gelatin silver prints, digitally exposed from a file, and not enlarged from negatives.

PK: But they're processed?

GS: They're processed in chemistry, often through roller transport. So Ilford makes a warm tone and cold tone silver paper for that process.

PK: Could you alter the texture?

GS: Yes, there's a print in the Czech portfolio that's on Portriga that was steamed, with a clothes steamer, to make the gelatin glossier.[6]

PK: You did that?

GS: Yeah, to more closely match the vintage print. So, somewhere between the normal surface and a ferrotype. All of our contact sheets were made on [Kodak] Azo single-weight fiber, and they were ferrotyped on a drum.[7]

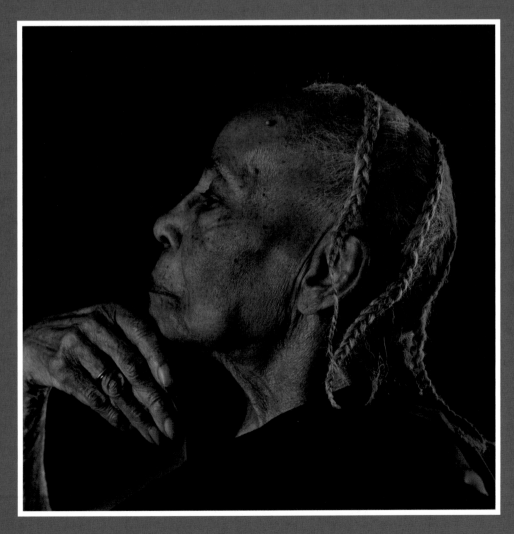

Fig. 6
Brian Lanker, *Septima Poinsette Clark*, from *I Dream a World*, 1987. Gelatin silver print, 37.8 × 38 cm (14⅞ × 14¹⁵⁄₁₆ in.). Harvard Art Museums/Fogg Museum, Schneider/Erdman Printer's Proof Collection, partial gift, and partial purchase through the Margaret Fisher Fund, 2011.285.

PK: You had a drum?

GS: A huge Pako drum for drying, but only to dry the commercial prints and the contact sheets. Our contact sheets were made on Azo, which was this amazing graded paper, but it was very, very slow and you had to have a contact printer with a huge amount of light to make the exposures. There is an Elite print in the Czech portfolio that I had to ferrotype; we actually ordered custom ferrotype plates from Germany, but they didn't arrive until a year after the project was done.[8]

PK: Is that why you didn't use them, because they came late?

GS: Yeah, we never uncrated them because they arrived a year after we were done. And so instead I bought a never used, never exposed to chemistry, flip flop ferrotyping drier so that the prints would remain uncontaminated and stable. But to ferrotype this thick Elite paper on a flip flop dryer was a hellish, time-consuming ordeal to achieve an overall, even, smooth, glossy surface. Which is why we had wanted the ferrotyping plates. So you can really ferrotype any emulsion, unless it was textured, like the Ektalure or the Matte papers.

PK: But you didn't ferrotype very often for artists?

GS: No, but ferrotyping had been popular much earlier, often for artist portfolios. I occasionally had the need to steam prints to make them slightly glossier; I borrowed this technique from Todd Watts. He printed on Ilford for Berenice Abbott, and he would steam the prints to make them glossier.

PK: So they are very shiny . . .

GS: Yes, they're glossy; they're made smooth glossy to remove surface texture, which would have been reproduced when they were re-photographed. Reproduction prints were called "glossies." It was colloquial: "Have you made your glossies?" We collected vintage ferrotyped reproduction prints—we loved them because they *were* reproduction prints I could learn from.

ON AN EXCHANGE WITH PHOTOGRAPHER SALLY MANN

PK: Sally Mann wrote to you because she was fighting with Agfa and was complaining about papers being discontinued (Fig. 7).

GS: Well, look at the date. It's 1995 and she's a major printer.

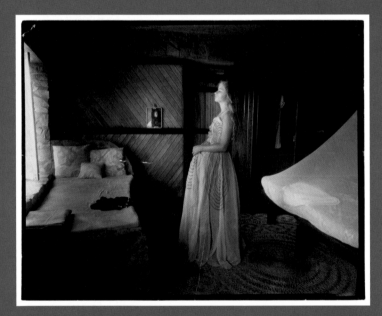

PK: She printed herself or with assistants?

GS: I assume she always printed herself; she didn't use a lab. She mentions Sally Gall as a mutual friend who gave her my information or how to contact me. It's almost 10 years after the demise of Portriga; she's asking advice about reprinting images that I assume were originally printed on old Portriga Rapid. What happened is, Agfa had to stop producing Portriga Rapid because, in the production of it, it released too much cadmium into the environment. Agfa came up with Insignia, which was not particularly good, but Sally [Mann] made it work for her.

Also, Agfa tried to match the color of Portriga with Insignia. They finally came up with Agfa Classic, but the paper was not very good. What you could achieve with Portriga was these eccentric choices of tones that always worked. You could have really gray, really flat, really compressed mid-tones. Sally made exquisite prints with Portriga. She was interested in really gorgeous tonalities. She's lamenting the loss of the paper in this letter. She also talks about another paper, Fortezo. There were Eastern Bloc countries, with no manufacturing restrictions on cadmium, that were producing chlorobromide papers; Fortezo was one of them.[9] We would all be excited, we would make some prints, we would order another batch.

PK: It was very inconsistent?

GS: Yes, and it had zero shelf life. Portriga has amazing shelf life. I kept the darkroom going for so many years using my collection of vintage papers. Later it just became really rough, because we didn't have the range of different papers to work with.

PK: Did you help her? She says, "Have you figured out how to make Classic look brown? Is there any way to make it look like Insignia?"

GS: Well, of course I would have had a telephone conversation with her and made some developer and toning suggestions. Maybe now I would recommend FOMA, a paper from the Czech Republic.

PK: She says, "People keep sending me boxes of paper to try, do you have any experience with reducing the green color of Forte?"

GS: Yeah, so we would have talked about that—and of course you can. You can change the color of papers with different developers and toning.

PK: So you think that you were able to help her a bit? Do you think you were able to direct her?

GS: I hope I was able to help her.

PK: Do you think only your eyes could see the difference?

GS: No, of course not, Sally can always see the difference between papers. This letter from her is a great illustration of how we all have to adapt to the changes in materials. Even today when I'm printing ink, each batch of paper is different, the new printers are different, the ink has changed, the color of the black shifts, so I'm always reinventing it. For each time that the gallery needs a new print, I have fun reinventing the image. I always did that Ansel Adams thing, the performance in the darkroom, but now I take that into the computer. I can't let it go; it's my thing. Once I started exhibiting in 1990 with PPOW [Gallery], I explained to them that no two prints would ever match in an edition. They said, "Oh, I don't think that that's right." And I said, "Well, let's see what happens." And no one ever rejected a print. I don't think it's a matter of only my eyes seeing the difference—it's a matter of all the prints functioning.

PK: You're a perfectionist.

GS: It's not even that I'm a perfectionist. It's more like I want to relive the process and reinvent the print.

PK: You enjoy it, even in the computer.

GS: I just love it. I make it the same as working in the darkroom. For me, it's the same. And my back doesn't go out from lifting full trays of chemistry or water anymore.

PK: You don't have to be around the chemicals.

GS: And I don't have to be in chemistry, which has definitely affected my liver.

PK: Do you know what [Mann] settled on?

GS: No, I'm not an expert on Sally Mann, but if you look at the history of her prints since then—I think she waxed them, and I think even varnished them with sand, and then she began making collodion wet-plate negatives. She continues to search for ways to shift the thing so that handmade-ness is there.

ON PRINTING FOR REPRODUCTION IN *LIFE MAGAZINE*

PK: This [article from *LIFE Magazine*] is a story about AIDS from 1994, and you did all of the printing. Do you still have all of these prints?

GS: No, I didn't even have this one (Fig. 8). I would have made a print, a silver print, and it would have gone to *LIFE Magazine* and would have been laser scanned for reproduction.

PK: *LIFE Magazine* would do that after you sent it off?

GS: Yes. [Photographer] Scott Thode came to me with the story. What's interesting is that you can see the reproduction is larger than the print supplied. Obviously, Scott didn't know that they were going to turn it into as major a story at that point. Normally, you would want the print larger than the reproduced image. Another point: the publication would expect me to make the print the way we would want to see it reproduced. I would not. In the laser scanning, you would have edge effects. I didn't really know they were edge effects, because edge effects are a digital artifact that I easily recognize today from Photoshop but was not familiar with back then. I knew they would be building contrast from my print, even subtly. So I would build more tonal information into the print in order to control the brightness in the reproduction.

PK: They were taking your prints and putting them on a scanner rather than re-photographing them?

GS: Yes, they called it laser scanning. Tom Hurley at Laumont Photographics recently explained to me that it was still an analog process and shifted to digital scanning in the mid-90s.

PK: So, you didn't have any of those original prints. When they went off to *LIFE Magazine* they either went back to the photographer or they got marked up.

GS: They never came back to me. They went to the photographer. And if they did come back to me, we would send the prints back to the photographer. In a conversation with Scott [Thode], I said, "It's such a pity that we have none of the reproduction prints from the Venus story." Scott did have the prints, and he generously gifted the Venus print to your collection.

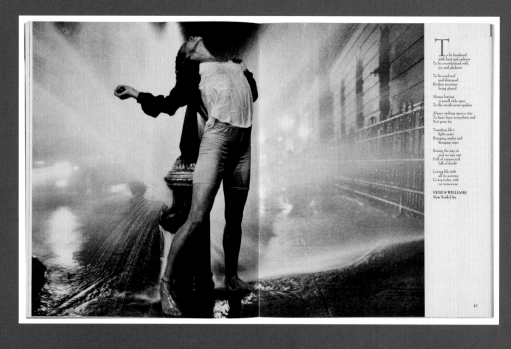

Fig. 8
Scott Thode, *Venus*, 1994, published in *LIFE Magazine*, February 1994. Center for the Technical Study of Modern Art, Harvard Art Museums, Gift of John Erdman and Gary Schneider, 2017.97.2.2. Reprinted from *LIFE* and published with permission of Time Inc.

PK: It's an incredible image.

GS: It's a wonderful image. Again, if you look at that reproduction in *LIFE*, because they enlarged it, they exaggerated certain tones to successfully compensate for the enlargement. Look at what's happening in the reproduced sleeve in relation to the print. *LIFE* was really a major picture magazine, and they would have made it work in the translation.

PK: All of the images are really amazing.

GS: It's a compelling extended portrait of Venus, which he intended to publish as a book. She was a homeless person and he developed this ongoing story about her.

ON A DAMAGED JULIA MARGARET CAMERON PRINT THAT SCHNEIDER AND ERDMAN PURCHASED FOR THEIR COLLECTION

John Erdman joined this part of the conversation.

PK: I'm so curious why this print (Fig. 9) was in your studio and what you used this for. Or did you just love it? Where did you get it?

John Erdman: It was from a photographica flea market, and nobody wanted it because it was torn. People were even saying, "Did you see the torn Julia Margaret Cameron?"

PK: People knew what it was, then?

GS: Yeah, it *was* signed. What's interesting about it, as John has said, is that it was torn, then mounted, then signed, so that—can you see here that the signature on the mount overlaps the print? She signed it *after* it was torn, then mounted. For Cameron, the print still functioned. It was not yet faded; it was not yet dirty. Despite the major tears, she still considered it worthy of being in the world.

PK: It has significant tears.

GS: We never put out a print that was damaged, but often I would keep for my printer's proofs prints that had a pleat on the border, or a curl.

PK: Well, they're in pretty fantastic shape.

GS: I would never give a print like this to the artist, but for my collection, if the image still functioned, I was happy with it. We bought it because it's extraordinary that Cameron was so comfortable with the power of this object.

PK: So for you this was about what she was doing.

GS: Yes! It's her choice as an artist to mount this and sign it, after mounting it with all of that damage. It still functioned for her.

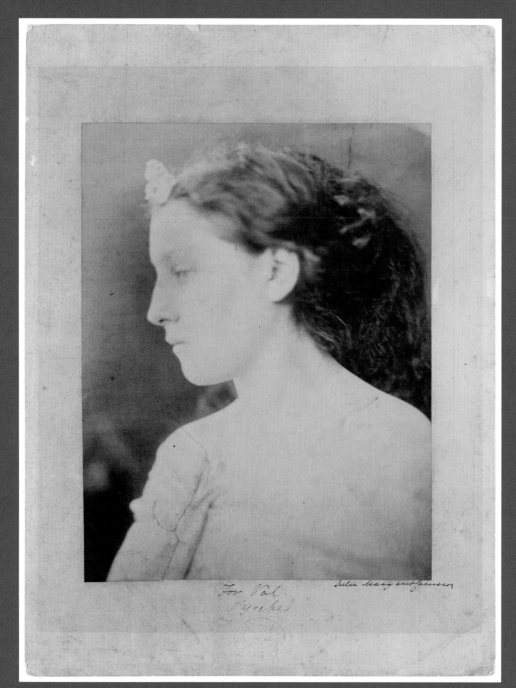

Fig. 9
Julia Margaret Cameron, *Psyche*,
c. 1870. Albumen silver print, 76.2 ×
101.6 cm (30 × 40 in.). Center for the
Technical Study of Modern Art, Harvard
Art Museums, Gift of John Erdman and
Gary Schneider, 2017.97.1.

PK: I had this fantasy that you were showing this to clients as an example of not great conservation.

PK: Yeah, and the more you have it up the more faded it would become.

GS: No, just the opposite. She made the decision to put this into the world even though it was this damaged. That was really the story. It's fabulous. I mean, we never lived with it because it's *so* faded.

JE: Yes, it would probably have disappeared. We did have a fantasy of using it for a client, but it never came about: if they picked out one little minor thing on the edge of the paper, we would pull it out and say, "Look what she did!"

PK: That's so funny. Just one more question about this work: what if we wanted to show it in the galleries?

GS: You could do it.

PK: We could?

GS: Why not? It has the story next to it. It's actually really useful.

PK: Obviously it's faded, torn, and dirty; I don't know if we ever would put it on display.

GS: Even if you did, you wouldn't be using it as an *example* of Julia Margaret Cameron, but an example of what an artist considered to be presentable. If a print functions and the intention of the artist is still present, then any damage may not be an issue. But the issues with the Cameron—you can't miss those, can you?

PK: It is really apparent, but the beauty of the print is still very present.

1
Visit http://www.harvardartmuseums.org/collections/special-collections.
2
Unlike the dodging tools, the burning-in tool Schneider discusses here—created specifically as a demonstration object for the interview—is not part of the museums' collection.
3
For more on "pushing" and "pulling" film, see the glossary.
4
For more on this portfolio, *Reconstructing the Original: Czech Abstractions 1922–1935*, see Jennifer Quick's essay in this volume.
5
Lanker was a Pulitzer Prize–winning photojournalist who worked for *LIFE* and *Sports Illustrated*, among other publications. He is best known for the book and exhibition *I Dream a World: Portraits of Black Women Who Changed America*. The show opened in 1989 at the Corcoran Gallery of Art in Washington, D.C. Schneider produced the prints for the exhibition and the book. The printer's proof collection includes all of the prints that Schneider retained from this project, and the Harvard Art Museums Archives holds copies of the book and a video recording of an interview with Lanker, during which he is shown visiting Schneider/Erdman, Inc.

6
For more on the Czech portfolio, *Reconstructing the Original: Czech Abstractions 1922–1935*, see Jennifer Quick's essay in this volume.
7
For more on contact printing, ferrotyping, and Kodak Azo, see the glossary.
8
One of these ferrotype plates is now in the Center for the Technical Study of Modern Art.
9
Fortezo was made by the manufacturer Forte.

LORNA SIMPSON

Artist Lorna Simpson first became well-known in the mid-1980s for her large-scale works that employed both photography and text. In June 2017, Jennifer Quick interviewed Simpson via email about her photograph in the printer's proof collection, decision-making around the use of gelatin silver, and experiences collaborating with Schneider and other printers. The following Q&A has been lightly edited for clarity and tone.

Jennifer Quick: Could you speak a bit about the background and genesis of the work *Is* (Fig. 1), including the image and its cropping [which omits the subject's face, but prominently displays the letters on her sweater]?

Lorna Simpson: It is a photograph of my father's sister, who died shortly after this school picture was taken. She died of meningitis at 16 years old in 1944 in Jamaica. The school insignia, IS, read to me as the word "is"—for me, the image speaks of presence and absence.

JQ: This photograph is a gelatin silver print, but you work across media. Could you explain the choice of silver photography for this specific print?

LS: At that time, all of the photographic work that I created was resolved in the medium of gelatin silver, somewhat in keeping with the mode of photographic reproduction of the time. I had also created multiple editioned works in photogravure.[1]

JQ: Had you received training in how to print your own photographs?

LS: I learned the darkroom techniques of making gelatin silver prints and how to develop black and white film as an undergraduate at the School of Visual Arts, New York, where I majored in photography.

JQ: How did you decide to work with Gary [Schneider] for this print? Do you remember how you heard about Schneider/Erdman, Inc.?

LS: I can't remember for certain, but he was recommended to me.

JQ: What are your memories of working with Gary? Could you describe the process of collaboration or share any other memories of the lab?

LS: My projects with Gary—which involved both printing and developing negatives—were pretty straightforward. I do remember sitting with him in his library and viewing room and noticing a print of the buffalo by David Wojnarowicz [see p. 48]. That moment of seeing that work in his office I will never forget. We had a long discussion about David's work. I think it was before his landmark exhibition at the New Museum [in New York].

JQ: The *Is* print is signed "PP LS 1991" on the back [identifying it as the print Schneider had selected as a printer's proof]. Before your experience working with Gary, had you encountered other printers who retained a printer's proof?

LS: Certainly other printers who worked in the traditional editioned print market, yes. But Gary was the only printer of silver prints whom I worked with who I would allow to retain a printer's proof.

JQ: Could you give a sense of some of your other collaborations with printers or technicians? Have they mostly been based in New York?

LS: I worked with [printer] Jean-Yves Noblet on felt works and photogravure in New York, in the Meatpacking District.

JQ: You produce both analog and digital photography. Is your decision to go with one over the other specific to each project? Is there something about these different methods that you've found yourself drawn to for different reasons or in different cases?

LS: I am not so concerned with matters of analog versus digital. It is only an issue when it comes to video and film and updating platforms of older work, that sort of thing. I continue to use both digital and analog mediums as dictated by the ideas behind the work. For me, they are interchangeable.

Fig. 1
Lorna Simpson, *Is*, 1991. Gelatin silver print, 61 × 50.2 cm (24 × 19¾ in.). Harvard Art Museums/Fogg Museum, Schneider/Erdman Printer's Proof Collection, partial gift, and partial purchase through the Margaret Fisher Fund, 2011.438.

1
Photogravure is a process in which an image from a photographic negative is etched onto a metal plate for printing.

ROBERT GOBER, WITH ANDREW ROGERS AND CLAUDIA CARSON

Artist Robert Gober met Gary Schneider in 1988. In a conversation that took place in Gober's studio on November 22, 2016, Gober; his studio manager, Andrew Rogers, who himself had an extensive background in photography; and the studio's managing director, Claudia Carson, discussed Gober's collaborations with Schneider.[1] Reflecting on that body of work, Gober said: "They were choice, the things that I did with Gary. I feel like they're all very special as photographs. There's nothing casual about them . . . each one is a long story."

The conversation, facilitated by Jennifer Quick, began with the first work Gober printed with Schneider and proceeded chronologically to cover all of Gober's works in the printer's proof collection. Excerpts presented here were lightly edited for clarity and tone.

Fig. 1
Robert Gober, *Untitled*, 1992–96.
Photolithograph, 57.2 × 34.6 cm (22 ½ ×
13⅝ in.). Whitney Museum of American
Art, New York, Purchase, with funds
from the Print Committee, 97.5.

ON GOBER AND SCHNEIDER'S FIRST PROJECT TOGETHER, FOR WHICH GOBER DRESSED AS A BRIDE

Robert Gober: I had an idea that I would be a bride in a photograph. This was in 1991, before any thought of marriage equality. We hired a portrait photographer named David Barry to take my picture. I had made a sculpture of a wedding dress years prior, and we hired Gayle Brown, a seamstress whom I work with, to remake that sculpture to fit me. Then we got a makeup guy; we got a hair guy—the whole thing. For the backdrop, we used seamless paper. We took a picture, but then we did a lot of work with the photograph. I had David's negative and we made a print from it, but it needed to be retouched. That's why I went to Gary, because the photograph wasn't what I had imagined it would be.

We then went to the guy Gary said was the last great black and white photo retoucher, who was still doing it by hand. We had him slim me down and get the highlights that we wanted in the photograph to make what I saw as a classic, old-fashioned, romanticized image of a bride. And then Gary took a large-format negative of that retouched photograph and printed it, and that was used to create the [fabricated newspaper advertisement, which ultimately became part of a larger sculpture (Fig. 1)]. It was an incredibly elaborate process to go through for something that you could easily overlook, because it was in a stack of what resembled everyday newspapers.

That's when my creative partnership with Gary started, because he had great ideas and technical knowledge about how I could achieve that perfect romanticized image by going to this particular retoucher, and then by re-photographing and printing that [touched-up image]. We ended up doing an edition of the bride photograph, which is what you have [at the Harvard Art Museums (Fig. 2)]. But I printed that edition later, after I had used it as a newspaper advertisement as part of the sculpture.

ON TWO BOOKS THAT GOBER MADE TO ACCOMPANY HIS INSTALLATION AT THE 2001 VENICE BIENNALE, WHERE HE REPRESENTED THE UNITED STATES

RG: The catalogue for [the 2001 Venice Biennale comprised] two books—one was explanatory, with two interpretative essays, and the other I thought of as a kind of gift, an artist book that went with the exhibition. [The latter] combined photographs that I took in the late 1970s with photographs I took the summer before I was working on the show (Figs. 3–24). It was a collage of those two

Fig. 2
Robert Gober, *Untitled*, 1992–93.
Gelatin silver print, 50.6 × 40.3 cm
(19¹⁵⁄₁₆ × 15⅞ in.). Harvard Art Museums/
Fogg Museum, Schneider/Erdman
Printer's Proof Collection, partial gift,
and partial purchase through the
Margaret Fisher Fund, 2016.149.

...series taken at very different times, decades apart. . . . I laid it out, and then Mats Hakansson, the book's designer, took it from there, because I'm pre-digital, so I had literally cut and pasted it together.

The earlier series of photographs is from 1978. . . . When I moved to New York, I started taking black and white photographs in 35mm. I had a little darkroom in my apartment. I had an idea for this project, and I wasn't sure what I was going to do with it, but it was going to be a flip book of photographs. But all that remained of that project was the cut-up contact sheet (Fig. 25), picturing a car trip that we took—for fun—from downtown New York City out to Jones Beach. I took photographs the whole way, but all that remained were the badly printed contacts.[2] The other series, which sort of dominates, was from when I was living in my house out on Long Island Sound. Every morning, my dog and I would go out with my 35mm camera and we

The other [interesting element of the collage] is that I had actually printed from these contact sheets, maybe half a dozen images. For instance, we had some as vintage prints. Some of them are inset; some of them are background. Almost all of them show the rubble of my amateur contact sheets. That's the back of a car hood, but then you've got the toner marks from the contact sheet blown up like crazy. These early photos are interspersed with the very clear photographs that I took on the beach the summer before Venice. And then there were a couple that were fictions, completely created. So there are three stories [in the catalogue] that interweave.

Much later, I had this idea that I would print all of the pages of the book separately. I thought when I did it in 2001 that it would just exist as an artist book, and then later . . . I decided to print them as large-scale photographs. That's when we went to Gary [to print the edition]. . . . He would make a large negative [from the book] . . . so all of the imperfections of the contact sheet got blown up, which we both found interesting.

Andrew Rogers: The printing was an intense process . . . because Gary was so exacting about getting it right. He would go to enormous lengths to get it right. And it required a lot of back and forth. As I remember it, he would come with three, four, five different proofs to the studio, and we would go through them with him and say: "This works in this one. This doesn't work in this one." . . . He did one print at a time, and he was obsessed—in a good way—about getting that print just right before moving on to the next one. I think that this book in particular was uniquely challenging for someone who has a more or less traditional background in black and white photography. Because there are all of these different things going on. There are the photos, as Bob [Gober] said, from 2000 or 2001 that he had made on the beach and for which the image quality was much higher: there were original negatives; it was shot on black and white film. And then there are these scans of these contact sheets that are—I don't know how to phrase it exactly, but they're . . . imperfect.

RG: They're crummy.

Figs. 3–24
Robert Gober, *1978–2000*, 1978–2000.
Gelatin silver prints, each: 51 × 75 cm
(20¹⁄₁₆ × 29½ in.). Harvard Art Museums/
Fogg Museum, Schneider/Erdman
Printer's Proof Collection, partial gift,
and partial purchase through the

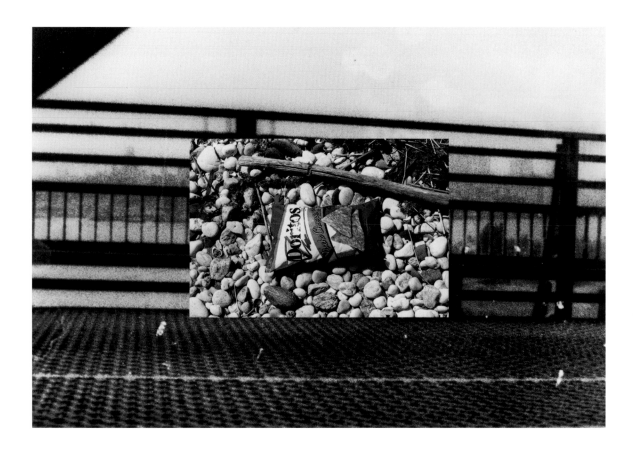

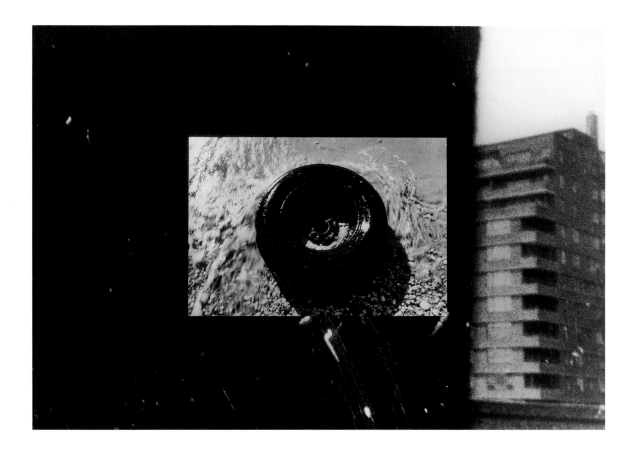

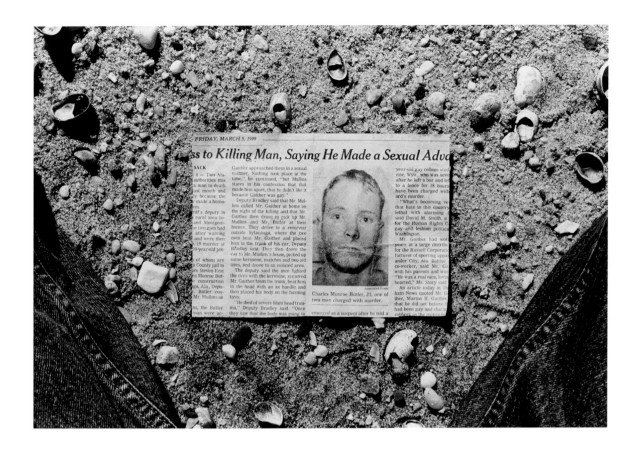

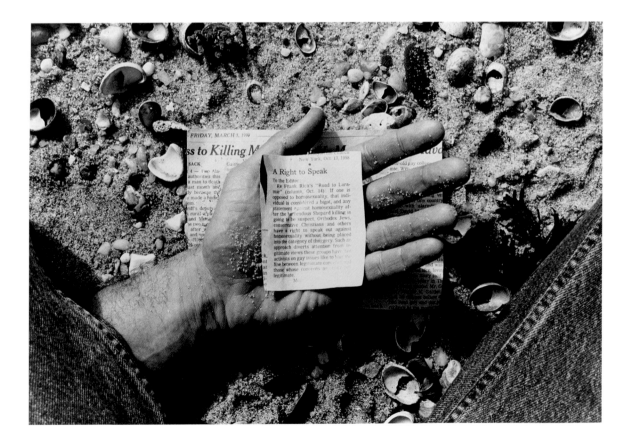

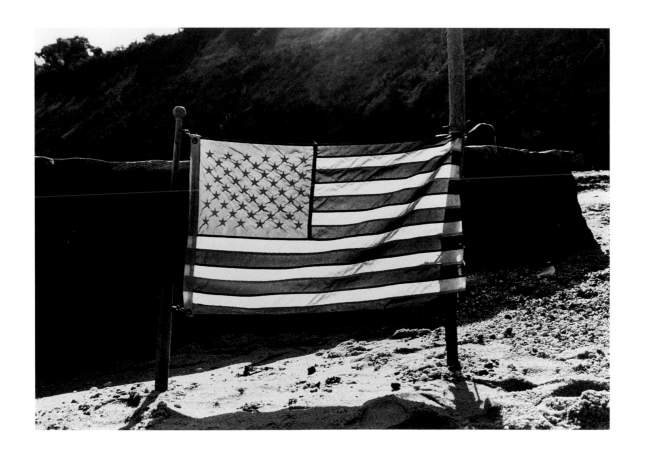

Fig. 25
Original contact sheets of Robert
Gober photographs, source material
for *1978–2000*, 1978. Dimensions
variable. Collection of the artist.

AR: I mean, I didn't want to say it, but yeah, they're crummy. And then the challenge was to take those two very different things and not only to make beautiful black and white prints, which is what I think Gary's goal was, because he is trained as a black and white printer and photographer, but also to get the result that Bob wanted, which conceptually is not always going to be your traditional, beautiful black and white image, your perfect gelatin silver image. It might fall to one side or another of that. So there were all of these challenges to getting this project done, between the conceptual and the technical, the material and the idea.

RG: And every print was a different challenge. It wasn't like he had one way to do it and then you could apply that consistently.

AR: Yeah, it wasn't like printing a suite or anything.

RG: No, because of the mix of the technical nature of the images—both how I put them together, and how he would then translate them into a seamless photograph. So for each photograph, Gary would come in with four or five *really* good prints that had variations. We could go this way, that way, or yet another way . . . sometimes I could not see the difference; that's how fine his eye is.

ON *UNTITLED, 1977–1994*

RG: By the time I graduated from college, I was painting realistically. And then I moved to New York, and painting realistically was not up to the challenge of representing the city. I've said it too many times: you can't paint dirt without romanticizing it. I was interested in depicting the world, and that led me to black and white photography.

So I started photographing what was around me. I had moved to a loft down on Mercer Street, so it would have been 1976 or '77 [when I took these photographs]. They were of a chicken that we cooked that had a broken leg. I don't know why we bought a chicken with a broken leg, but I took a picture of it uncooked (Fig. 26) and then we roasted it and I took a picture of it cooked (Fig. 27). I printed [the uncooked chicken] as an announcement card for a [1994] show at Paula Cooper's [gallery]. But after seeing it as an announcement card, I wondered about making it into a beautiful black and white photograph, so I called Gary.

ON THE PHOTOGRAPH USED AS THE BASIS FOR *WEST ROCK TUNNEL*

RG: I had the image that I wanted in mind, which was a double tunnel. I knew the composition, how it would be centered in the vertical rectangle. I knew the actual tunnel, because it's on the Merritt Parkway in Connecticut, near where I grew up. It's outside New Haven. I just drove through it yesterday when I picked up my mom. And I knew the vantage point. I also assumed that I would take the photo myself, but each time that I attempted to, something went wrong. So I went with my assistant Daphne.

You come out of the tunnel and on one side there's a big hill. I thought, "Great, we're going to photograph from the top of the hill," but it was impossible, because there was no median on either side of the road. So I instructed Daphne, "Slow down, slow down," because I was trying to shoot it from the car, out of the window—and that didn't work. So we pulled off of the highway, drove on local roads, and we scrambled up the hillside to try to get the shot from there—and that didn't work either. Everything went wrong. The 35mm wasn't detailed enough.

Fig. 26
Robert Gober, *Untitled, 1977–1994*, 1977. Gelatin silver print, 20.3 × 25.4 cm (8 × 10 in.). Harvard Art Museums/Fogg Museum, Schneider/Erdman Printer's Proof Collection, partial gift, and partial purchase through the Margaret Fisher Fund, 2011.194.

Fig. 27
Robert Gober, *Untitled, 1977–1994*, 1977. Gelatin silver print, 20.3 × 25.4 cm (8 × 10 in.). Harvard Art Museums/Fogg Museum, Schneider/Erdman Printer's Proof Collection, partial gift, and partial purchase through the Margaret Fisher Fund, 2011.195.

Then, the large-format camera failed to work on-site for whatever reason. Getting the right vantage point was impossible. In my frustration, I began to think of all of the alternatives. A historical or vintage photo came to mind. So, we went to the New Haven Public Library, which led us to the Library of Congress and the Historical American Engineering Record, an archive that began in 1933 alongside the [Works Progress Administration]. They have such beautiful photographs. Much like its brother organization, [HAER] began by hiring unemployed architects, engineers, photographers. . . . It's still going, with an archive of some three million images, and you can order black and white prints for a very modest sum.

I loved the idea of exhibiting a photo from this archive at the [Venice Biennale], because I was representing America in the U.S. Pavilion. It was all coming together. I intended to give the information for ordering your own print to the public; I thought that that would be a nice thing. The Merritt was built in the 1930s, and there are extraordinary photos of its bridges, a brand new landscape not driven upon, unbelievably beautiful shots. But this particular tunnel [located on an extension of the Merritt called the Wilbur Cross Parkway] was built in the late '40s, right after the war, when there was no money, so there are no photographs of it in [the HAER] archive.

I looked locally, and we found the contractor who built the tunnel, so Daphne and I went to them and went through their visual records, but there was nothing usable. I ended up at the archives of the State Library in Connecticut, and there I found an old, homemade scrapbook with small, aged black and white snapshots of the construction of the tunnel. One photograph in this book was a good possibility, close to what I had in mind, but I could neither remove the book from the archive nor take the photograph out from under its brittle, cellophane page protector. They did provide a copy stand for 35mm, so I took a shot of it there. . . . That's where we started. We made the best black and white print of that negative possible.

ON MAKING THE ORIGINAL *WEST ROCK TUNNEL* PHOTOGRAPH INTO A TONED GELATIN SILVER PRINT

RG: I began to work with a very talented Photoshop technician, Jim Deyonker of Lux Imaging. It was when Photoshop was relatively new, at least for me. Cars were erased. The vantage point and the directions of the roads were made symmetrical and centered. The forest above the tunnel replaced another work road with debris. All of the details were worked on in some way, but the essence of the photo remained true. For instance, I didn't make three tunnels or change its intrinsic nature. A new, large-scale negative was output from this process, and then Gary made the toned gelatin silver print on Luminos Charcoal R paper.

I had an agreement with the library that if I used the photograph I would always credit the source. I knew that

I could call this photo my own and date it 2001, but it felt wrong. The history of the source and the photograph's relationship to that source was, I felt, more complex and more mysterious, [so I dated it from a year that] predates my birth. I thought of it as a type of collaboration, and this led to my decision not to sell the photographs. It didn't seem quite right that I alone should profit. . . . That's why the [work is dated] 1949–2001 (Fig. 28).

It's always Gary [who advocates specific papers]. He was obsessive, and papers were starting not to be produced anymore. He would say, "I have this trove of paper, but there's no more." I took his lead. He would give us options sometimes with papers, but he knew it so much better than me. That's why I went to him: to learn things and to be surprised at what he would bring to these projects.

AR: [His choice probably] had to do with the texture of the paper. If I'm recalling correctly, Gary was very particular about how a paper accepted a toner; if he was going to tone a print, [he wanted to find] the perfect formula.

RG: [The photograph] was shown framed in the [U.S. Pavilion at the 2001 Venice Biennale]. It greeted you as you came in. The pavilion is symmetrical; there are two dead ends going left and right. The photograph was in the rotunda where you come in. So the two tunnels were kind of a perfect introduction to your two twin pathways.

ON *UNTITLED, 2008*

RG: The photograph of the ear was for a card for a show that I did at the Matthew Marks Gallery (Fig. 29). I like announcement cards, because I feel like I can use them to put different kinds of information out that isn't necessarily, say, an advertisement for a sculpture. I had made an ear sculpture back in the 1970s that I gave to Steve Wolfe, so [the motif] goes way back in my work, but I don't think that we had made another sculpture of an ear yet. . . . I think [Andrew and I] photographed each other's ears to see who had a better ear for the card, and it was something about Andrew's ear—and his hair—that was more "ear" to me than my ear, with whatever my hair or non-hair was, and then I turned it upside down for the card. The photo wasn't in that exhibition, but we were simultaneously making another sculpture of an ear in the studio. It ended up being bigger than life.

AR: We made a mold off of the ear [of someone working with me in the studio at the time].

RG: I would have cast from Andrew's ear, except that he is the person with the mold-making skills. Another assistant, Bill Abbott, was here. I looked at his ear and I thought, "That'll do," so we ended up casting Bill's ear for the sculpture.

AR: [We made the mold using this] kind of an analog material, actually; it's a polyurethane. We cast it in this material called HydroSpan, and then that cast goes into a bucket of water for 19 to 21 days or something. . . . And then it proportionately expands. So then [we'd] take it out and make a mold off of that. We did that for three or four generations to make it bigger.

Fig. 28
Robert Gober, *West Rock Tunnel*, 1949–2001. Toned gelatin silver print on Luminos Charcoal R paper of digitally enhanced archival photograph (Archives of the Connecticut Department of Transportation, Record Group 89, Item 30, The West Rock Tunnel on the Wilbur Cross Parkway, New Haven, 1948–49, State Archives, Connecticut State Library, Hartford, Connecticut), 61 × 50.8 cm (24 × 20 in.). Harvard Art Museums/Fogg Museum, Schneider/Erdman Printer's Proof Collection, partial gift, and partial purchase through the Margaret Fisher Fund, 2016.151.

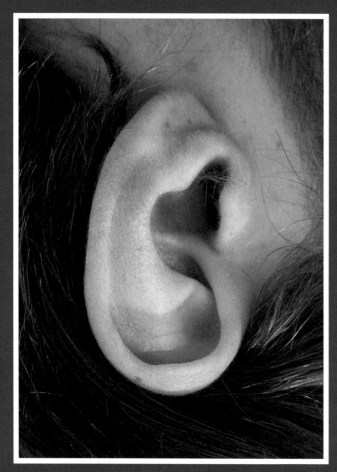

Fig. 29
Robert Gober, *Untitled, 2008*, 2008.
Pigmented ink print, 25.4 × 20.3 cm
(10 × 8 in.). Harvard Art Museums/Fogg
Museum, Schneider/Erdman Printer's
Proof Collection, partial gift, and partial
purchase through the Margaret Fisher
Fund, 2011.196.

RG: It expands something like 20 to 30 percent.

Claudia Carson: At first, you were going to do a gelatin silver print, and so Gary printed that, then the pigmented ink print.[3] It turns out that that's when Gary was taking his equipment apart; it was actually the last gelatin silver print he ever made.

RG: And that made me sort of lose interest [in photography as a medium]. I liked the challenge of traditional black and white printing. As a sculptor, it made sense to me. As a process person, black and white photography made sense—as opposed to digital printing, which doesn't interest me that much.

ON NEW YORK IN THE 1980s AND '90s

RG: I was working out of a studio on East 10th Street, so I was just two blocks away from Gary's studio on St. Mark's. He would bring stuff to 10th Street, too. It was a pretty easy back-and-forth thing, because we were neighbors. . . . Peter Hujar lived around the corner. . . . David Wojnarowicz also lived close by. I used to see him all the time.

 They were printing all through the [AIDS] epidemic in a neighborhood that was decimated, printing for photographers who were on their way out. One of my strongest memories of David was standing in line with him to vote. It was one of the Reagan votes—against Reagan, but I don't remember which time.

1
Andrew Rogers died unexpectedly on
February 11, 2017.
2
Here, Gober refers to the fact that
the original negatives were lost. As
he states below, some vintage prints
made from the contact sheets were still
in his possession.
3
Schneider used Light Valve Technology
(LVT) to make the gelatin silver print
from a digital file. See the glossary for
more on LVT.

JOHN SCHABEL

Photographer John Schabel met Gary Schneider in 1993 through the artist Peter Campus. In a conversation that took place in Schabel's New York studio on November 21, 2016, Schabel and Jennifer Quick discussed photographs that he printed with Schneider, his working relationship with Schneider and Erdman, and his thoughts on printing in the darkroom. Of their partnership, Schabel said: "I know that Gary thinks about a performance in the darkroom, and that makes a lot of sense. . . . I think of a performance in the shooting. And maybe that's why we got along so well. We both come at it from some similar tangent."

Quick and Schabel began by discussing the first works Schabel printed with Schneider and proceeded chronologically to cover his other photographs in the printer's proof collection. The excerpts of their conversation presented here have been lightly edited for clarity and tone.

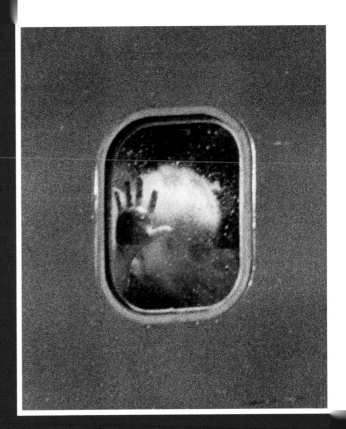

ON *PASSENGERS*

John Schabel: The ones that I had printed first with Gary [Schneider] were the photographs that really jumped out as being enigmatic in some sense. Then, when I published the series as a book [*Passengers* (Twin Palms Publishers, 2013)], I went into the darkroom and exhaustively reviewed all of the contact sheets and negatives and printed anything that looked like it might work. Some of them did, and some of them didn't. This further level of editing was interesting in that you get down to images that you don't think are going to work, and then they really do. That also happened sometimes when I took negatives to Gary and John [Erdman].

I did a lot of shooting for *Passengers*. It was kind of an addictive activity. You know what it's like when you have to get ready and fly somewhere: it can be very stressful, getting to the airport through all the traffic on time with all of your stuff. I would usually go on nights when it was raining or rain was predicted—the rain delayed the flight, which gave me more time to shoot, and at night you could see inside the plane, whereas during the day it's really difficult because there's glare on the window. So I was always driving to the airport at rush hour on rainy nights. It was a nightmare, but I wanted to get there to shoot. I didn't have to worry about missing a plane, but driving out there was still kind of tense.

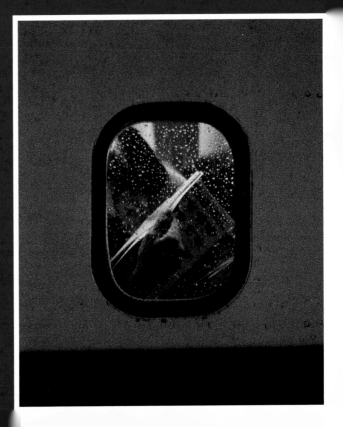

Fig. 1
John Schabel, *Untitled (Passenger #3)*, 1994–95. Gelatin silver print, 61 × 50.8 cm (24 × 20 in.). Harvard Art Museums/Fogg Museum, Schneider/Erdman Printer's Proof Collection, partial gift, and partial purchase through the Margaret Fisher Fund, 2011.418

Fig. 2
John Schabel, *Untitled (Passenger #8)*, 1994–95. Gelatin silver print, 61 × 50.8 cm (24 × 20 in.). Harvard Art Museums/Fogg Museum, Schneider/Erdman Printer's Proof Collection, partial gift, and partial purchase through the Margaret Fisher Fund, 2011.423

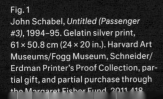

Then I would go around the terminals and get the schedule for the gates that I had scouted beforehand. I would write the flight times in a notebook, and then I would sit down and decide, "OK, I'll go here and then here and then here." And that would be my activity for the night. I always photographed from outside, on public walkways and overpasses, not inside the terminal. I would see when the plane would start to board, and people would get on and get settled a bit. And then I would pull out my tripod and set everything up. I didn't want to do that too soon, because I didn't want someone to come by

and tell me, "No, you can't do that," or ask me to move on. So I would wait until just the right moment, get everything out, shoot, and then put everything away again very quickly. Then I was just a person with a backpack carrying stuff at the airport, so it was not suspicious. Security was not like it is today, but I still didn't want to push it. I knew that I didn't want to shoot at the airport just once or twice; it was a project that I wanted to sustain over months. I ended up doing it on and off for about two years. I felt like I was good at a certain kind of logistics—I plan shoots like heists.

ON *CLOUDS*

JS: I was thinking about the way children draw clouds, this self-contained outline. Almost like the symbol of a cloud. [My association with clouds] as a childhood image also stems from the first time I flew on an airplane. I think that I was about 10. We were going on a family vacation—my mother, my sister, and me. We got up in the air, and my sister and I looked out the window and there was this cloud out there, this tiny puff of a cloud just sitting right outside the window. There was something about it that we both found humorous, because we looked at each other and laughed. That was interesting to me. What was it about the cloud that made us laugh? Why did it strike us as being funny?

I wanted the [subject of the] photograph to be itself. I wanted it to be a cloud—not look like a rabbit or suggest a stormy mood or anything. In that sense, the photo was like a portrait of a cloud, and I wanted it to have all the particularity of itself, all the details and all the huge complexity of the physics of what's going on in there. I wanted just to make an image or a document of that. That was the reason for putting the clouds against this black background . . . almost as if it was a cloud chamber or this scientific experiment or something (Figs. 4, 5). Every detail about it is a fact. Another interesting thing about clouds is that it's very hard to tell how big they are. Is this cloud a block long, or is it the size of a car? It's very hard to say.

You learn early on in black and white photography that if you put a red filter on the camera it will make the sky darker. It's a kind of cheap effect in photography. In movies, it's called "day for night"—when they shoot during the day but make it look like night. It has a particular look. It's very dramatic, like there's this intense moon. I wanted

to use that, to get a red filter, put it on the camera, and turn the sky black. But I wanted it to make it really, totally black. I learned that you can add to the red-filter effect by going to a higher altitude, because the resulting shade depends on how dark the sky is to begin with, how deep the blue is. At sea level, the atmosphere is denser and scatters more light, so the sky is never as deep blue as it is when you're on a mountain top; when you're that many thousands of feet closer to the edge of Earth's atmosphere, the color gets darker.

I went to Colorado. It's already 6,000 feet closer to the edge of the atmosphere than New York. And there are mountains that are pretty accessible where you can go up to 12,000 and 14,000 feet. On a good day, if you're there and a cloud happens to pass by in a good position relative to where you are at that moment (because they move and change very rapidly), and you have a red filter on your camera, you can capture that cloud against an even blacker sky. Then, if you take the film to Gary and he processes it in a certain way to make the contrast a little stronger, and then it's printed even more "contrasty," you start to really get a deep black in the sky. It becomes an even cheaper effect, I guess. But now all of that effort and performance and research is kind of moot, because it's very easy to turn the sky black digitally.

ON WORKING IN THE DARKROOM, PRINTING, AND COLLABORATING WITH SCHNEIDER AND ERDMAN

JS: I had access to a darkroom that was in my neighborhood. A friend of mine, James Wentzy, worked for James Dee, who had a business photographing art. [Dee] had a darkroom on Wooster Street that he let me use. That's where I printed the photographs for the *Passengers* book

Schabel 7/25/01

20x24 Roughs

60101 -2 # 35. More contrast.

61901 —1 # 6 find detail in the light form.

62701 —1 # 31 LH Grey Form make darker.
 keep contrast good/strong.
 exagerate the light form.

 keep Dark

30801 -4 #11 keep Dramatic / high Contrast,
 Detail in the fingers.

60101 —1 #2 Burn down background
 exagerate the light Form.

Fig. 6
Gary Schneider's lab notes on John Schabel's *Night Shots*, 2001. Records of Schneider/Erdman, Inc., Harvard Art Museums Archives, Gift of John Schabel, ARCH.2017.4.13.

Fig. 7
John Schabel, *Yuma, Arizona*, from the *Cities and Towns* series, 1999. Gelatin silver print, 64.7 × 92.8 cm (25½ × 36⁹⁄₁₆ in.). Harvard Art Museums/Fogg Museum, Schneider/Erdman Printer's Proof Collection, partial gift, and partial purchase through the Margaret Fisher Fund, 2011.428.

Fig. 8
John Schabel, *Night Shot 4*, 2001. Gelatin silver print, 61.5 × 92.2 cm (24³⁄₁₆ × 36⁵⁄₁₆ in.). Harvard Art Museums/Fogg Museum, Schneider/Erdman Printer's Proof Collection, partial gift, and partial purchase through the Margaret Fisher Fund, 2016.180.

tried using communal darkrooms, but I'm too secretive, or if I started something and had to do an all-nighter . . . needed [access to a private space]. I used communal darkrooms in college and that didn't seem to be a problem, but I didn't like working in the ones in New York that I tried a couple of times.

The practical reason that I worked with Gary is that I'm not that prolific. For me, maintaining a darkroom is not a very practical or economic idea. Gary is such a fantastic printer; I knew that if he was doing the printing, the photos were going to be the best they could be. And I got along with him really well. Gary is really unique in the

way he can take a very deep approach to the work. That was the great thing about working with John and Gary: we would have discussions not just about the prints, but about the project and the work. I feel like they were also really helpful in the editing process. That's not something you find with most commercial labs. . . . It really worked for me.

If I was shooting a project, [Gary] would process the film and make contact sheets, and I would then select from the contact sheets and bring the negatives back in, and he would make what we called a "work print." . . . It's kind of a filmmaking term, "work print"; it means a print

ON SPOTTING AND *CITIES AND TOWNS*

JS: When each edition was printed, I would go in and John [Erdman] and I would spot them on his desk.[2] I also liked that. It was a fun part of the process, deciding what to spot out and what not to spot out. It's very interesting when you start spotting: there will be some very obvious things that you want to spot out, but then other things will appear because your eye isn't being distracted by the things you just got rid of. It becomes these layers, and you have to know when to stop . . . or guess when it's enough. Maybe you don't have to get rid of something completely, maybe you just have to tone it down a bit. Sometimes just removing a few little spots will result in a remarkably smooth transformation. The image sort of floats. You get rid of just a few things and it becomes this remarkable window that you fall into. With *Passengers*, it was very easy, because the grain is so huge. I remember John saying, "You can almost spot these with a mop." . . . But the *Cities and Towns* series (Fig. 7) was challenging. . . . I had learned a lot about spotting from John, so I did those myself in my studio, because it was very tedious and something that you had to really be in the right mood to do. Plus, I really enjoyed it—it's sort of Zen.

I remember John talking about spotting, that it works on a subconscious level. As a viewer, you may never have noticed that there was that little white speck or black line or whatever, but if it's removed, it's a different experience for you and you may not even be aware of it. It can operate on that level, too. That was fun and part of the magic about sitting with John and doing spotting.

ON THE *NIGHT SHOTS*

JS: [The idea for the *Night Shots* came to me while] I was watching TV—it was either a concert or a football game, something where you see the view of the stadium and all of those little flashes going off (Figs. 8–10). Those are people taking pictures. What's so striking is how many there are. First of all, the flash is not really doing anything, because it's going off in this stadium situation. The person taking the picture probably has a snapshot camera; to the camera, there's not enough light, so it makes the flash go off, but the subject is too far away for the flash to have any effect. More than actually improving the picture, the flash became a sign that there was a picture being taken.

It was kind of remarkable that—whatever was going on—there were many people deciding to record this particular moment. I liked the idea that the flashes were an indication that someone had the impulse to make a photograph. There was so much of it going on at these events. You start to think, how much film is going through

that you're going to cut (Fig. 6).[1] This was back in the days when you actually cut and spliced the film, as opposed to working with video or digital files. I always called the first print a "work print." I think that Gary more often called them "roughs." He would make a "rough" or a "work print"—just one per image—from the negatives that I had selected. Generally, I would pick those up and take them away to look at them and decide whether I wanted to have him print particular images for an edition. I'd then go back and put the prints up on the wall, and we'd discuss them—what we were going to do or what we were going to change.

If we couldn't decide on something . . . John was always kind of in the background listening, and we would call him over and he would always go right to the heart of the issue and come up with the right answer. We would say: "Erdman is never wrong. We better call Erdman in and get him over here." That whole dynamic I really loved. I looked forward to that whole process . . . kind of like a critique. I *needed* that. . . . It was a wonderful thing that I think would be really hard to find anywhere else.

Fig. 9
John Schabel, *Night Shot 6*, 2001.
Gelatin silver print, 61.9 × 92.4 cm
(24⅜ × 36⅜ in.). Harvard Art Museums/
Fogg Museum, Schneider/Erdman
Printer's Proof Collection, partial gift,
and partial purchase through the
Margaret Fisher Fund, 2016.182.

Fig. 10
John Schabel, *Night Shot 10*, 2001.
Gelatin silver print, 92.2 × 67.3 cm
(36⁵⁄₁₆ × 26½ in.). Harvard Art
Museums/Fogg Museum, Schneider/
Erdman Printer's Proof Collection, par-
tial gift, and partial purchase through
the Margaret Fisher Fund, 2016.186.

their cameras? How many prints are being made at the drugstore? How much does all of that weigh? And they're probably not going to be very good shots, because there's not enough light and the subjects are very far away. But it's someone's moment of, "Oh, I was at this concert," or, "This is when we saw our team." These kinds of photographs are not necessarily very good, but they were made by a person at this event and are therefore somehow more desirable or meaningful than if, on their way out, they could buy professional photographs of the concert to take home. They might do that, too, but they want to take the photograph themselves. They want some sort of proof.

Now that most people have cell phone cameras, it's much easier to take a photo. You don't need as much light and you can see whether you got the shot you want. Or maybe you just take a picture of yourself there, because that's really what you were doing before. You were just proving that you were there.

So I thought, if I wanted to photograph people taking flash pictures, what would I do? Would I go to stadiums with a really long lens? How would that work? I would have to search through the crowd and try to catch that exact moment—and a flash is one one-thousandth of a second. Even with a cheap camera, it's an extremely small amount of time, which is why it works: it's such a brief duration of light. To actually catch that on film, you'd have to find that one one-thousandth of a second, point your camera there, and push the button at just the right moment. It was a challenge to figure out how to do that. And then I thought, what would that image look like? Well, if you get that moment, it doesn't matter what it looks like. The photograph is about synchronizing with that precise moment . . . that's what was interesting to me. I'm going to perform this activity and the result is going to be what that image looks like to the camera when the light goes off. And if the light is not there, then I didn't get it. . . . [Like photographing *Passengers*, taking the *Night Shots*] was a kind of addictive activity because of that tension that was in the shooting. It felt like it was a real abstraction of taking a photograph. Almost like an X-ray of someone taking a picture. It was using someone else's impulse to make a photograph to make my own, kind of like piggybacking on or using the energy of someone else's camera. The elements in the photograph are reversed: the subject of their photograph becomes the foreground in mine, the out-of-frame becomes the background, and the photographer becomes the subject. So there was all

of this mirroring and reversal that I really liked. It was fun to make those transitions. I sometimes thought of it as taking a photograph from inside a photograph.

I remember the first contact sheets that Gary processed [for the *Night Shots*]. The contact sheets had all of these dark frames and he said, "They all came out really dark." Then there were these frames where you couldn't see anything because they were practically all white. He probably thought that those were mistakes, but in fact those were the only ones that had worked. I said, "No, those *are* the pictures!" Out of thirty-six frames, there would only be about three or four [possible images] on each contact sheet, because it was really hard to synchronize and capture someone else's flash. There would be contact sheets that were really just all dark, where you couldn't see anything, or couldn't see much, and then there would be these big bursts of light. They had to be printed down a lot, because it would make a very thick negative, looking directly into the light.[3]

One of the places I shot was on the Empire State Building. I was looking at it one night from a distance and I could see flashes going off on the observation deck. It's a situation where people are up there at night and they want to take a picture, and their camera says, "Oh, it's dark, I have to flash." That flash travels—you can see it—but of course it's not illuminating the city, so it's not really doing anything for their photograph. I watched [the top of the building] and counted the number of flashes that I could see on one side. . . . In a 30-second period, there was an average of two to three flashes; multiply that by four sides of the building, that's about one every three or four seconds. . . . I decided I had to go up there to shoot. It's really difficult, because [the people taking pictures] are all looking out over the edge, so you can't get in front of them. Still, it was a good spot, because there were a lot of flashes going off up there. I could occasionally get a good angle if someone was taking a picture of someone else.

1
For more on contact sheets, see the glossary.
2
For an explanation of the term spotting, see the glossary.
3
To "print down" a photograph is to print the image darker by allowing for additional exposure time. A "thick negative" results from overexposure; the large amount of light that has struck the film causes more emulsion to remain after processing.

SELECTED BIBLIOGRAPHY

PHOTOGRAPHIC TECHNIQUES AND PROCESSES

Abbaspour, Mitra, ed. *Object:Photo. Modern Photographs: The Thomas Walther Collection 1909–1949*. New York: Museum of Modern Art, 2014.

Adams, Ansel. *The Negative*. New York: Little, Brown and Company, 1981.

———. *The Print*. New York: Little, Brown and Company, 1983.

Baldwin, Gordon. *Looking at Photographs: A Guide to Technical Terms*. Malibu, Calif.: J. Paul Getty Museum, 1991.

Benson, Richard. *The Printed Picture*. New York: Museum of Modern Art, 2008.

Edwards, Elizabeth, and Janice Hart. *Photographs Objects Histories: On the Materiality of Images*. New York: Routledge, 2006.

Stulik, Dusan C., and Art Kaplan. *The Atlas of Analytical Signatures of Photographic Processes: Silver Gelatin*. Los Angeles: The Getty Conservation Institute, 2013.

PHOTOGRAPHY THEORY

Benjamin, Walter. "The Task of the Translator." In *Illuminations*, trans. Harry Zohn, ed. Hannah Arendt, 69–82. New York: Schocken Books, 2007.

———. "The Work of Art in the Age of Its Technological Reproducibility, Second Version." In Walter Benjamin, *The Work of Art in the Age of Its Technological Reproducibility, and Other Writings on Media*, trans. Edmund Jephcott et al., ed. Michael W. Jennings, Brigid Doherty, and Thomas Y. Levin, 19–55. Cambridge, Mass.: Harvard University Press, 2008.

Crimp, Douglas. "The Photographic Activity of Postmodernism." *October* 15 (Winter 1980): 91–101.

———. *Pictures: An Exhibition of the Work of Troy Brauntuch, Jack Goldstein, Sherrie Levine, Robert Longo, Philip Smith*. New York: Committee for the Visual Arts, 1977.

Fogle, Douglas, ed. *The Last Picture Show: Artists Using Photography 1960–1982*. Minneapolis: Walker Art Center, 2003.

SPECIFIC PHOTOGRAPHERS

Ambrosino, Giancarlo, ed. *David Wojnarowicz: A Definitive History of Five or Six Years on the Lower East Side*. Cambridge, Mass.: MIT Press, 2006.

Blinderman, Barry, ed. *David Wojnarowicz: Tongues of Flame*. New York: Distributed Art Publishers, 1990.

Carr, Cynthia. *Fire in the Belly: The Life and Times of David Wojnarowicz*. New York: Bloomsbury, 2012.

Casebere, James. *Model Culture: Photographs 1975–1996*. San Francisco: Friends of Photography; in collaboration with Galleria Galliani, Genoa, and Lisson Gallery, London, 1996.

Gober, Robert. *Robert Gober: The United States Pavilion, 49th Venice Biennale, June 10–November 4, 2001*. Chicago: Art Institute of Chicago, 2001.

Harris, Melissa, ed. *David Wojnarowicz: Brush Fires in the Social Landscape*. New York: Aperture Foundation, 2015.

Koch, Stephen. "Peter Hujar and the Radiance of Unknowing." *DoubleTake* 4 (1988): 68–75.

Lippard, Lucy R. "Out of the Safety Zone." *Art in America* 78 (12) (December 1990): 130–39.

Schabel, John. *Passengers*. Santa Fe: Twin Palms Publishers, 2012.

Simon, Joan. *Lorna Simpson*. Munich: Prestel, 2013.

Smith, Joel, ed. *Peter Hujar: Speed of Life*. New York: Aperture Foundation, 2017.

Stahel, Urs, and Hripsimé Visser, eds. *Peter Hujar: A Retrospective*. New York: Scalo Publishers in collaboration with the Stedelijk Museum Amsterdam and the Fotomuseum Winterthur, 1994.

Vischer, Theodora, ed. *Robert Gober: Sculptures and Installations, 1979–2007*. Basel, Switzerland: Steidl, 2007.

Wojnarowicz, David. *Close to the Knives: A Memoir of Disintegration*. New York: Vintage Books, 1991.

CZECH MODERNISM

Anděl, Jaroslav, ed. *The Art of the Avant-Garde in Czecho-slovakia, 1918–1938*. Valencia, Spain: L'Centre Generalitat Valenciana, Conselleria de Cultura, Educació i Ciéncia, 1993.

Anděl, Jaroslav, et al. *Czech Modernism, 1900–1945*. Houston: Museum of Fine Arts, 1989.

Birgus, Vladimír, and Jan Mlčoch, eds. *Jaroslav Rössler: Czech Avant-Garde Photographer*. Cambridge, Mass.: MIT Press, 2004.

Greenberg, Howard, Annette Kicken, and Rudolf Kicken. *Czech Vision: Avant-Garde Photography in Czechoslovakia*. Ostfildern, Germany: Hatje Cantz, 2007.

Witkovsky, Matthew S. *Foto: Modernity in Central Europe, 1918–1945*. New York: Thames & Hudson, 2007.

IMAGE CREDITS

This item is accompanied by:

1 Glossary - Back cover

This book accompanies the exhibition *Analog Culture: Printer's Proofs from the Schneider/Erdman Photography Lab, 1981–2001*, on view at the Harvard Art Museums, Cambridge, Massachusetts, from May 19 through August 12, 2018.

Published by
Harvard Art Museums
32 Quincy Street
Cambridge, MA 02138-3847
harvardartmuseums.org

Distributed by
Yale University Press
302 Temple Street
PO Box 209040
New Haven, CT 06520-9040
yalebooks.com/art

Managing Editor: Micah Buis
Editors: Sarah Kuschner, Cheryl Pappas
Design Manager: Zak Jensen
Designer: Adam Sherkanowski
Production Coordinator: Becky Hunt

Typeset in Neutral by Tina Henderson
Printed on Symbol Matt Plus and Symbol Freelife Gloss
Printed in Belgium by die Keure

Library of Congress Cataloging-in-Publication Data

Names: Quick, Jennifer, editor. | Harvard Art Museums, host institution.
Title: Analog culture : printer's proofs from the Schneider/Erdman photography lab, 1981–2001 / edited by Jennifer Quick.
Description: Cambridge, Mass. : Harvard Art Museums, [2018] | "This book accompanies the exhibition Analog Culture: Printer's Proofs from the Schneider/Erdman Photography Lab, 1981–2001, on view at the Harvard Art Museums, Cambridge, Massachusetts, from May 19 through August 12, 2018." | Includes bibliographical references.
Identifiers: LCCN 2017049733 | ISBN 9781891771750 (Harvard Art Museums : alk. paper) | ISBN 9780300233032 (Yale University Press (distributor) : alk. paper)
Subjects: LCSH: Photography, Artistic—Exhibitions. | Photography—Printing processes—Technique—Exhibitions. | Schneider, Gary, 1954– —Exhibitions. | Erdman, John, 1948– —Exhibitions.
Classification: LCC TR645.C212 H373 2018 | DDC 770.74/7444—dc23 LC record available at https://lccn.loc.gov/2017049733

Cover image: John Schabel, *Night Shot 6* (detail), 2001. See p. 178 for full information.

Full-page image spreads, in order of appearance:

Alexander Hammid, *Maya* (detail), 1942–47. Gelatin silver print, 25.4 × 20.3 cm (10 × 8 in.). Harvard Art Museums/Fogg Museum, Schneider/Erdman Printer's Proof Collection, partial gift, and partial purchase through the Margaret Fisher Fund, 2011.250.

David Maisel, *Open Pit Copper Mine at Pima, Arizona* (detail), 1985. Toned gelatin silver print, 99.7 × 75 cm (39¼ × 29½ in.). Harvard Art Museums/Fogg Museum, Schneider/Erdman Printer's Proof Collection, partial gift, and partial purchase through the Margaret Fisher Fund, 2011.371.

Nan Goldin, *Naomi and Colette gossiping, Boston* (detail), 1973. Gelatin silver print, 40.6 × 50.8 cm (16 × 20 in.). Harvard Art Museums/Fogg Museum, Schneider/Erdman Printer's Proof Collection, partial gift, and partial purchase through the Margaret Fisher Fund, 2011.232.

John Schabel, *Night Shot 8* (detail), 2001. Gelatin silver print, 81.3 × 101.6 cm (32 × 40 in.). Harvard Art Museums/Fogg Museum, Schneider/Erdman Printer's Proof Collection, partial gift, and partial purchase through the Margaret Fisher Fund, 2016.184.

Jaromír Funke, *Untitled* (detail), 1923–24. See p. 71 for full information.

Detail of print used by Gary Schneider in teaching demonstrations. See p. 128 for full information.

John Schabel, *Laramie, Wyoming* (detail), 1998. Gelatin silver print, 66.6 × 93 cm (26¼ × 36⅝ in.). Harvard Art Museums/Fogg Museum, Schneider/Erdman Printer's Proof Collection, partial gift, and partial purchase through the Margaret Fisher Fund, 2011.429.

David Maisel, *Abandoned Log Flow, Lake Chesuncook, Maine* (detail), 1987. Toned gelatin silver print, 99.5 × 75 cm (39³⁄₁₆ × 29½ in.). Harvard Art Museums/Fogg Museum, Schneider/Erdman Printer's Proof Collection, partial gift, and partial purchase through the Margaret Fisher Fund, 2011.367.

Alexander Hammid, *Maya* (detail), 1942–47. Gelatin silver print, 25.4 × 20.3 cm (10 × 8 in.). Harvard Art Museums/Fogg Museum, Schneider/Erdman Printer's Proof Collection, partial gift, and partial purchase through the Margaret Fisher Fund, 2011.247.